Amazing
Art Adventures

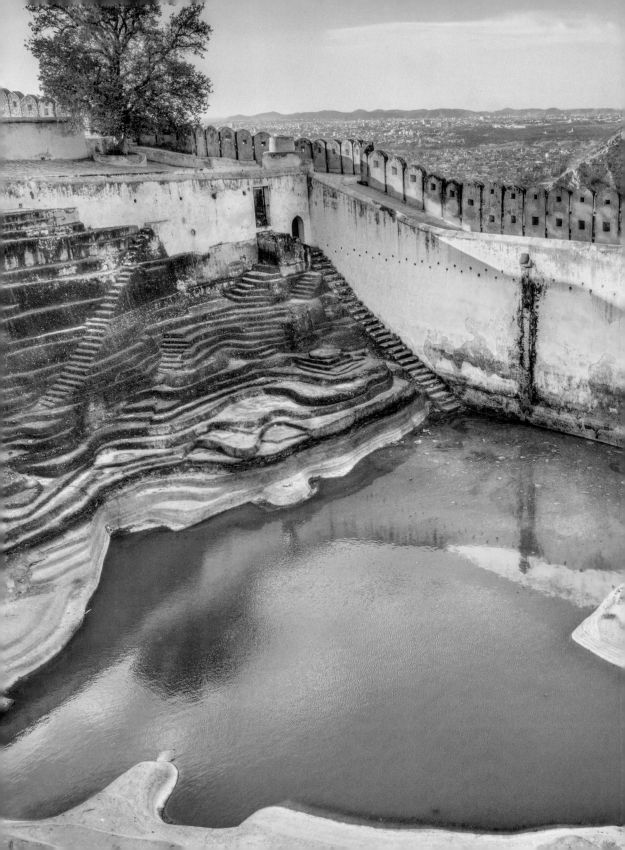

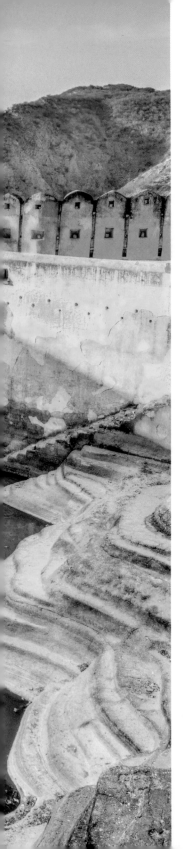

Amazing Art Adventures

around the world in 400 immersive experiences

Written and edited by Yolanda Zappaterra

With contributions from James Payne, Ruth Jarvis,
Sarah Guy, Cath Phillips and Paul Murphy

F

FRANCES
LINCOLN

Contents

Introduction

For hundreds of millennia, mankind has been making visual art, creating figurative representations of the real and the mythical to express, represent and respond to our world, emotions and beliefs. Closer to modern times, abstraction, symbolism and expressionism have added to the 30,000 years of art history charted in museums and galleries around the world, from petroglyphs, sculptures, frescoes and murals to canvasses, photography, multimedia and installations. But museums and galleries only tell half the story.

The other half of the story of art lies as much in the places, feelings and experiences that have inspired creativity, and the unexpected repositories of art that have emerged over centuries. For the history of art is told not only through the paintings, sculptures and applied arts collected in the world's museums and galleries, but through the streets and landscapes artists have wandered and walked. It's told through the houses they have occupied, the times they've lived through, the fantastical and mundane places they've experienced, the extraordinary landscapes that have beguiled and obsessed them, the equally extraordinary creatives who've come before them and inspired them, or the lovers, family and friends that have shaped their lives and work.

It's this combination of art as an experience both within and beyond the gallery that I've tried to bring together in *Amazing Art Adventures*. Aimed at all of us who travel to learn about new places and cultures, and to see the art associated with them, the book brings together hundreds of art experiences around the world, acting as an inspirational armchair travel guide and planner for everyone interested in art.

You might be surprised to find some of the world's most famous artworks missing, or only mentioned in passing. But I make no apologies for that. Art appreciation is subjective, and in selecting the final shortlist for the entries here, my choices were equally subjective. The main question I asked myself was 'will *everyone* reading about this work, space or place, whether they know everything there is to know about art or have never set foot in a gallery, find something wonderful, extraordinary, remarkable or memorable in it, something that makes them want to experience it first-hand?'

The answer often lay in entries that offer a different way to connect with art in our major galleries and institutions, or highlight small museums and their stand-out exhibits. Many entries don't involve galleries or museums in the traditional sense at all; in more than one city, the walls of buildings

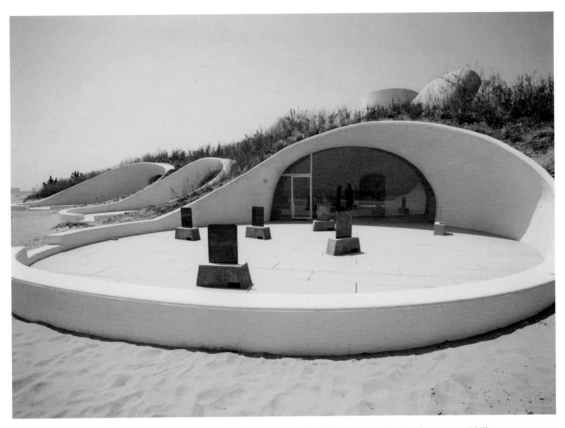

ABOVE UCCA Dune Museum in China, formed from a complex of subterranean galleries (see page 237).
TITLE PAGE Nahargarh Fort in Jaipur (see page 231).

and the pavements they rise from have been the canvas for artists intent on changing the fortunes and living standards of their inhabitants. In Rome, amid the world's greatest religious art and Roman relics, a building occupied by squatting refugees and artists living and working together has had enough political clout to make it a safe haven for both. In a major museum or world-class collection, a spotlight might be shone on an overlooked artwork rather than the obvious, offering a new experience that might border on the spiritual in a way that's rarely to be found standing ten-deep in front of the obvious big hitters.

Gallery walls of a different kind can be found in spaces like the tiny Kent church housing a unique Marc Chagall collection (see page 105), or the walls of French caves covered in paleolithic paintings (see page 134), or the undulating cave-like spaces of a Dune museum on China's Aranya Gold Coast (see page 237). Outdoors and in the natural world, a garden, beach, park, vineyard or canyon can not only contain but be a work of art in the most unexpected way, expanding our definition and understanding of art in exciting new directions. This is the aim of all the entries here, all of them places and experiences any art-loving traveller will be able to gain access to. I hope my writing about them will inspire you to visit some of them, and find a world of art experiences that will enrich your life beyond your imagination.

CHAPTER 1

North America

Murals in various locations

*thegroupofseven
outdoorgallery.com*

McMichael Collection
of Canadian Art

10365 Islington Avenue,
Kleinburg, ON L0J 1C0,
Canada
mcmichael.com

Take a hike and see art in its natural habitat in Ontario

Like hiking *and* art? Ranged across Ontario's Muskoka district and Algonquin Park is a unique outdoor trail featuring more than ninety murals replicating paintings by Canada's famous 'Group of Seven' and the man who inspired them, Tom Thomson. The original seven painters – Franklin Carmichael, Lawren Harris, A.Y. Jackson, Frank Johnston, Arthur Lismer, J.E.H. MacDonald and Frederick Varley – all believed that a Canadian art movement could be established and developed through direct contact with nature, so it's wonderfully fitting that the murals are all located in the sites where the originals were painted. They are vastly scaled up from the paintings but perfectly match them, offering a great opportunity to appreciate the skills of the early twentieth-century artists they replicate, the murals themselves and, of course, the beauty of their subjects. To see many of the real works, head to the McMichael Collection of Canadian Art in Kleinburg, Ontario.

Vancouver Art Gallery

750 Hornby Street,
Vancouver, BC V6Z 2H7,
Canada
vanartgallery.bc.ca

Fall in love with Emily Carr's landscapes of British Columbia

You may never have heard of her, but the British Columbian-born artist and writer Emily Carr achieved firsts in many areas – among them being one of the first painters in the world to become engaged with environmental issues, and one of the first in her country to adopt a Modernist and Post-Impressionist style of painting, achieved through extensive travel around Europe at the turn of the twentieth century. Rooted in the wide-ranging interests she had in Canada, from the aboriginal villages of Vancouver Island's Ucluelet peninsula to the landscapes of British Columbia, which she engaged with affectionately for decades, her works are filled with luminous light and colour, as evidenced here through four of her iconic paintings: *Big Raven* (1931), *Red Cedar* (1931), *Scorned as Timber, Beloved of the Sky* (1935) and *Above the Gravel Pit* (1937), which celebrate the vitality of the natural world and present a deeply personal vision of the coastal rainforest.

RIGHT View inside the Maud Lewis house in the Art Gallery of Nova Scotia.

▼ Home is where the art is

Art Gallery of Nova Scotia

1723 Hollis Street, Halifax, NS B3J 1V9, Canada
artgalleryofnovascotia.ca

The Canadian folk artist Maud Lewis lived in poverty in remote Nova Scotia, selling her paintings to road-trippers for a few dollars until she achieved relative success in the mid-1960s. Despite being born with birth defects and juvenile rheumatoid arthritis which made her whole life very painful and difficult, her paintings are joyous and humorous representations of Nova Scotia and its people. Her house, which she eventually shared with her husband Everett, was a tiny, one-room clapboard building on Highway 217 which was brightly decorated with her whimsical art; a (now iconic) signpost read 'Paintings for Sale'. Maud died in 1970, Everett in 1979, and the iconic house began to fall apart. A group of locals got together and decided to save the landmark, which was finally sold to the art gallery of Nova Scotia in Halifax, where it resides today as a monument to a remarkable woman.

Colour yourself happy courtesy of Dale Chihuly

Chihuly Garden and Glass

305 Harrison Street, Seattle, WA 98109, USA
chihulygardenandglass.com

At some point during this exhibition you'll say 'wow'. The glass sculptures are so impressive and so technically difficult, not to mention beautiful, that there's no avoiding it. The amazing pieces fashioned by Dale Chihuly and his team have an other-worldly quality. They come in many sizes, colours and shapes, from graceful fronds to unearthly globes. Set in a prime location near the soaring Space Needle, the exhibition runs to eight vibrant rooms and a glasshouse, which holds one of Chihuly's largest suspended sculptures – a flowing piece made up of delicate flower-like shapes in colours through red, orange and yellow. One of the loveliest areas is the garden, where there's a chance to see how the glass forms interact with nature. More gasp-inducing glass can be seen at Tacoma's Museum of Glass (see page 12) and in Oklahoma's City Museum of Art, where the *Eleanor Blake Kirkpatrick Memorial Tower* is the tallest Chihuly piece in the world.

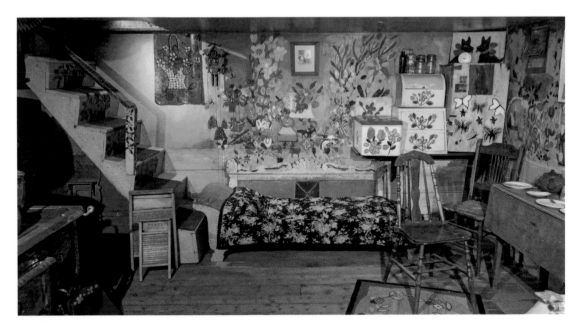

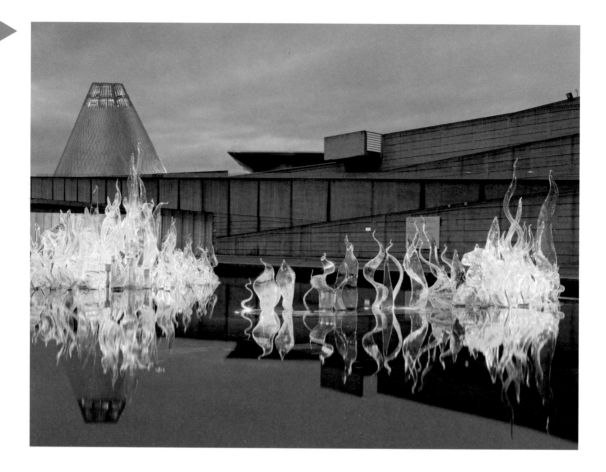

Museum of Glass

1801 Dock Street, Tacoma,
WA 98402, USA
museumofglass.org

▲ Be blown away by Tacoma's Museum of Glass

For some, the standout artwork related to the Museum of Glass isn't actually in the building – or indeed, even part of it. It is the Chihuly Bridge of Glass, opened in 2002. Connecting downtown Tacoma with the museum, this 152-m/500-ft long pedestrian bridge commissioned by the City of Tacoma consists of three installations by the local-born high priest of glass art, Dale Chihuly, including a rooftop panel of 2,364 handblown pieces that's a vibrant throwback to the psychedelic 1960s and a pair of 12-m/40ft-tall crystal towers. Inside the museum, standout elements include a mini forest and the Hot Shop amphitheatre, where visiting glass artists show off their skills by creating pieces in a red-hot furnace. For added glass class, stay at the Hotel Murano, where exhibits include stained-glass Viking boats and a floor-length gown made of cast glass.

See the invisible made visible in Minneapolis

Walker Art Center

725 Vineland Place, Minneapolis,
MN 55403, USA
walkerart.org

Politics with both a small 'p' and a capital 'P' lies at the heart of the art of Kerry James Marshall, as beautifully exemplified by his work at the Walker Art Center where seventeen of his pieces are just a small part of a collection reading like a star-spangled cast list of international contemporary artists. At the time of writing just two of Marshall's paintings were on display, but both illustrate his ongoing engagement with making visible what, for centuries, was invisible in the art world; black bodies. The power and intensity of Marshall's works exploring race in America, black identity and the iniquities of colonial regimes is astonishing when you first encounter them, and never ceases to astonish wherever you encounter them; the Museum of Contemporary Art in Chicago and The Broad in Los Angeles (see page 35) are two other great places to see more of his works.

▼ Celebrate a happy marriage of east and west in Minneapolis

Minneapolis Institute of Art

2400 Third Avenue South, Minneapolis, MN
55404, USA
new.artsmia.org

Chances are you've never heard of Sheikh Zain al-Din, but once you've seen his art, you almost certainly won't forget it. The eighteenth-century Indian artist's oeuvre is the standout work in the Minneapolis Institute of Art's Impey album paintings, named for the British colonial official Sir Elijah Impey and his wife Lady Mary, who commissioned the artist to catalogue their private menagerie in Calcutta. What Zain al-Din created is a collection of drawings whose stark, ethereal beauty is rooted in a mesmerizing mix of English botanical illustration married with ornate Mughal artistic style, and they form part of eleven images from the album bequeathed to a museum whose 90,000-strong collection is filled with not only a fine selection of South and South-East Asian art, but can also boast works by Vincent van Gogh, Henri Matisse and Nicolas Poussin among its treasures.

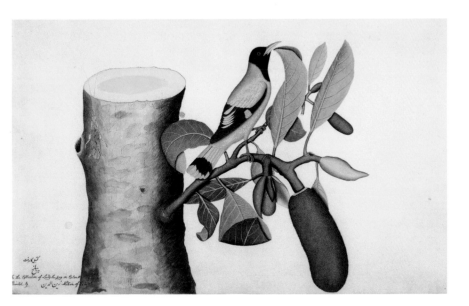

LEFT Tacoma's Museum of Glass illuminated at night.

RIGHT *Black-hooded Oriole and Insect on Jackfruit Stump* (1778) by Sheikh Zain al-Din, from the Impey Album.

▼ Plan ahead for a trip to the mother of all modern art museums

Museum of Modern Art (MoMA)

11 West 53rd Street, Manhattan, New York, NY 10019, USA
moma.org

It is often insanely busy but MoMA's collection – five floors chronologically covering the history of modern art – is truly amazing, so as an art experience it has to be included here. If you're visiting on the free entry evening (at time of writing, Fridays from 4.00–8.00pm), when the crowds flock around iconic pieces like *Flag* by Jasper Johns (1954–5), *Les Demoiselles d'Avignon* by Pablo Picasso (1907), *Number 31* by Jackson Pollock (1950) and *The Starry Night* by Vincent van Gogh (1889), maybe head instead for less well-known works that may be just as big as those in years to come. Kara Walker's *40 Acres of Mules* (2015), for example, documents a dark part of history with a large-scale charcoal triptych that layers totemic images related to the American Civil War and racism into a horrific scene of domination and degradation. It's a hard work to look at, but a vital one.

Go gaga for the garden and more at DIA:Beacon

Dia:Beacon

3 Beekman Street, Beacon, New York, NY 12508, USA
diaart.org

Set on the banks of the Hudson River in a low-slung 1930s building that once housed a Nabisco box-printing factory, Dia:Beacon is part of the art foundation co-created by art patron Philippa de Menil. Conceived with the idea of housing the work of just one artist in one space, the twenty-five galleries here, filled with natural light, are dedicated to just twenty-five artists, among them Dan Flavin, Richard Serra, Michael Heizer, Walter De Maria and Donald Judd. It is spectacular, but equally so are the garden and plaza designed by Robert Irwin as an extension of the interior spaces. Walking through the non-natural forms, the relationship with the works in the galleries is obvious, and making those connections as you explore the tranquil spaces is a pleasure. In Texas, Irwin's *Dawn to Dusk* (2016) at the Chinati Foundation (see page 44) is another stunner from the Californian light and space artist.

Brooklyn Museum

200 Eastern Parkway, New York, NY 11238-6052, USA
brooklynmuseum.org/ exhibitions/dinner_party

Sit down with the great women of history

Considered by some to be the first epic feminist work of art when it was unveiled in 1979, *The Dinner Party* by Judy Chicago has always been controversial. It was labelled 'pornography' by Congress, 'bad art' by critics and even denounced as 'kitsch'. It is none of these things; rather, it is a powerful mixed-media piece in which Chicago aimed to redress the balance of the overwhelming maleness of history and highlight women who had been ignored or trivialized. The triangular table with its thirty-nine place settings for notable women and the names of ninety-nine other women inscribed on the floor took five years and 400 people to complete, using overlooked and undervalued 'female' mediums such as pottery, textiles and needlework. Everything is hand-crafted and each plate is painted with a stylized vulva representing a particular woman, among them Georgia O'Keeffe, Virginia Woolf and Mary Wollstonecraft.

Guggenheim

1071 5th Avenue, New York, NY 10128, USA
guggenheim.org

Walk past the hidden Miró mural at New York's Guggenheim

If you've ever been to Frank Lloyd Wright's landmark Guggenheim Museum in New York, you'll know that the long white wall of the first bay on the ramp is usually where an exhibition's opening piece takes pride of place. What you might not know is that *behind* that wall sits *Alicia*, a 6 m x 2.5 m/20 ft x 8 ft mural comprised of 190 ceramic tiles created by Joan Miró in 1966. With its trademark swirling broad strokes of black and pops of yellows, blues and reds, the piece formed a wonderfully striking introduction to the museum when it was unveiled in 1967. Too striking. Within two years of its unveiling it was covered over with a 'temporary' white wall to appease curators who felt it detracted from the subsequent art and exhibitions in the space. Uncovered just once in the museum's recent history, for the exhibition *From Picasso to Pollock: Classics of Modern Art* in 2003, it is surely due for another outing?

LEFT *40 Acres of Mules* (2015) by Kara Walker.

▶ Have a magical encounter in the Hudson Valley

Storm King Art Center

1 Museum Road, New Windsor,
NY 12553, USA
stormking.org

The beautiful setting of the Storm King Art Center in Mountainville, named after its proximity to Storm King Mountain, would make it an essential art destination any time of the year. But in autumn, when the Hudson Valley blazes with golden colour, a walk or cycle around the hundred or so sculptures and installations that form one of the largest collections of contemporary outdoor sculptures in the US is particularly special. The juxtaposition of the seemingly natural – the undulating hills of Maya Lin's *Storm King Wavefield* (2007–08), Patricia Johanson's trail of stones in *Nostoc II* (1975) and Manuel Bromberg's *Catskill* (1968), a rock aggregate – with unnatural but startlingly alive pieces like Mark di Suvero's vibrant red *Mother Peace* (1969–70), or Alexander Liberman's *Iliad* (1974–75) bright orange elliptical and circular forms, ensures there is something to enjoy at every turn and through every season. And other works such as Ursula von Rydingsvard's *For Paul* (1990–92/2001) with a honeycomb pattern, and Andy Goldsworthy's *Storm King Wall* (1997–98) beguile with forms that are clearly constructed but compellingly in tune with their surroundings.

RIGHT *Endless Column* (1968) by Tal Streeter, on the grounds of the Storm King Art Center.

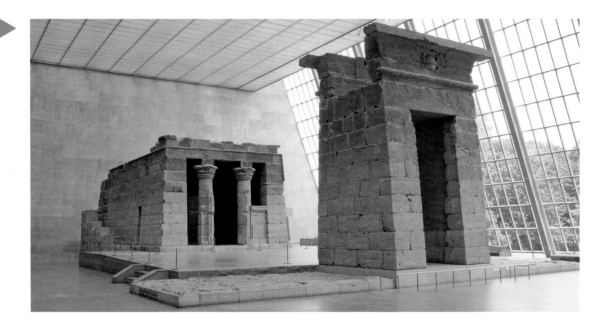

▲ Try to take in five millennia of art over three days

Metropolitan Museum of Art

1000 5th Avenue, New York, NY 10028, USA
metmuseum.org

Where to begin trying to cover what's on offer at one of the world's most popular museums? In a 2 million-strong collection spanning 5,000 years of art and culture drawn from every part of the planet, there are many standouts: the Edo figures and masks, seventeenth-century Japanese ceramics, a Greek and Roman Sculpture Court, a European collection featuring works by Pierre-Auguste Renoir, Paul Cézanne, Vincent van Gogh, Georges Braque and Henri Matisse ... you could spend days here and not see everything (luckily, an admission ticket is valid for three consecutive days). If we had to choose one piece, it would have to be the Temple of Dendur, built on the banks of Egypt's Nile more than 2,000 years ago (and with the hieroglyphics to prove it) and placed here in a lofty purpose-built space with a small body of water symbolizing the river.

Commune with a unicorn at the Met Cloisters

Metropolitan Museum of Art

99 Margaret Corbin Drive, Fort Tryon Park, New York, NY 10040, USA
metmuseum.org/visit/plan-your-visit/met-cloisters

New York's Metropolitan Museum of Art is a must for art fans, but in Washington Heights the Met Cloisters houses what is widely regarded as one of the greatest artworks in existence. Centred around four cloisters that give the space its name, this Met outpost is a contemplative, fitting space for a wonderful collection of European architecture, sculpture and decorative arts dating from the twelfth to fifteenth centuries. Of these, the seven monumental tapestries comprising *The Unicorn Tapestries*, or *The Hunt of the Unicorn* (1495–1505), are some of the most stunning examples of textile art from the period. Woven in fine wool and silk with silver and gilded threads, and, as their name suggests, depicting scenes associated with a hunt for the elusive, magical unicorn, seeing their craftsmanship in such a beautiful space is genuinely moving.

Yale Center for British Art

1080 Chapel Street,
New Haven, CT 06510, USA
britishart.yale.edu

▼ Relive the golden age of British culture in Connecticut

Homesick Brits or keen Anglophiles will love the Yale Center for British Art. It houses the largest and most comprehensive collection of British art outside the UK, from paintings and sculpture to drawings, prints, rare books and manuscripts, covering the development of British art and culture over more than 500 years. The paintings alone number some 2,000 works, with an emphasis on the period between William Hogarth's birth in 1697 and J.M.W. Turner's death in 1851, but don't discount other areas of the collection; a whopping 20,000 drawings and watercolours and 40,000 prints include works by William Blake and Walter Sickert, all of it housed in a fine example of 1970s Modernist architecture by Louis Kahn. It was his last building, and neatly bookends a successful career with its location opposite his first major commission, the Yale University Art Gallery.

LEFT The Temple of Dendur on view at the Metropolitan Museum of Art, New York.

BELOW The Long Gallery in the Yale Center for British Art.

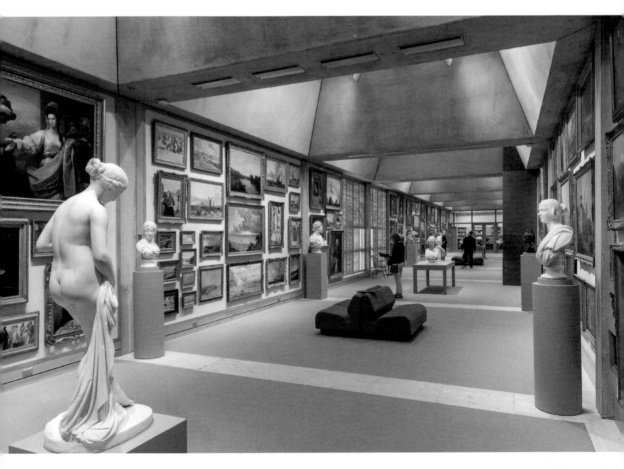

Museum of Fine Arts Boston

Avenue of the Arts, 465
Huntington Avenue, Boston,
MA 02115, USA
mfa.org

▼ Be pulled into the world of Harriet Powers in Boston

There are many reasons to visit the excellent Museum of Fine Arts in Boston, including a collection of Japanese art and pottery which is the largest outside Japan. But we'd recommend that you make a beeline for *Pictorial Quilt* (1895–98) by the African-American slave, folk artist and quilt-maker from rural Georgia, Harriet Powers. Using traditional appliqué techniques in a style that more than a century after their completion still feels modern and relevant, thanks to her innovative use of figurative motifs and bold original designs, Powers made quilts whose narratives drew on the many stories the self-taught artist read, from Bible tales and local legends to historical events. It's a glorious example of nineteenth-century Southern quilting, and unforgettable once you've seen it.

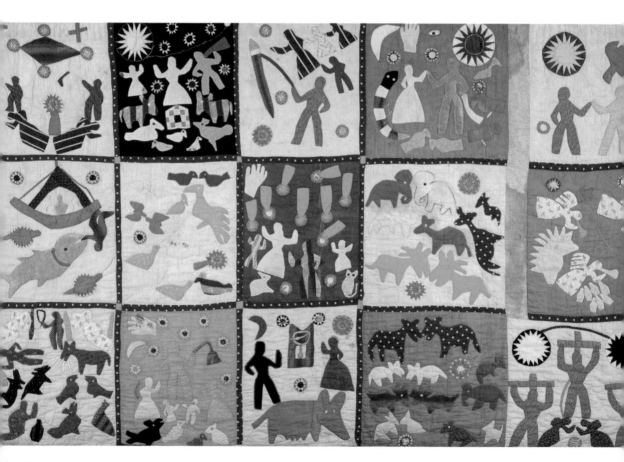

Smithsonian
American Art Museum

Donald W. Reynolds Center
for American Art and
Portraiture, 8th and
F Streets NW, Washington,
D.C. 20004, USA
americanart.si.edu

LEFT *Pictorial Quilt* (1895–98)
by Harriet Powers.

BELOW *Repetitive Vision* by
Yayoi Kusama.

Get an eyeful of Georgian colour in Washington

The paintings of Alma Thomas are almost as extraordinary as her life. Born in Georgia in 1891, the African-American schoolteacher taught for thirty-five years, putting her art on the back burner until she retired in her seventies. It's hard to imagine how she could have held such exuberance in check for all those years, for when she did start to reveal her signature style, the expressive and bold abstract works were like an explosion settling into mosaic-like fragments of eye-popping colour. In the past her pieces have graced the White House, but they have also found more permanent tenure in other parts of Washington; for example, the lovely *Pansies in Washington* (1969) is on permanent show at the National Gallery of Art. But for a view of her work in the context of the history of American art, the impressive collection of African-American and Latino art at the Smithsonian American Art Museum is a must.

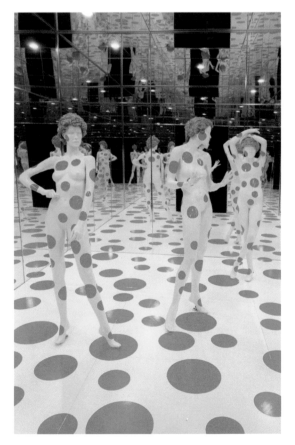

◀ Jump into immersive experiences at a very unusual art venue

The Mattress Factory

500 Sampsonia Way, Pittsburgh, PA 152112, USA
mattress.org

For more than forty years, this former mattress factory, created by artists as a space for site-specific pieces, has been exhibiting work by some of the world's best creators of immersive experiences, video and performance art – more than 750 of them. In a great mix of temporary and permanent pieces you might find a passing Kiki Smith, Christian Boltanski or Yayoi Kusama, but you'll definitely find a couple of permanent rooms dedicated to the latter's work, as well as early light installations by James Turrell and pieces by Bill Woodrow and Rolf Julius. It all makes for a fantastic mix of art experiences, heightened by a walk down the street to the madcap Randyland. This hyper-colourful house, turned into a huge piece of outside art by Randy Gilson, is a wonderfully OTT space filled with all manner of oddities.

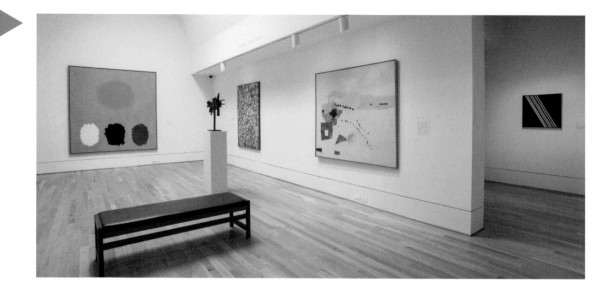

▲ Follow the trail of a migrating million

Phillips Collection

1600 21st St NW, Washington, D.C. 20009, USA
phillipscollection.org

Behind its unprepossessing red brick exterior, the former family home of Duncan Phillips contains a surprise – or a lot of surprises. As an art critic who played a seminal role in introducing America to modern art in the 1920s, Phillips built a first-class art collection that began with Francisco Goya, El Greco and Édouard Manet, and continued through Henri Matisse and Pablo Picasso to Georgia O'Keeffe and Mark Rothko. What's special about it is the intimate space in which the collection is housed, and a refusal to simply rest on its laurels as a repository of great but past masters. A highlight for many is Jacob Lawrence's sixty-panel narrative series *The Migration of the Negro* (1940–41), which portrays the flight of more than 1 million African-Americans from southern to northern states following the outbreak of the First World War. The series eloquently details the struggles of migrants through history, as well as the more personal African-American experience of which Lawrence himself was a part, as the son of migrants.

Pay homage to a unique *Stations of the Cross*

National Gallery of Art

Constitution Avenue NW, Washington, D.C. 20565, USA
nga.gov

Through their jagged vertical wounds and gashes splitting raw canvas in two with black and white paint, *The Stations of the Cross: Lema Sabachtani*, Barnett Newman's fifteen-part abstract painting cycle of 1958–66, pose the fundamental question asked by Jesus before his death, but also essential to the human state: '*Lema Sabachtani* – why? Why did you forsake me? Why forsake me? To what purpose? Why? This is the Passion. This outcry of Jesus. Not the terrible walk up the Via Dolorosa, but the question that has no answer,' said Newman in the catalogue notes for the work. From *First Station* to *Fourteenth Station*, with a fifteenth painting, *Be II*, the only one with a hint of colour in the room, the series perfectly conveys the despair and pain of death. Elsewhere in this fantastic museum, don't miss *Ginevra de' Benci* (1474–78) by Leonardo da Vinci, the only Leonardo painting in the Americas.

Hillwood Estate,
Museum & Gardens

4155 Linnean Avenue NW,
Washington, D.C. 20008,
USA
hillwoodmuseum.org

LEFT Gallery in the Sant
Building, part of the Phillips
Collection.

BELOW The Japanese-style
garden at the Hillwood Estate,
Museum & Gardens.

▼ Picnic with Russian masterpieces in Washington, D.C.

Away from Washington, D.C.'s fascinating but exhausting mile-long cornucopia of museums and galleries that make up the Mall, the Hillwood Estate, Museum & Gardens offers a surprising sight – some of the best Russian iconography outside Europe. The collection, created by Marjorie Merriweather Post in the 1950s, is supplemented by an impressive eighteenth-century French decorative art collection, all of it set amid 10 hectares/25 acres of serene landscaped gardens and natural woodland. Once you've had your fill of the Fabergé eggs and delicate sky-blue Sèvres porcelain in the French rooms, and the sacred Russian Orthodox icons, chalices and textiles in the Russian Gallery, visit one of the special exhibitions; past ones have included Japanese Art Deco and the *papier mâché* haute couture creations of Belgian artist Isabelle de Borchgrave.

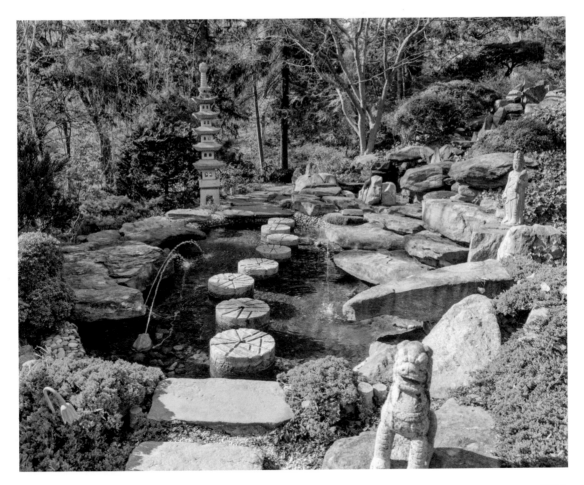

Get outta town to discover the real art of Chicago

Smart Museum of Art

The University of Chicago, 5550 S. Greenwood Avenue, Chicago, IL 60637, USA
smartmuseum.uchicago.edu

With so much art to see in downtown Chicago, it would be easy to overlook the Smart Museum of Art. Easy, and very wrong. It's not just the 15,000-strong collection, highlights of which include the plethora of delightful half-cartoon half-art works by Venezuelan artist Arturo Herrera, the John Chamberlain car crash (more of which are fabulously displayed as part of the Chinati Foundation's collection in Marfa, see page 44), Kerry James Marshall's arresting *Slow Dance* (1992–93) and a large number of works by local artists, including the Chicago Imagists, the Monster Roster, and self-taught artists such as Henry Darger and Lee Godie. All these and more make a visit here a delight, but it is the limestone-clad Modernist building and setting, in the lovely University of Chicago campus, that will stay with you. Oh, and Frank Lloyd Wright's Robie House, the original dining room furniture for which is, yes, also in the Smart.

▼ Have way more fun than you should with a piece of sculpture

Millennium Park

201 E. Randolph Street, Chicago, IL 60601, USA
choosechicago.com/articles/tours-and-attractions/the-bean-chicago

Whether they're viewed at the edge of a fjord in Norway, in London's Olympic Park, outside the Israel Museum in Jerusalem, or inside Italy's Pollino National Park, fans of Anish Kapoor adore the playfulness of the interactive work he creates. And one of the most playful is surely the gleaming stainless steel *Cloud Gate* (2004) in Chicago. Named for the fact that 80 per cent of its surface bends the reflection of the sky down, it is locally known as the bean, for obvious reasons, and enables visitors to put themselves in the picture while capturing the city's fabulous skyline. You'll find it hard to put your finger on why you're so drawn to it, but drawn to it you will be, and unlike too many sculptures, putting your finger on it (at least in a pre-COVID world) is fine – it's cleaned from top to bottom twice a day, with the lower portion being cleaned up to seven times a day.

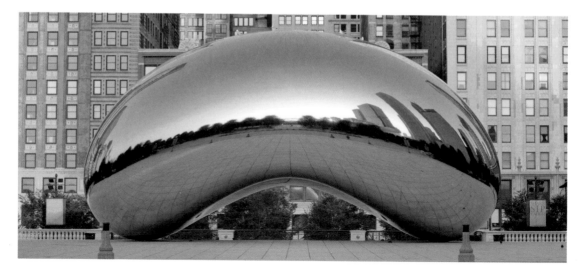

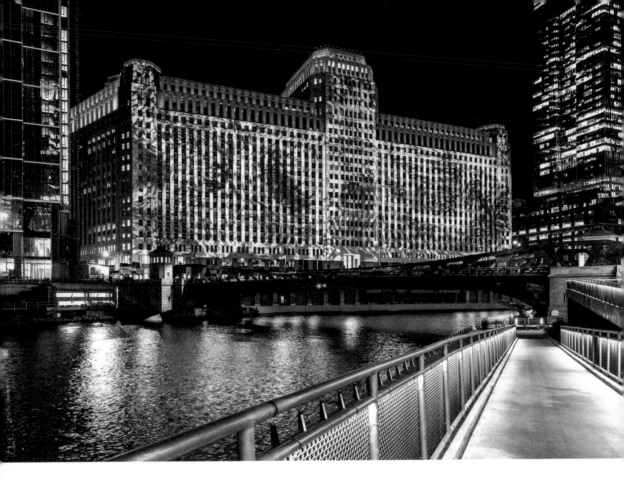

Art on theMART

278–294 W Wacker Drive,
Chicago, IL 60606, USA
artonthemart.com

▲ See art on the big screen in Chicago

Watching art on a big screen outside the containing walls of a
gallery is always a memorable experience, particularly if that
screen is 1 hectare/2½ acres in size. Art on theMART, a sight
and sound initiative by the City of Chicago and privately funded
organization theMART, offers just that. From March to December,
two hours of digital art are projected on to the façade of the
landmark Merchandise Mart building every week from Wednesday
to Sunday nights, using thirty-four projectors to deliver the first
advert-free permanent large-scale projection installation. Time
your visit to coincide with a trip to the annual Expo Chicago in
September to immerse yourself in a citywide art experience that
takes in hotels and public spaces as well as the city's impressive
roster of major and independent galleries.

ABOVE *Harmonic AI* by Ouchhh
Studios projected on the
Merchandise Mart building.

LEFT *Cloud Gate* (2004) by
Anish Kapoor.

TRAIL: A land art map of North America

Land art, broadly defined as art that uses natural landscapes and materials to create site-specific structures, art forms and sculptures, can be a puzzler at first sight. Hollow concrete tubes and frames or trenches and paths stretching across landscapes often leave visitors bemused rather than amazed ... at first. But spend time with these totemic pieces, letting their ephemerality and interaction with their surroundings work their magic, and you'll find yourself experiencing an intense response that offers everything gallery-based work can – and more. With ideas rooted in unsellable art, it takes the whole debate about art to an entirely different level. Here are some of my favourites in the US, where the form emerged in the 1960s as a reaction to the commercialization of art.

Double Negative by Michael Heizer

near Overton, Nevada

'There is nothing there, yet it is still a sculpture,' says Michael Heizer of this 1969 double trench, one of the world's most famous pieces of land art. As the title suggests, the piece is about the absence of the removed earth and the negative space created.

City by Michael Heizer

near Hiko, Nevada

Even more monumental than *Double Negative*, this 2-km/1.2-mile long sculpture, begun in 1972, will – if and when it is completed – be one of the largest sculptures ever built.

Roden Crater by James Turrell

near Flagstaff, Arizona

Decades in the making, this extinct volcano in Arizona may one day be turned into a 183-m/600-ft tall stone and earth sky observatory by the world-famous light artist.

Effigy Tumuli by Michael Heizer

near Ottawa, Illinois

Another popular Heizer piece, this time from the mid-1980s, is this series of mounds featuring five figures, located 137 km/85 mi south-west of Chicago.

Spiral Jetty by Robert Smithson

Rozel Point, Utah

See page 32.

Seven Magic Mountains by Ugo Rondinone

outside Las Vegas, Nevada

These seven Day-Glo boulder stacks finished in 2016 by Swiss artist Ugo Rondinone have proved so popular that they're still turning heads in the Nevada desert years after they were meant to be removed.

Lightning Field by Walter De Maria

New Mexico

See page 37.

Earth Mound, by Herbert Bayer

near Aspen, Colorado

Austrian-born Bauhaus artist Herbert Bayer's 12-m/40-ft diameter circular mound, designed in 1954, is notable as being what many regard as the earliest piece of land art. His *Mill Creek Canyon Earthworks*, constructed in 1982 in Kent, Washington are another fine example of his work.

Johnson Pit #30 by Robert Morris

SeaTac, Washington

Finished in 1979, the once sharp contours of this gently shelving depression are blurring after more than forty years, but still offer a mesmerizing site and sight. For Land Art completists, there's another Morris piece, *Grand Rapids Project X* (1974), in Grand Rapids' Belknap Park, Michigan.

Star Axis by Charles Ross

New Mexico desert

Thirty years in the making, this arresting naked eye observatory/earth sculpture, begun in 1976 and replete with solar pyramid and star tunnel will, if and when completed, work as a sundial, compass and celestial pointer.

Wood Line and Spire by Andy Goldsworthy

The Presidio, San Francisco, California

Andy Goldsworthy's work is often ephemeral in the extreme, and the pieces here are a fine example, including a path of eucalyptus disappearing into the forest floor and a bundle of cypress trunks that will eventually be swallowed by surrounding cypresses.

OVERLEAF ▶
Seven Magic Mountains by Ugo Rondinone.

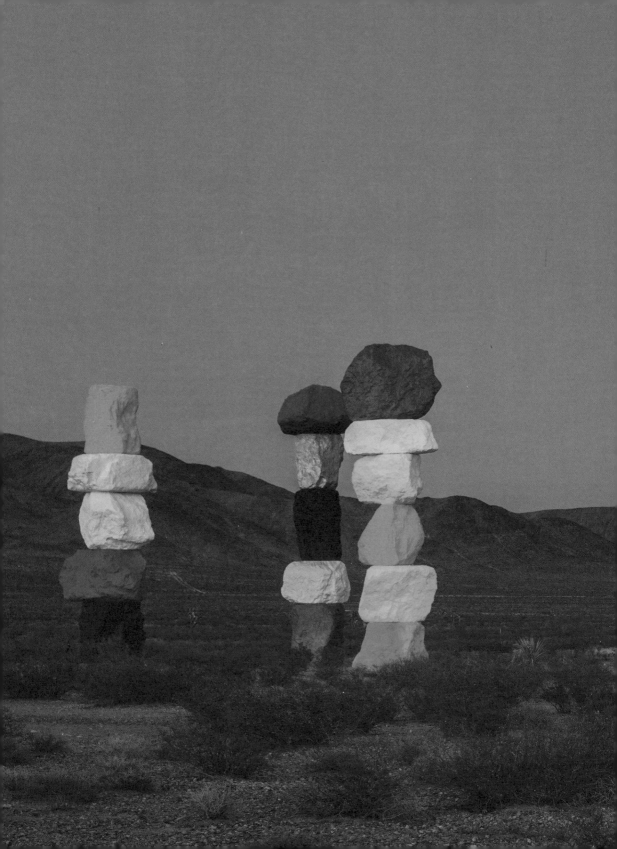

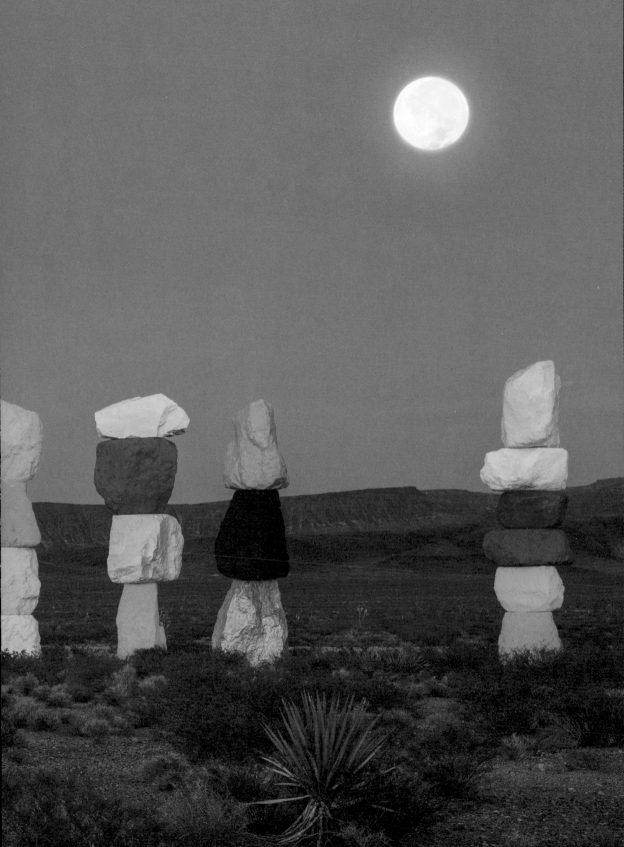

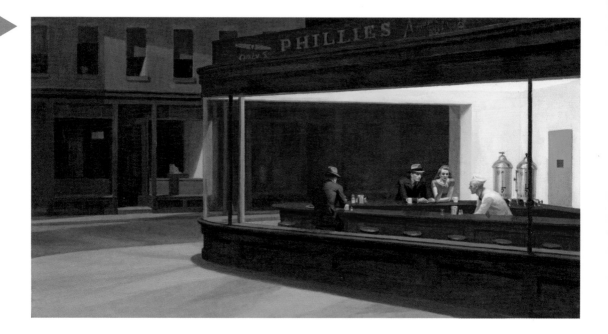

The Art Institute of Chicago

111 S Michigan Avenue,
Chicago, IL 60603, USA
artic.edu

▲ Find world-class pieces and some tiny wonders in the Windy City

The largest art museum in the US after New York's Metropolitan Museum of Art is not, as some might expect, in Los Angeles, Dallas or Washington, D.C., but in Chicago. However, it's not its size that impresses the most; what is truly epic about the nineteenth-century museum is its collection, one that boasts some of the world's most famous art, spanning centuries of European works through more recent American classics. In the galleries dedicated to the latter, Grant Wood's *American Gothic* (1930) and Edward Hopper's *Nighthawks* (1942) are just two of the world-recognizable works on show, while the Impressionist and Post-Impressionist collection includes Georges Seurat, Vincent van Gogh, Pablo Picasso and seemingly every other major European artist of the last 200 years. Don't leave without seeing the Thorne Miniature Rooms in the basement; the one hundred or so delicate, incredibly detailed dioramas and models of European and American interiors are gorgeous, as are the 800 bejewelled glass paperweights.

ABOVE *Nighthawks* (1942) by Edward Hopper.

RIGHT *Detroit Industry*, South wall (1932–33) by Diego Rivera.

▼ Do the Diego murals in Detroit

Detroit Institute of Arts (DIA)

5200 Woodward Avenue, Detroit, MI 48202, USA
dia.org/riveracourt

Mexican painter and muralist Diego Rivera was prolific in his politically charged art, and you can still find many of his murals both in the US and Mexico, but this series of twenty-seven paintings, created in 1932 over nine months for the interior courtyard of the Detroit Institute of Art, is undoubtedly one of the best in existence. Depicting workers at the Ford Motor Company and across the city, to offer not just a comprehensive overview of industry in 1930s Detroit but its achievements through its wider history too, the murals were considered by the artist to be his most successful work. Get a multimedia guide from the DIA's Rivera Court information desk to help you understand the depth, context and workmanship behind the piece and you'll probably agree.

Follow the money to find treasures in Ohio

Cleveland Museum of Art (CMA)

11150 East Boulevard, Cleveland, OH 44106, USA
clevelandart.org

New York and Washington, D.C. get the plaudits when it comes to art in America, but in Ohio the Cleveland Museum of Art holds its own with an internationally renowned collection that makes it one of the most visited art museums in the world. Asian and Egyptian art are particularly well represented in a 61,000+ strong collection that continues to grow, thanks to a $755m endowment which makes CMA the fourth-wealthiest art museum in the US. Shopping cart goodies have included twelfth-century religious and Byzantine art, as well as works by Sandro Botticelli, Vincent van Gogh, Francisco Goya, Henri Matisse and more. The setting in Wade Park, where its buildings include a 1971 addition by Marcel Breuer and gardens include outdoor art, is perfect too.

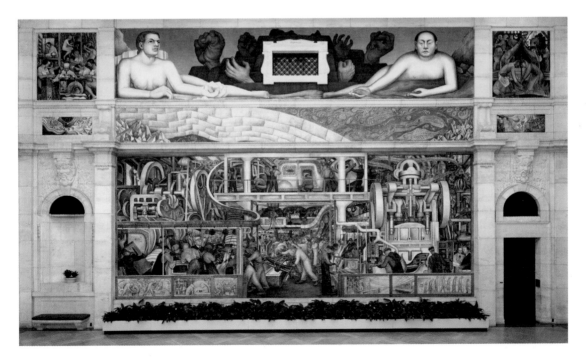

▶ Experience climate change in action in Utah

Spiral Jetty

Great Salt Lake, Utah, USA
diaart.org/visit/visit/robert-smithson-spiral-jetty

We tend to think of land art as a relatively modern art form, but 2020 saw the fiftieth anniversary of a large-scale piece that has not only stood the test of time, but also celebrates artistic merit and achievement. And, somewhat ironically, given its interpretation by some as a metaphor for the inexorable processes of geological time, thanks to climate change it's looking better than ever. It was in 1970 that Robert Smithson's *Spiral Jetty* saw the light of day at Rozel Point in Utah's Great Salt Lake, and while the mud, salt crystal and basalt rock sculpture used to often be submerged, these days it's nearly always visible, making it very possible to walk the 460-m/1,509-ft length of the white coil, reaching out like a tendril from the shore of the lakes. To do so is a surreal and memorable experience.

RIGHT *Spiral Jetty* (1970) by Robert Smithson.

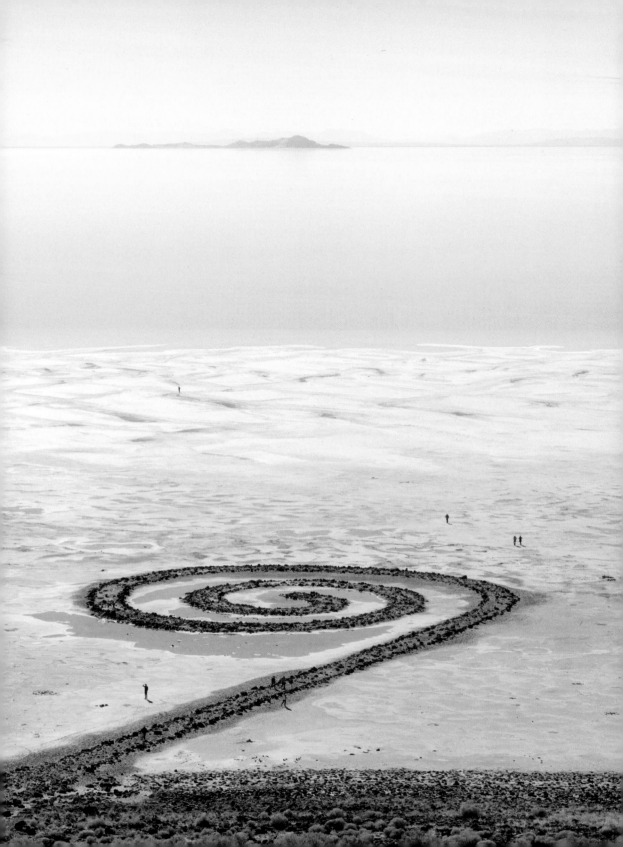

Sun Tunnels

Great Basin Desert,
Wendover, Utah, USA
*umfa.utah.edu/land-art/
sun-tunnels*

Peer through tunnels to see a timeless landscape in a new light

Some might argue the expansive, otherworldly landscapes of places such as Utah, Texas and Arizona don't need land art to heighten the experience of being among something monumental and timeless, but the interaction of art and nature is never more arresting than when seen at such scale, and always brings something new to it. Take Nancy Holt's *Sun Tunnels* in Utah (1973–76). Looking for all the world like a series of concrete tubes left behind after an abandoned building project, the four large concrete cylinders, arranged in an 'X' across 16.2 hectares/40 acres of the desert, align with the sunrise and sunset during the summer and winter solstices to act as viewfinders framing precise images which, in Holt's words, 'bring the vast space of the desert back to human scale'. The experience of looking through them is extraordinary, and one that grows and grows in strength the longer you spend with them.

◀ See African-American identity explored in Los Angeles

California African Art Museum (CAAM)

600 State Drive, Exposition Park, Los Angeles, CA 90037, USA
caamuseum.org

With a stated mandate of assembling a comprehensive, thoughtful and wide-reaching art collection representing the historical and contemporary contributions of African-Americans in the US and beyond, CAAM is filled to bursting with pieces spanning 200 years examining identity and how it has been shaped by the past. From nineteenth-century landscape paintings to modern sculpture by Maren Hassenger and even oral histories, many of the pieces reflect on cultural and political events, such as a 1975 bronze bust of civil rights activist Dr Mary McLeod Bethune by artist Richmond Barthé. Recent acquisitions highlight the museum's desire to bring in more work by African-American women artists, including Sadie Barnette, April Bey, Carla Jay Harris, Janna Ireland and Adia Millett.

The Broad Museum

221 South Grand Avenue,
Los Angeles, CA 90012, USA
www.thebroad.org/art

LEFT View inside the California African American Museum.

BELOW Contemporary art museum The Broad in downtown Los Angeles.

▼ Take a Broad view of modern art in Los Angeles

When Jean-Michel Basquiat burst on to the New York art scene in the 1980s, his works were immediately snapped up by canny buyers who recognized his frenzied Neo-Expressionist paintings filled with arresting motifs such as skulls, crowns and masks as modern masterpieces that would withstand the test of time. One of those buyers was billionaire philanthropist Eli Broad, who with his wife Edythe discovered the Brooklyn-born Basquiat working in a basement and bought his early work for $5,000 a piece. Fast-forward four decades and thirteen of their Basquiat pieces can be seen in rotation at the Broad Museum, the downtown LA gallery they opened in 2015 to house their collection of more than 2,000 contemporary artworks. Located opposite Frank Gehry's Disney Hall, the soaring space, lit by 300 individually operated skylights, is a stunning new addition to the city and the art world, and is unmissable … as are the two Yayoi Kusama *Infinity Mirrors* in it.

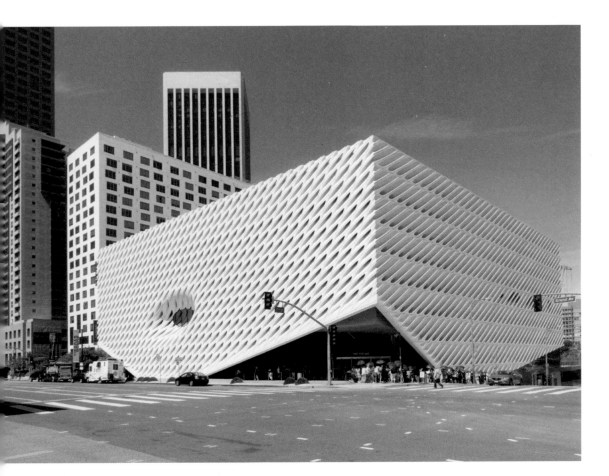

Precita Eyes Mural Arts
and Visitor Center

2981 24th Street, San
Francisco, CA 94110, USA
precitaeyes.org

▲ Cast an eye over the
Mission District murals

San Francisco's Mission District, one of the world's most famous
outdoor art galleries of murals, can be tricky to navigate and
explore without some context and a plan. Do you focus your
attention on the socio-political statements and themes of injustice
along Balmy Alley or head for Clarion Alley's collection around
themes such as social inclusiveness? We suggest a start at
the Precita Eyes Mural Arts and Visitor Center, where helpful
volunteers at this community based non-profit space will sort you
out with self-guided tours covering the murals' history, cultural
and historical significance, and offer context for key pieces like
the Women's Building's *MaestraPeace* (1994) and the vibrantly
restored *Carnaval* (1983) on 24th Street. It's also worth spending
some time checking out the centre itself, as it's filled with the
work of practising mural artists who teach and study here, while
also leading guided tours.

ABOVE *MaestraPeace* (1994)
seen on the side of the
Women's Building.

The Museum of International Folk Art

Museum Hill, 706 Camino Lejo, Santa Fe, NM 87505, USA
internationalfolkart.org

Take a grand tour of global culture in Santa Fe

Fierce Japanese demons, colourful Panamanian textiles, New Mexico quilts and glistening Turkish ceramics are just some of the collections contained among the 130,000+ objects from more than one hundred countries held in the Museum of International Folk Art. Wandering through the different galleries, arranged geographically, is a treat, and illustrates not only the delightful breadth of human creativity but also the surprising range of re-occurring motifs shared by different cultures, all presented in an accessible and enjoyable space.

The O'Keeffe Museum

217 Johnson Street, Santa Fe, NM 87501, USA
okeeffemuseum.org

Get into Georgia O'Keeffe in New Mexico

Remarkably, given that it opened in 1997, the Georgia O'Keeffe Museum is still the only museum in the United States dedicated entirely to an internationally renowned female artist. It says much about her reputation and standing, and it makes a great setting off point for a tour of the region that inspired her, but is also worth repeated visits in its own right. Across nine galleries, at least 120 paintings from a collection of more than 3,000 works are on display at any one time, along with pastels, watercolours and some 700 drawings from each decade of her life. And to contextualize it all, O'Keeffe's art materials and an extensive collection of personal possessions offer an up-close and intimate portrait. You'll come away feeling a personal connection with this most singular of artists – and eager to get on the trail of the faraway with her (see overleaf).

The Lightning Field

Near Quemado, Western New Mexico, USA
diaart.org/visit/visit/walter-de-maria-the-lightning-field

Be struck by Walter de Maria's *The Lightning Field*

American sculptor Walter de Maria's *The Lightning Field* land art piece (1977) is something of a misnomer, suggesting that the piece has the purpose of attracting lightning. In fact, storms are not common, and when lightning does strike and char one of the 400 polished stainless steel poles, it has to be replaced to maintain the clean sleek look of the steel. Set in a grid measuring 1.6 km/1 mi by 1 km/0.6 mi on an empty high desert plateau, it has been described as mind-altering by visitors who stand in the middle of the piece gazing out at what appears to be a perfectly horizontal plane despite the changing landscape – an effect created by the height and placement of the poles. At sunrise and sunset brilliant golden light reflects off them, making the obligatory overnight stay in the site's cabin unforgettable.

TRAIL: On the faraway trail of Georgia O'Keeffe, New Mexico

To follow in the footsteps of the great landscape artist Georgia O'Keeffe from New York to New Mexico is to see two very different sides of America. If she were alive, the taciturn, solitary O'Keeffe would doubtless pour scorn on any desire to follow in her footsteps, but visiting the sites she so loved offers real insight into her decision to quit New York's formerly inspirational cityscapes in order to spend forty years of her life at an isolated adobe ranch house in New Mexico's Rio Chama valley, painting the red-rock mesas of the nearby Jemez Mountains.

Georgia O'Keeffe Museum

Begin your tour at the Georgia O'Keeffe Museum in downtown Santa Fe. The museum (of which the artist's home and studio are part) houses 120 paintings, as well as a café and shop.

See page 37.

Restaurant Eloisa

Dine at Santa Fe restaurant Eloisa, which has a menu dedicated to O'Keeffe, called – in tribute perhaps to the artist's own directness – the Georgia O'Keeffe dinner menu. It uses ingredients used by O'Keeffe in her own recipes, and dishes are served in ways that reference her work (one course arrives on a cow's skull). The owner's great aunt cooked for O'Keeffe for fifteen years in her two New Mexico homes, creating dishes for the likes of Andy Warhol and Joni Mitchell.

Petrol station on Highway 84

Head north on US Highway 84 towards Abiquiú, filling up with gas at the petrol station en route – it's where O'Keeffe herself used to 'gas up' before heading out to the desert.

Georgia O'Keeffe Home and Studio

The Georgia O'Keeffe Home and Studio, some 80 km/50 mi north of Santa Fe in Abiquiú, is the house that was O'Keeffe's winter home from 1945–84. It inspired more than two dozen paintings: she painted one door more than twenty times, and the cottonwood trees growing in the Rio Chama valley nearby even more.

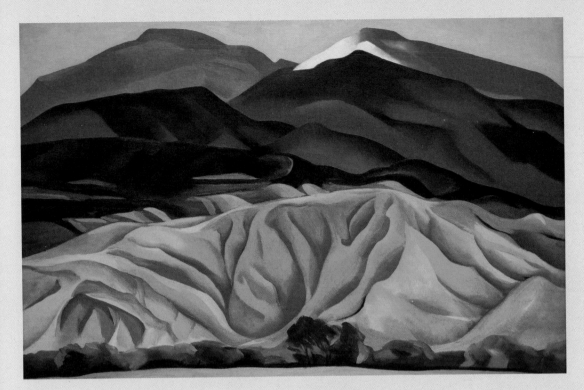

ABOVE *Black Mesa Landscape, New Mexico/Out Back of Marie's II* (1930) by Georgia O'Keeffe.

Ghost Ranch
Conference Center

About 24 km/15 mi north of Abiquiú, you'll find the Ghost Ranch Conference Center, once the dude ranch O'Keeffe discovered in 1929. So taken was she with the arresting red, ochre and yellow cliffs that characterize the area that she bought an old adobe house on the property in 1940, from where she would venture out to hike and paint. The ranch now offers bus and walking tours of the sites O'Keeffe painted nearby, such as the eerie rock formations found in the canyon she called the White Place, and the site of works such as fossilized cedar *Gerald's Tree I* (1937).

Mabel Dodge
Luhan House

Head north-east from Abiquiú to Taos, where, if you literally want to follow in her footsteps, you can actually stay in a room O'Keeffe slept in at what is now the Mabel Dodge Luhan House, a conference centre hosting art and meditation workshops, as well as a B&B, where you can stay in O'Keeffe's small first-floor room for the very reasonable sum of $75.

OVERLEAF ▶
The red sandstone landscape
near Abiquiú, New Mexico.

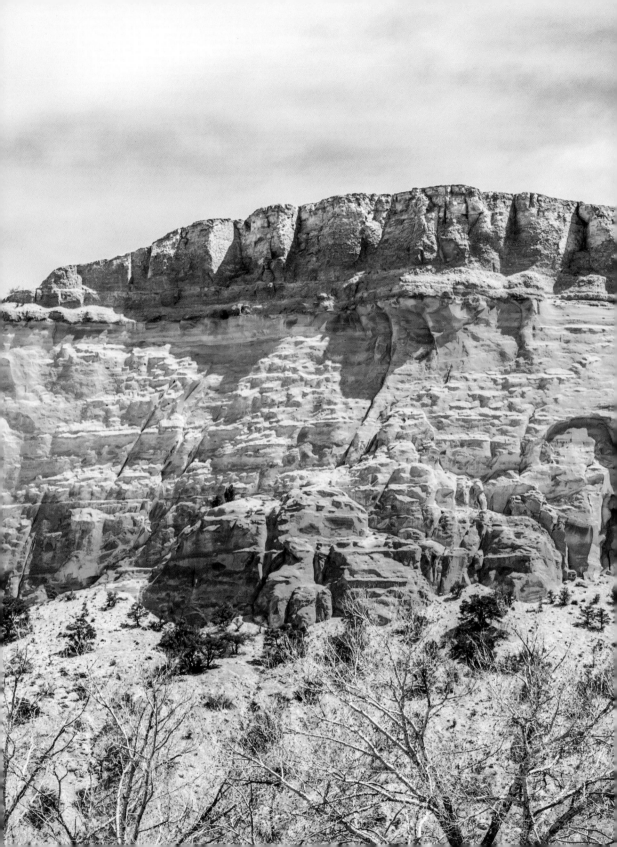

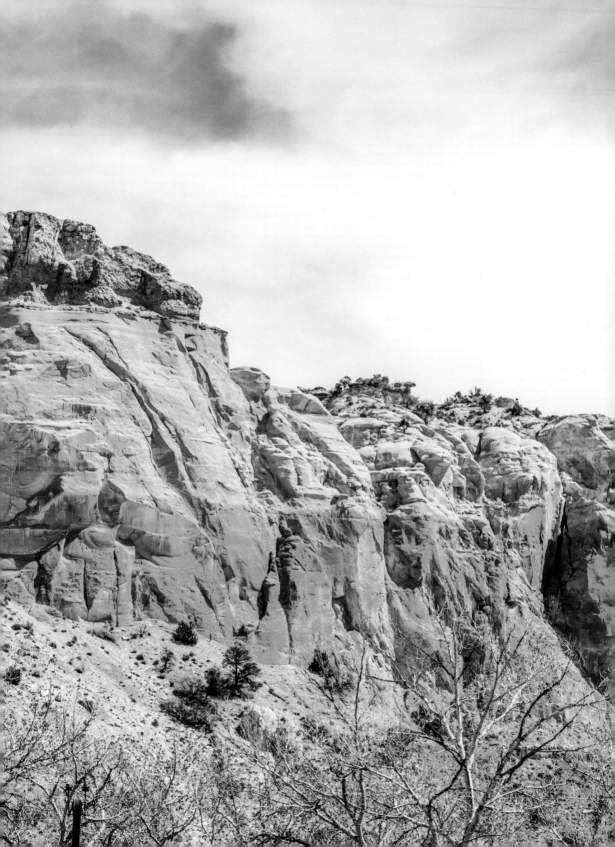

BELOW One of the interactive
passages at the *House of
Eternal Return*.

RIGHT Entrance to Ellsworth
Kelly's *Austin* (2015).

▼ Enter the House of Eternal Return in Santa Fe

The combination of immersion and narrative has long existed in art. Indeed, it could be seen as an integral part of any art experience, but with art collective Meow Wolf's work, the immersion is total, the narrative shaped by the visitor rather than the artist. The collective's first permanent installation, the 1,858 m²/20,000 ft² *House of Eternal Return* in Santa Fe, has been such a smash hit since its opening in 2016 that outposts are due to open in Las Vegas and Denver (2021), Washington, D.C. and Phoenix (2022). With support and input from the *Game of Thrones* creator George R.R. Martin, the narrative success of the installations was assured, but it's the sumptuous visual feast visitors experience as they walk, crawl and climb through the secret passages and portals to magical worlds of interactive light, sound and musical objects that truly delight visitors of all ages.

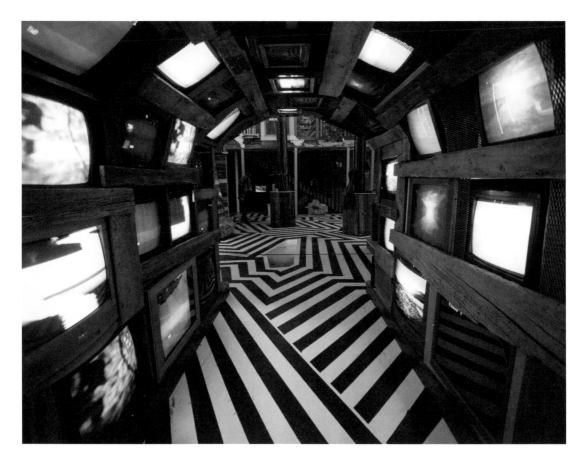

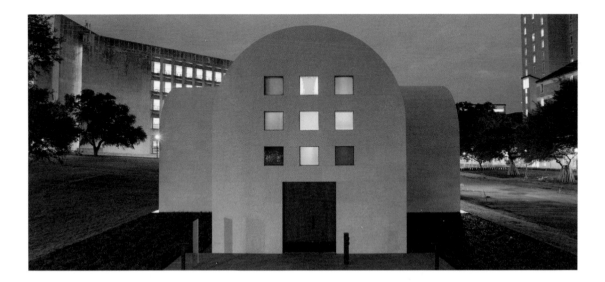

See Eastern art through the eyes of Mary Cassatt

McNay Art Museum

6000 North New Braunfels Avenue, San Antonio, TX 78209, USA
mcnayart.org

Many art galleries and museums across the US hold works by the renowned Pennsylvania-born painter and printmaker Mary Cassatt, as her winsome yet often unsentimental depictions of the domestic world of women and children is the kind of subject that has universal appeal. But the McNay's collection is a particularly fine one, with one suite of drypoint and aquatint works adding wonderfully delicate Japanese tropes to the Degas-like style Cassatt adopted while living in France, where she was the only American woman to exhibit with the Impressionists. The clear influence of an exhibition of Japanese woodcut prints Cassatt had seen in 1891 is evident in the delicate patternwork on pieces such as *Mother's Kiss* (c. 1891), *The Letter* (1891) and *The Bath* (c. 1891). Coupled with the fine-line drypointing of the subjects in them, they are breathtaking.

▲ Find mind-bending colours in Ellsworth Kelly's Texas 'chapel'

Blanton Museum of Art

The University of Texas at Austin, 200 E Martin Luther King Jr Boulevard, Austin, TX 78712, USA
blantonmuseum.org/ellsworth-kellys-austin

Known for certain repeating motifs through his life – totems, monochrome, colour grids and the colour spectrum – the artist Ellsworth Kelly's final work, *Austin* (2015), is a piece writ large on the landscape of the University of Texas's Blanton Museum of Art. The only building he ever worked on, and described by Kelly's partner Jack Shear as 'a chapel really dedicated to creativity', the limestone exterior of the double-barrel vaulted space looks like a strange igloo studded with jewels of colour in its hand-blown glass windows, but it's the interior that literally glows with the blocks of coloured light created by these windows. They bend the light in moving, playful ways, and along with fourteen black and white marble panels and a signature Kelly totem sculpture in place of the traditional cross, create a piece that is a stunning culmination of the artist's life and work.

Suzanne Deal Booth
Centennial Pavilion

West Quadrangle, Rice
University, Houston, TX
77005, USA
skyspace.rice.edu

Trip the light fantastic in Houston – or dozens of other locations around the world

Diehard fans might say 'You really have to see it at dawn and dusk', but luckily for late risers, the dusk experience of James Turrell's *Twilight Epiphany* (2012) at Rice University in Houston is definitely more dramatic than its morning counterpart. As the sky imperceptibly darkens and you watch the sequence of colours change above you from your ground-floor bench – or below you if you're in the upper tier (you can move between the two) – the positively kaleidoscopic effects are the closest you'll come to a drug-free psychedelic trip. But it's perhaps the effects the colours have on the changing sky, viewed through a large square aperture, that is the most mesmerizing aspect of this, and indeed most of Turrell's skyscapes. It's just one among the eighty-seven observatories Turrell has designed and built around the world, but, at least until the Roden Crater in Arizona (see page 26) is completed, it's one of the best.

Chinati Foundation

1 Cavalry Row, Marfa, TX
79843, USA
chinati.org

Get a different view of an army base in Texas

In the 1970s, minimalist sculptor Donald Judd came to the remote rural town of Marfa, Texas to escape the New York art scene. Acquiring a disused army base, he began to fill the 162-hectare/400-acre space with arresting site-specific works by himself and fellow artists, among them six buildings filled with Dan Flavin's *untitled (Marfa project)* of 1996. And the Chinati has added to the site with masterful pieces like Robert Irwin's *untitled (dawn to dusk)* of 2016, the only permanent, freestanding structure conceived and designed by Irwin as a total work of art. But the standout works are undoubtedly Judd's own, in particular the one hundred untitled works in mill aluminium (1982–86) housed in two artillery sheds. It's hard to convey how spellbinding the encounter with these works is, and how perfect its interaction with the surrounding landscape. Back in the centre of this very art-centric town, don't miss John Chamberlain's 22 crushed car sculptures in painted and chromium-plated steel.

RIGHT Inside the Rothko Chapel.

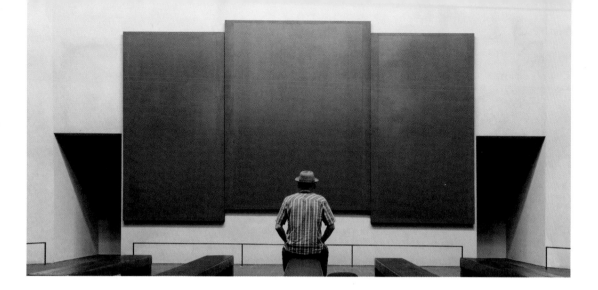

▲ Repose with Rothko and Philip Johnson in Houston, Texas

Rothko Chapel

3900 Yupon Street, Houston, TX 77006, USA
rothkochapel.org

Just as with Ellsworth Kelly's 'chapel' in Austin, Mark Rothko's 'chapel' in Houston is not a religious space but, also like Kelly's space, the octagonal structure is likely to elicit a deeply spiritual and emotional response from its visitors. Part-designed by Philip Johnson, the brick building houses fourteen paintings by Rothko, who took his own life a year before its opening in 1971. With that in mind, the darkness of the paintings – seemingly all black but created in different colour hues – clearly suggest the strong emotional state Rothko, who the year before his death said 'art must have a clear preoccupation with death', was in when he created the work. Outside, Barnett Newman's *Broken Obelisk* (1963–67), dedicated to Dr Martin Luther King Jr, rises above a reflecting pond, and nearby, Johnson's Chapel of St Basil is a superlative example of the architect's later work, a curvilinear white stucco and black granite building topped with a gold dome that's as pleasing to the spirit as it is the eye.

Promenade the Cy Twombly Pavilion and other parts of the Menil Collection

Menil Collection

1533 Sul Ross Street, Houston, TX 77006, USA
menil.org/campus/cy-twombly-gallery

Close to the Rothko Chapel, the Menil Collection, housed in a low-slung sleek Renzo Piano building, comprises the private art collection of John and Dominique de Menil – an impressive 17,000 paintings, sculptures, prints, drawings, photographs and rare books. Virtually every European and American artist of the twentieth century is represented, from Man Ray and Henri Matisse to Jackson Pollock and Robert Rauschenberg, but perhaps the most impressive work is actually not among them. To find it, make for the small, standalone Cy Twombly Pavilion (1992–95), designed by Piano from a sketch by Twombly. Outside it resembles a squat stone block, but inside, the light, gently filtered through a louvred roof and white canvas sailcloth, creates an ethereal space perfect for the colours and delicate beauty of Twombly's large canvases. Don't miss the room devoted to *Untitled (Say Goodbye, Catullus, to the Shores of Asia Minor)* (1994).

New Orleans Museum
of Art (NOMA)

One Collins Diboll Circle,
City Park, New Orleans,
LA 70124, USA
noma.org

Lose yourself in reflection in New Orleans

The city's oldest fine arts institution celebrated its centenary in 2011, and is going from strength to strength with a dynamic collection that has expanded from the nine pieces it owned when it opened, to more than 40,000 works of art across all media, with a strong focus on African and Japanese art. Outside, the well-established Sydney and Walda Besthoff Sculpture Garden is a great place to wander, its ninety sculptures set amid landscaped grounds that take in reflecting lagoons spanned by bridges and ancient moss-covered live oaks. From Jeppe Hein's *Mirror Labyrinth* (2017), its vertical mirror columns creating endless reflections of the garden that keep people transfixed, or Katharina Fritsch's bone-white oversized *Schädel* (Skull) of 2017, reflected in the calm water of the gardens, this is art as engaging and questioning as it can possibly be.

Museum of Graffiti

299 NW 25th Street,
Miami, FL 33127, USA
museumofgraffiti.com

Wynwood Walls

2520 NW 2nd Avenue,
Miami, FL 33127, USA
thewynwoodwalls.com

▼ Take in outsider art in Miami

The idea of an institution devoted to street art or graffiti could be seen as distinctly at odds with the anti-institutional stance at the heart of the form, but Miami's Museum of Graffiti, co-founded by the graffiti artist, collector and historian Alan Ket and Miami-based lawyer Allison Freidin, has taken this dichotomy and run with it. In an exuberant space located in the neighbourhood of Wynwood, it begins outside, where eleven commissioned murals bombastically eschew the traditionally blank museum façade, and continues inside, where a permanent exhibition charts six decades of the history of graffiti art through photos, original works and temporary exhibitions. For the real deal, the nearby Wynwood Walls and Doors offers some 8,361 sq m/90,000 sq ft of ever-changing graffiti on huge warehouse buildings and the walls and metal roll-down gates of a former dump centred around 25th and 26th Streets.

Crystal Bridges Museum
of American Art

600 Museum Way,
Bentonville, AR 72712, USA
crystalbridges.org

▲ Trace **500** years of American art in Arkansas

What a special place this is – a series of elegant pavilions designed by Moshe Safdie set amid grounds featuring spring-fed ponds, sculpture and walking trails in a 48.6-hectare/120-acre park. Inside these pavilions, galleries devoted to different periods of American art are filled with a terrific collection. Highlights in the Early American Art galleries include *Rosie the Riveter* (1943) by Norman Rockwell and a fab collection of tropical bird paintings by Martin Johnson Heade and John James Audubon; in the Modern Art gallery Georgia O'Keeffe, John Biggers and Edward Hopper, and in the Contemporary Art gallery Kerry James Marshall, Helen Frankenthaler and Alma Thomas. Beyond the galleries, the grounds include a fully furnished Frank Lloyd Wright house and the Bachman-Wilson House, originally built as a family home in 1956 along the Millstone River in New Jersey and reconstructed here in 2015.

ABOVE The beautiful pavilions of the Crystal Bridges Museum of American Art.

LEFT An example of some of the graffiti to be found around the Wynwood neighbourhood.

▶ Get the inside (and outside) scoop on pre-Columbian culture

National Museum of Anthropology

Avenue Paseo de la Reforma s/n, Polanco, Bosque de Chapultepec I Secc, Miguel Hidalgo, 11560 Mexico City, Mexico
museu.ms

From its wonderful 1960s building featuring a huge floating slab of concrete held aloft by a single column (known as *el paraguas*, or umbrella) to contents that take in a comprehensive greatest hits of pre-Columbian culture by the Teotihuacan, Zapotec, Mixtec and Mayan peoples, Mexico's National Museum of Anthropology is one of the world's great museums. Inside (and outside, across numerous courtyards) you'll find every form of creative expression, from the giant stone heads of the Olmecs found in the jungles of Tabasco and Veracruz to a colourful Cacaxtla bird-man mural, vibrant ceramics, turquoise-covered mortuary masks and perhaps the most famous work of Aztec sculpture, the sixteenth-century sun stone.

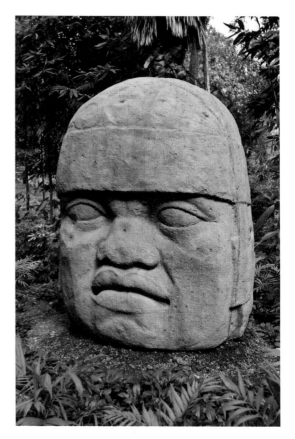

University City

Coyoacán, 04510 Mexico City, Mexico
unam.mx

Make a study of the Ciudad Universitaria (UNAM) murals

The National Autonomous University of Mexico, known as UNAM, gained its status as a UNESCO World Heritage site not only because it was designed by some of Mexico's best-known architects, but also because the designs were then decorated with murals painted by some of the most recognized artists in Mexican history, including Diego Rivera and David Alfaro Siqueiros. A day out of Mexico City to take in these behemoths, many of which cover entire façades of campus blocks, is a great experience. Don't miss Juan O'Gorman's four-sided *Historical Representation of Culture* (*c.* 1953), which offers depictions of Mexico's pre-Hispanic past, colonial Mexico, the Mexican Revolution and the university in the twentieth century around the four façades of UNAM's Biblioteca Central (Central Library).

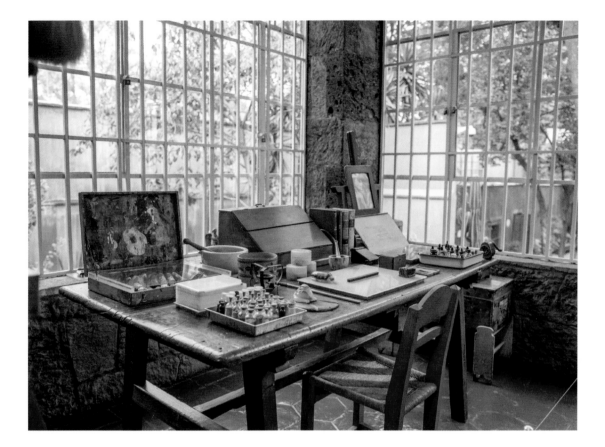

**Frida Kahlo Museum
(La Casa Azul)**

Calle Londres 247, Colonio
Del Carmen, Delegación,
Coyoacán, C.P. 04100,
Mexico City, Mexico
museofridakahlo.org.mx

LEFT Olmec colossal sculpture
head at the National Museum
of Anthropology.

ABOVE The artist's studio inside
the Frida Kahlo Museum.

▲ Be drawn into the world of 1940s Mexico … and beyond

There is always something satisfying about exploring the workspace
and home of a creative person, and when that person was as
creative as Frida Kahlo, you would hope that exploration would be
especially satisfying. And in the Casa Azul (named for its cobalt-
blue decoration) – where the iconic artist was born, lived and died
– it is. The house is filled not only with Frida and Diego Rivera's
personal belongings, from jewellery and clothes to books, letters,
photos and knick-knacks, but also with ephemera that clearly bring
to life Kahlo's tumultuous personal world at a tumultuous time in
the world – portraits of Lenin and Stalin are interspersed with a
collection of butterflies given to her by Japanese sculptor Isamu
Noguchi. And then, of course, there is the art – not just Frida's, but
pre-Hispanic and traditional Mexican folk art in all kinds of media
and forms, all of it combining to offer a fascinating trawl through
the country's cultural history and its finest artists.

▶ Say 'ola' to Rodin's *Thinker* in Mexico City

Soumaya Museum

Boulevard Cervantes Saavedra esquina Presa Falcón, Ampliación Granada, C.P. 11529 Mexico City, Mexico

museosoumaya.org

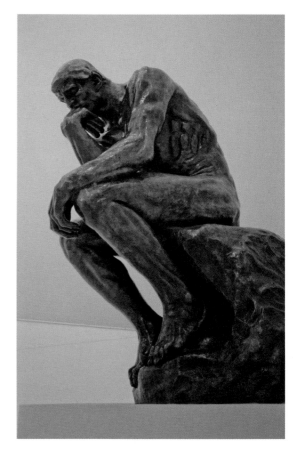

Even if you had no idea what lay inside, you would want to enter Mexico City's Soumaya Museum, set on Plaza Carso in Polanco. Shimmering in the sunshine thanks to the 16,000 aluminium tiles cladding its six-storey exterior, the sweeping organic lines of Fernando Romero's building tempt you in to see how those curves and lines manifest themselves inside. You won't be disappointed. The space soars and shines, and from the sunny top floor down to the ground it is filled with unexpected treasures – beginning with Auguste Rodin's *The Thinker* in the foyer. Museum founder Carlos Slim has collected a number of the sculptor's works here, but very deep pockets have enabled him to collect a lot more too, ranging from fine works by Mexican artists such as Rufino Tamayo and Diego Rivera – the latter's *Río Juchitán* of 1956 is a beauty – to an excellent body of European works from the fifteenth to twentieth centuries.

Museo Amparo

Avenue 2 Sur 708, Centro, 72000 Puebla, Puebla, Mexico

museoamparo.com

Appreciate a refreshingly different approach to anthropology

In 2013, TEN Arquitectos came up with an inspired response to the Amparo family's design brief of creating extra space for their collection of pre-Columbian artefacts and colonial-era art and furniture, which was beginning to overflow an entire city block of traditional houses. They left the exterior unchanged but filled the courtyards with new galleries and dropped a stunning glass atrium on the roof. This instant cultural update was also applied to the curation, with the result that, refreshingly, the Amparo shows its archaeological artefacts as art rather than anthropology. Taken together, the exhibits, dating from 1200 BC–AD 1500, provide an introduction to Mexico's pre-Hispanic history, but their presentation fosters a distinctly left-brain appreciation. They are shown as individual works rather than cluttered cabinets, lit for appreciation rather than inspection, and grouped by theme rather than classification. It's revelatory.

Museo Internacional del
Barroco [Baroque]

Reserva Territorial Atlixcáyotl,
2501 Puebla, Puebla, Mexico
mib.puebla.gob.mx

LEFT Auguste Rodin's *The Thinker* at the Museo Soumaya.

BELOW The striking architecture of the Museo Internacional del Barroco.

▼ Explore Puebla's Baroque past in an expressively futuristic space

The statement-making architecture and high concept of this museum, opened in 2016, suggests that it is pitching to be the Guggenheim of Mexico, catapulting the post-industrial city of Puebla into the international tourist limelight, as was the case in Bilbao. It is certainly impressive. The vast structure, by the Japanese Pritzker Architecture Prize-winner Toyo Ito, is enclosed by pure white concrete walls that billow like sails or a dandy's ruff, expressing the showy essence of Baroque rather than a literal imitation. Inside, eight galleries showcase themes such as art, theatre, architecture and the home. Given Baroque's appeal to the senses, they are inherently experiential, aided by clever tech, such as headphones relaying the authentic sound of a Baroque cello or the light-up scale model of Puebla with screens showing close-up detail of the many Baroque features that make the city a fitting location for the museum.

Reforma 504, Ruta
Independencia, Centro,
68000 Oaxaca de Juárez,
Oaxaca, Mexico
mufi.org.mx

▼ Get stuck into stamps at the Museo de Filatelia de Oaxaca

Locally known as the MUFI and housed in a series of sympathetically refurbished houses connected by courtyards, Oaxaca's unlikely museum of philately is utterly absorbing, replete as it is with thousands of those tiny works of art known as stamps. Born from a temporary exhibition in 1996, the permanent collection, begun from the private collections of keen local philatelists Alfredo Harp Helú and Jorge Sayeg Helú, has grown to incorporate more than 200,000 works from all over the world, and they are stunning. Here are fluorescent stamps, a room dedicated to Cuban stamps, private collections of stamps related to bridges and baseball, stamps in times of war and, perhaps most interesting of all, a section devoted to the letters of Frida Kahlo and different artists who created works of art with stamps.

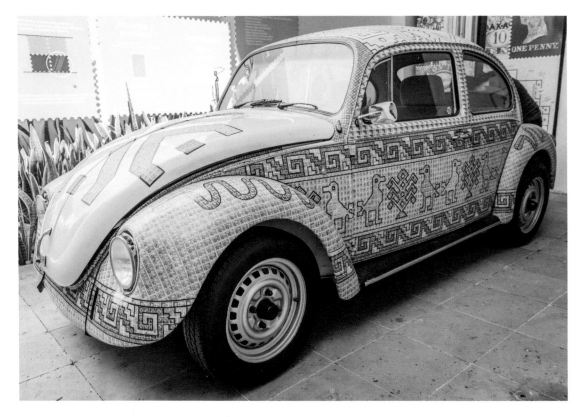

▶ Enjoy Mexican folk art at its best in a very special setting

Casa de los Venados

Calle 40 Local 204 X 41, Centro, 97780 Valladolid, Yucatán, Mexico
casadelosvenados.com

Mexican folk art is distinguished not just by its extraordinary fecundity but by the fact that it is a vital, living genre in continuous production and an inherent part of everyday life, not just museum catalogues. A visit to the Casa de los Venados, the private residence of American connoisseurs John and Dorianne Venator, provides a rare opportunity to see it in an intimate high-end context. Their traditional *casona*, with its central patio, is beautifully furnished, decorated and ornamented entirely with works purchased or commissioned from contemporary makers. It's part-home and part-gallery, and the private apartment (usually accessible) is particularly arresting, with its dining chairs bearing portraits of Mexican folk heroes and its card table attended by skeleton players. As well as architectural commissions, there are murals, paintings, ceramics, metal sculptures and a fine ensemble of colourful *alebrije* fantasy animals.

SFER IK Museion

Carretera Tulum-Punta Allen KM 5, Zona Hotelera, 77780 Tulum, Quintana Roo, Mexico
sferik.art

LEFT One exhibit at the Museo de Filatelia de Oaxaca shows a car covered in stamps.

ABOVE The wonderfully-decorated Casa de los Venados.

Experience a unique space on the Caribbean coast

It looks like something you might find in *The Hobbit*, with its organic forms and materials (all locally sourced) creating a nest-like natural space in the lush forest and white Caribbean beaches it's set in. But SFER IK is a space that's very much man-made, and with a purpose. Once you've entered (barefoot), you'll find site-specific exhibitions by leading installation artists such as Ernesto Neto, Katinka Bock and Tatiana Trouvé, as well as more left-field interactions with the space by people such as Norwegian artist and researcher Sissel Tolaas, known for her work with smells. Consequently, a visit here is likely to be an encounter that will engage any or all of your senses in unexpected ways that might include a polysensory connection, clay sculptures or both. Is it art? That might depend on your definition of art, and what's on when you visit, but it's definitely unlike anything else you'll ever have experienced in an artistic space.

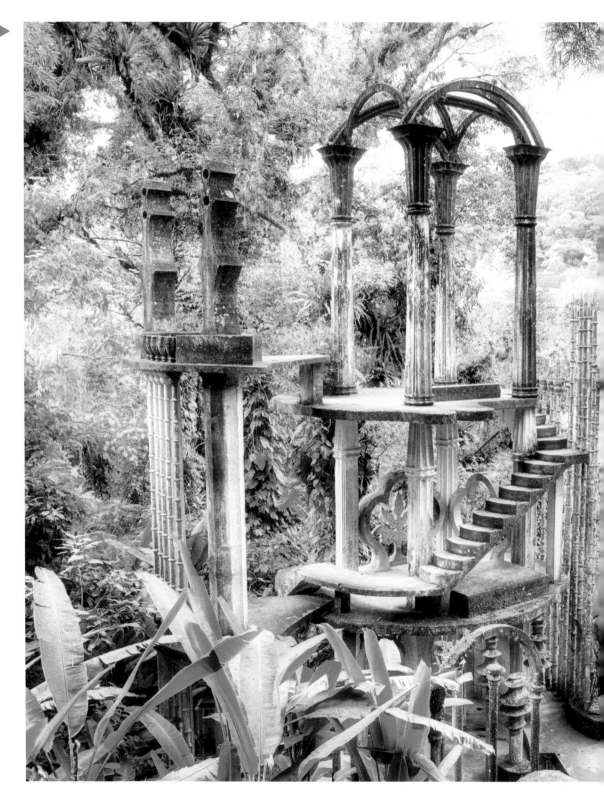

◀ Get lost amid the giant serpents of a surreal Garden of Eden

Las Pozas

Camino Paseo Las Pozas s/n, Barrio La Conchita, 79902 Xilitla, Mexico
laspozasxilitla.org.mx

In Surrealist circles, it is surely the highest possible praise to be described as 'crazier than all the Surrealists put together' by none other than Salvador Dalí. The 'crazy' person in question was British writer and Surrealist art collector Edward James, who came to Xilitla, Mexico at the end of the 1940s and immediately set about building an idiosyncratic home at Las Pozas. It's the landscape surrounding the home that is the most fantastical aspect of the place; through lush jungle vegetation threaded with waterfalls and streams, James sited all manner of colourful concrete columns and structures across differing levels, including a spiral staircase that ends in mid-air, stone snakes and giant floral elements creating a perpetual garden or, as he thought of it, a permanent garden of Eden. Decades on, the marriage of nature and art has turned the space into something utterly unique, magical and unmissable.

LEFT *The Staircase to Heaven* in the surreal garden of Las Pozas.

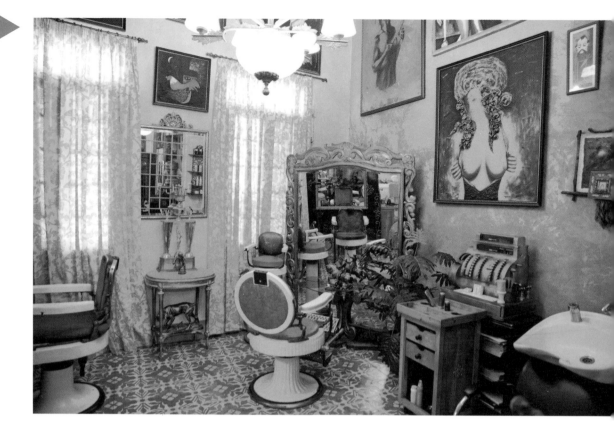

Papito's Arte Corte

Aguiar 10, between Peña
Pobre and Avenida de las
Misiones, Havana, Cuba
artecorte.org

▲ Get a groom with a view in Cuba

Set in a small Habana Vieja street just off the Malecón in Havana,
the barbershop established almost two decades ago by one
Gilberto 'Papito' Valladares is quite possibly unique. Yes, Papito's
Arte Corte is a traditional barbershop, but it is also a wonderfully
surreal art project and historical museum, stuffed not only with
Papito's paintings but also with antique objects and artefacts
related to his profession, from vintage hairdressing chairs to
brushes, razors and other tools of the trade. But it's the paintings
that make the place special. Almost every surface is covered in
hair-themed works by Valladares and other artists, and the project
has been so enthusiastically embraced that it has taken over the
whole street – unofficially rechristened Callejón de los Peluqueros
(Hairdressers' Alley) – and surrounding area. If you have little
ones in tow, visit the nearby children's park with its barber-themed
playground apparatus and the El Figaro restaurant, named after
the main character in *The Barber of Seville*.

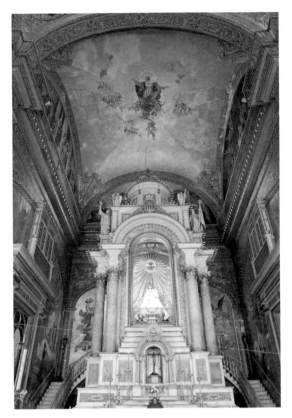

◀ Find heavenly works at Havana's Convento e Iglesia de la Merced

Convento e Iglesia de la Merced

1422 Calle 17, Havana 10400, Cuba
T: +53 7 638873

Seeing the work of great Cuban artists in Havana's impressive Museo Nacional de Bellas Artes and National Museum of Fine Arts is a must, but for a more spiritual context, don't miss this exquisite church and convent. Behind a Baroque façade lies a space filled with works and murals by prestigious Cuban artists – among them Esteban Chartrand, Miguel Melero, Pidier Petit and Juan Crosa. The Lourdes chapel, with its lavish robin-eggshell blue interior and outstanding frescoes, is undoubtedly the star of the show, but make time to visit the other spaces as well, among them the peaceful grotto of the small chapel and the serene cloister, dotted with beautiful sculptures.

Museo de Leyendas
y Tradiciones

León, Nicaragua

LEFT Papito's Arte Corte is both a traditional barber shop and art project.

ABOVE The stunning altar in the Convento e Iglesia de la Merced.

Take in the enormous tit and lots more Nicaraguan folklore

Nicaragua's lively second city, León, is the home of its main twentieth-century art gallery, Fundación Ortiz-Gurdián. But in terms of sheer experience, the far humbler Museo de Leyendas y Tradiciones is the one to visit. It's housed in the former Cárcel La XXI prison, where, during the internal strife of the mid-twentieth century, revolutionary prisoners were interned and tortured. Stark black and white murals illustrate the abuses where they happened; next to them, crude mannequins and models sport the costumes, hats and giant papier-mâché heads of the stock characters of Nicaraguan folklore, very much a living tradition. You will meet Toma La Teta ('take the tit'), a well-dressed woman who attacks men with her one enormous breast, skeletal funeral corteges, the Giantess and the moustachioed midget Pepe Cabezón. In terms of local art and culture, this is as unmediated as it gets, and moving with it.

CHAPTER 2

South America

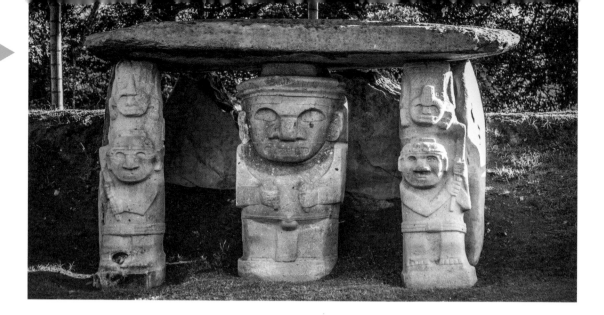

▲ Marvel at the river of tombs along the Magdalena

San Agustín Archaeological Park

Cra. 307, San Agustín, Huila, Colombia
sanagustinhuilacolombia.com.co/parque-arqueologico-de-san-agustin

Colombia's mother river, the Magdalena, flows 1,609 km/1,000 mi along the valley between the Andes and the coastal range. Its indigenous name is Guacacollo, 'river of tombs', and, near its headwaters, the fertile area around San Agustín contains an extraordinary number of grave sites and funerary sculpture from three millennia, most of them unexcavated and little studied. The greatest concentration of monuments is in this beautifully landscaped heritage park. As virtually nothing is known about the civilizations that created them, contemplating the sculptures and earthworks is as much an artistic and mystical experience as an intellectual one. The impact of the giant graven birds, 7 m/23 ft dolmens supported by carved figures, and impassive flat-faced figures delivering a baby or playing a snake-like pipe makes the walk through the expansive site feel like a spiritual journey, especially when crossing the Magdalena, its bed incised with ceremonial channels and animal shapes.

Find the origins of the myth of El Dorado

Museo del Oro

Parque Santander, Bogotá, Colombia
banrepcultural.org/bogota/museo-del-oro

It was in Colombia that the myth of El Dorado arose, the conjectured city of gold at the end of the colonial rainbow. It was spawned by stories about a Muisca (AD 600–1600) ceremony in which a new ruler was burnished with gold dust and offerings were thrown into a lake. El Dorado did not exist, but the ritual was real, and in 1969 a gold votive raft was discovered in a cave depicting it. At just 20 cm/8 in long, it is both a testament to the Muiscas' gold-working skills and a rare depiction of a historic scene. Most artefacts were melted down, which makes the Museo del Oro's 34,000-piece collection (the largest in the world) particularly special. Gold was a sacred metal, and the awe-inspiring displays comprise mainly ceremonial artefacts such as masks, priestly adornments and *poporos* (vessels for preparing coca leaves), showcasing 3,000 years of master craftsmanship and cultural expression.

Comuna 13

Medellín, Colombia
guiaturisticademedellin.com

LEFT A tomb platform with supporting statues in San Agustín Archaeological Park.
BELOW The colourful street art of La Comuna 13.

▼ See a modern *rinascimento* in La Comuna 13

Granted it's not the Renaissance of medieval Italy, but to the residents of La Comuna 13 in Medellín, it is surely as life-changing. Long seen as one of the most dangerous neighbourhoods in the city, the area has shifted from a no-go zone filled with warring drug gangs to a creative hub filled with colourful street art. Centred around its famous *escaleras electricas* – or outdoor escalators – is an exuberant display of creativity that has not only reclaimed the street but acts as memorials to loved ones lost in the violence of the past with tentative messages of hope for the future. A local guide will point out motifs such as white cloths (a reference to a time when residents flew white sheets as a request for ceasefire), birds as a symbol for peace, and even elephants, representing Comuna 13's pledge to never forget the events of the past. Uplifting in every way.

◀ Parade past a whimsical menagerie of bronze in Plaza Botero

Carrera 52 and Calle 52

El Centro, Medellín, Colombia
guiaturisticademedellin.com
museodeantioquia.co

Named for the country's most famous artist, local-born Fernando Botero, Medellín's Plaza Botero is a must for sculpture fans. Filled with twenty-three bronze pieces that span the gamut from cats, dogs and horses to figures from history and mythology – including a Roman soldier, Adam and Eve and a sphinx – the square is a great place to experience the artist's signature style of 'Boterismo'. The wonderfully rounded figurative, overblown representations of animals and humans beg to be touched, and because they are in this public sphere, you can do just that. In the adjacent Museo de Antioquia, set in the grand old Municipal Palace, one hundred or so further pieces by Botero are contextualized by pre-Columbian, colonial and modern art collections.

LEFT Sculptures of Adam and Eve by Fernando Botero in Plaza Botero.

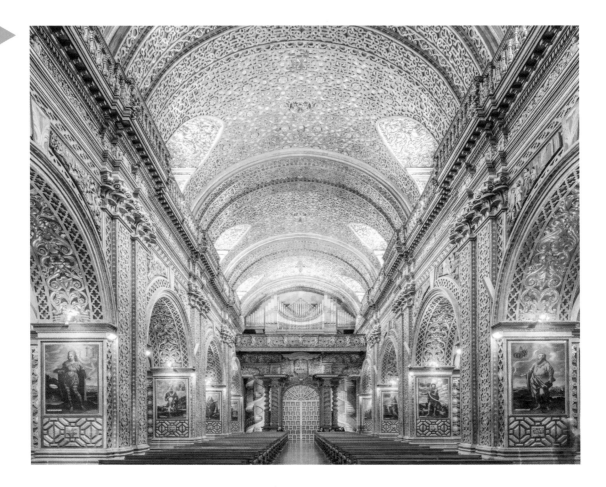

Iglesia de la Compañía
de Jesús

García Morena N10-43,
Quito 170401, Ecuador
fundacioniglesiadela
compania.org.ec

ABOVE The lavish interiors of the
Iglesia de la Compañía de Jesús.

RIGHT A glimpse of the beautiful
gardens surrounding the
Museo Larco.

▲ Find a hellish mix of spiritual tropes in this OTT church

Quito's colonial centre is the best preserved in Latin America, and this beyond-ornate Jesuit church acts as a time capsule of the shock and awe with which the empire-builders imposed their presence. It also goes some way in explaining why surprisingly little gold arrived back in the Old World: a goodly amount of it decorates the staggeringly sumptuous interior. Built between 1605 and 1775, the church reflects an evolution of the mother country's religious architecture from the Renaissance to Rococo. This includes Islamic elements – as in several of Spain's cathedrals – such as the nave carvings. Whether to inveigle the Ecuadorians into the faith or smuggled in by their artisans, the church also incorporates Inca symbols – the sun – and local flora, fauna and faces. The pomp fails to stir the soul: this is left to a painting of hell by Hernando de la Cruz, a Bruegel-esque scene of torture that today denounces the conquerors rather than cowing the subjugated.

Brave the labyrinth to discover a terrifying ancient icon

Temple

Chavín de Huántar, Peru
whc.unesco.org/en/list/330/

If art is a 'mediator of the unspeakable', as Goethe declared, it is no wonder that many religions have enlisted it to inspire and – sometimes – terrify. A prime example of this is found in Chavín de Huántar, on central Peru's Andean slopes. Pre-dating Machu Picchu by two millennia, Chavín was a grand temple city, and, if the temple's exterior is now little more than stone-strewn mounds, the labyrinth of precisely chiselled passageways, chambers and sculptures within continues to fulfil its original design brief: to conjure menace and mysticism. Only because the site's remoteness means that few will ever visit does it seem fair to divulge that at its centre, artfully arranged to show itself (or be revealed by a priest) first gradually, then suddenly in a beam of light, is a vertical statue of a stone serpent so masterly its power to awe is little diminished by time.

▼ Pass through peaceful gardens into a thoughtful arena of war

Museo Larco

Avenue Simón Bolívar 1515, Pueblo Libre, Lima 21, Peru
museolarco.org

It's easy to forget in the gorgeous gardens of this colonial mansion that much of its collection of pre-Columbian artefacts represents the spoils of conquest. They are, though, honoured by thoughtful, accessible and well-interpreted curation that balances their artistic, historical and religious significance in galleries that cover the ceramics, textiles and metalwork of 10,000 years of civilizations in what today is Peru. Particularly striking are friezes telling stories of ritual combat and sacrifice and, more prosaically, uncannily lifelike ceramic food and animals. It's a breathtaking ensemble, not least the Erotic Gallery, in which omnivorous sensual pleasures survive some religious overinterpretation. Look out for the Moche vessel numbered ML013572; significant as the piece that inspired the museum's founder, Rafael Larco Hoyle, to establish the museum in 1926, it is also a sculpted portrait whose artistry and humanity speaks across two millennia.

TRAIL: The best places to see pre-Columbian art in South America

Museums devoted to pre-Columbian art are plentiful across Central and South America, all of them beautifully showcasing the imagination and dexterity of civilizations as varied as the Olmec, Tarascan and Teotihuacan, as well as the more famous Incas and Mayas, that thrived before the fifteenth-century arrival of Christopher Columbus to the Americas. Here are some of our favourites.

Chilean Museum of Pre-Columbian Art

Santiago, Chile

The grand neoclassical Palacio de la Real Aduana this museum is housed in is an indicator of how important its collection is to Chile. A wide-ranging selection of pre-Columbian artworks from Mesoamerica to the South Andes and Chile includes beautiful wooden and terracotta figures.

Pre-Columbian Art Museum

Cusco, Peru

This collection of works from pre-Columbian Peru is housed in a very appropriate building – a fifteenth-century Inca ceremonial courthouse. The 450 artefacts here, among them some gorgeous ceramics (particularly the vessels), span more than a millennium.

National Museum of Archaeology, Anthropology and History

Lima, Peru

The oldest state museum in Peru includes around 100,000 objects illustrating the history of human presence in the country. Pre-Incan pottery and ceramics are the highlight, although a scale model of Machu Picchu is impressive too.

Museum of Pre-Columbian and Indigenous Art (MAPI)

Montevideo, Uruguay

Across four permanent exhibition halls, MAPI displays some 700 objects representing the various cultures of ancient America over a span of 3,000 years. Musical instruments are a feature, and information is in Spanish, English and Portuguese.

Museo del Oro

Bogotá, Colombia

See page 60.

National Museum of Anthropology

Mexico City, Mexico

It is not, of course, in South America, but we have to include Mexico's National Museum of Anthropology because it contains a brilliant collection of pre-Columbian Mexican art, housed in an equally brilliant building whose central courtyard umbrella is a marvel of engineering.

See page 48.

Museo Nacional de Colombia

Bogotá, Colombia

Housed in the Panóptico, designed as a fortress prison in 1874, the Colombian National Museum's collection spans more than 12,000 years of art, culture and ethnography, with a great selection of art from both pre- and post-Columbian periods. Lovely gardens and café too.

Museo Larco

Lima, Peru

See page 65.

Casa del Alabado Museum of Pre-Columbian Art

Quito, Ecuador

Housed in an attractive seventeenth-century townhouse dotted with courtyards and gardens, the Casa del Alabado's collection eschews an archaeological chronology and displays the 500 pieces on permanent display thematically, with a focus on artistic merits.

Museo del Banco Central

Quito, Ecuador

A large collection of pre-Columbian artefacts includes delightful pieces like the Chorrera ceramic whistle-bottles; in the shape of animals, they mimic animal noises when water is poured into them. Colonial, republican and contemporary art are strong too, making this a must-visit.

OVERLEAF ▶
Mapuche funerary statues in the Chilean Museum of Pre-Columbian Art.

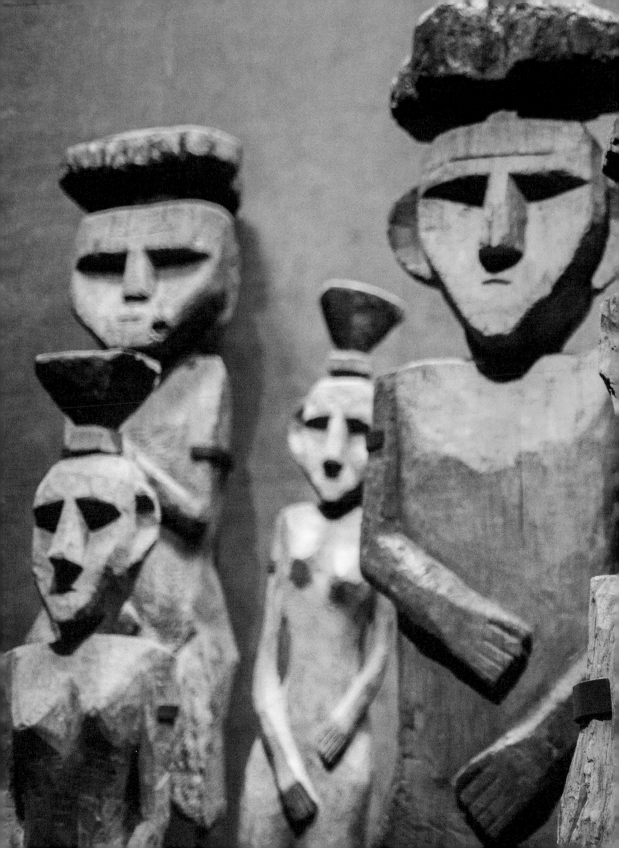

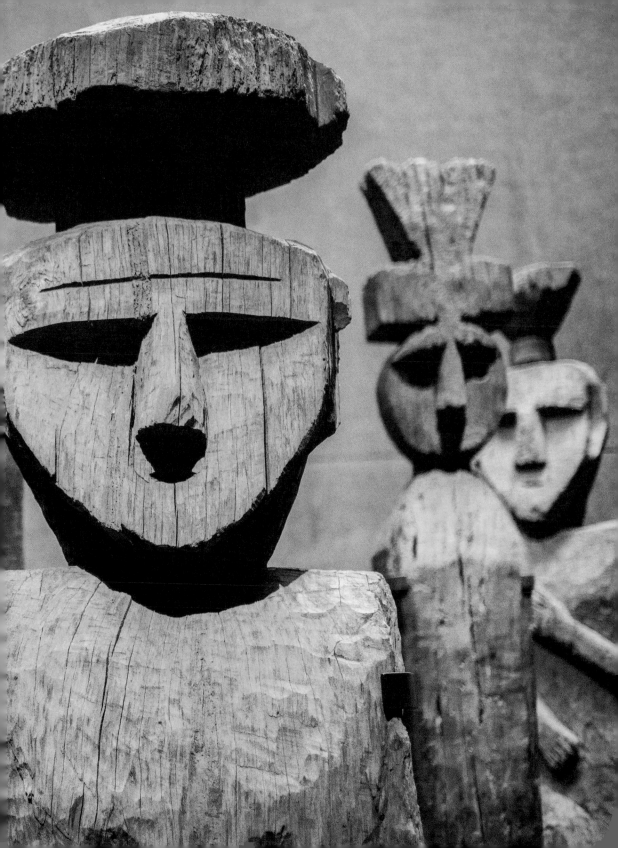

Museo de Arte de Lima (MALI)

Parque de la Exposición,
Paseo Colón 125,
Lima 1, Peru
mali.pe

Trace the history of art in Peru from ancient to modern

You can follow a simple path through more than 3,000 years of creativity at the MALI, confusingly nothing to do with Mali but instead the acronym for the Museo de Arte de Lima. For here, displayed chronologically, are some 18,000 textiles, ceramics, metalwork, photography, drawings and paintings displayed in four sections: pre-Columbian, Colonial, Republican and Modern art. And taken together they present a collection that has some real stunners in it, whether it's a thousands-year-old ceramic bottle in the shape of a contortionist, European religious art from the colonial period or perhaps, best of all, the more modern artworks of Peruvian artists such as Francisco Laso, whose *The Three Races* from 1859 displays a use of light and composition learned in Europe but made entirely his own. It is a gorgeous collection in a gorgeous building, and should not be missed.

Semana Santa

Ayacucho, Peru

Marvel at Holy Week's magical flower carpets in Ayacucho

Semana Santa (Holy Week) is celebrated with overlapping but distinct traditions throughout the Catholic world. In Peru, a delirious party spirit pervades. Saints and relics are taken from their church niches, dressed up and processed, fireworks are detonated, streets are decorated and, Lent notwithstanding, delicacies consumed. Several cities vie to host Peru's best event but Ayacucho takes the crown. Having recovered from the Sendero Luminoso activist/terrorist era, it embodies a spirit of youth, social change and creativity expressed in the styles and subjects of the pigment paintings and petal carpets that transform the streets and squares into evanescent galleries. Pushing the demanding medium to its limits (the makers must squat, scatter and avoid disturbing finished sections), some works nod to the artistic canon, perhaps with a Warholian repeat, while traditional graphic borders recall Andean textiles and architecture as Ayacucho speaks its identity.

RIGHT Aerial view of a spider geoglyph, part of the Nazca Lines.

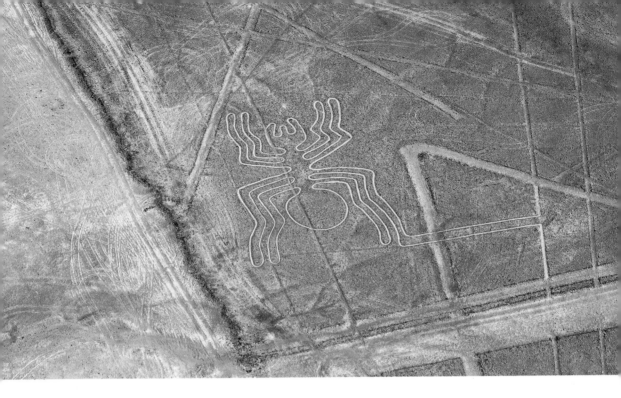

▲ Get a bird's-eye view of alien art in south Peru

Nazca Desert (between Nazca and Palpa)

Peru
whc.unesco.org/en/list/700/

Man-made or alien-made? There are many wild theories about the creators of the Nazca Lines, 300 or so geoglyphs of figures, plants and animals including dogs, hummingbirds, monkeys, spiders, whales and pelicans. It's hardly surprising, given their spread across a mind-boggling 520 km/323 mi of the south coastal deserts of Peru, the venerable age of the geoglyphs, which date from 200 BC to AD 700, and the fact that they're composed of thousands of lines created by clearing away the dark red surface stony soil to reveal the lighter subsoil below it. Perhaps most baffling of all, the drawings are only recognizable from high above, ideally in one of the many light aircraft that fly over them – an experience that just might make you believe the alien theory.

Support Bolivia's textile industry

Museo de Textiles Andinos Bolivianos

Plaza Benito Juárez 488, Miraflores, La Paz, Bolivia
museodetextiles.org

Walk through the doors of the unprepossessing La Paz villa ambitiously calling itself the Museo de Textiles Andinos Bolivianos and a world of rich treasures opens up, one filled with the warm tones and great skills of Bolivia's textile artists. Covering both the craft's history in the country and its contemporary relevance to South America's art scene, the little museum is filled with wonders drawn from all over Bolivia – including the Cordillera Apolobamba of the South American Andes and the Jal'qa and Candelaria regions of the Central Highlands. Descriptions are in Spanish and English, the creative process is explained from yarn to finished item, and the lovely shop sells unique pieces made by artists who receive 90 per cent of the sale price.

◀ Delight in the sinuous curves of Oscar Niemeyer's MAC

Museu de Arte Contemporânea de Niterói (MAC)

Mirante da Boa Viagem, Niterói, Rio de Janeiro 24210-390, Brazil
culturaniteroi.com.br/macniteroi

The resemblance of this Oscar Niemeyer building to the comic book flying saucer of popular imagination is inescapable. Sitting across the bay from Rio, its spinning-top form is etched clearly against a backdrop of sea and sky. Niemeyer, Brazil's defining twentieth-century architect and the auteur of Brasília, evolved a distinctive national version of Le Corbusian Modernism, infusing its sculptural, machine-age designs with sensuality. Form, he believed, should follow beauty rather than function, and that tenet is dramatically expressed here. Indeed, for many visitors the building itself is the art, from its exterior to the walk up the projecting entrance ramp, blood red and sinuous. 'What attracts me is the free and sensual curve – the curve that I find in the mountains of my country, in the sinuous course of its rivers, in the body of the beloved woman,' said Niemeyer.

LEFT The incredible shapes of the Museu de Arte Contemporânea de Niterói building, designed by Oscar Niemeyer.

▲ Get an eyeful of Oscar Niemeyer's golden eye in Curitiba

Museum Oscar Niemeyer

Rua Marechal Hermes 999, Centro Civico
80530.230, Curitiba, Paraná, Brazil
museuoscarniemeyer.org.br

Not many museums are named after their architects, and you might be forgiven for thinking the world-recognizable white eye on its bright yellow pedestal is devoted to the work of the great Brazilian, but no, inside you'll find an enjoyable mix of temporary and permanent exhibitions of Brazilian and global fine art, design and architecture – maybe a Man Ray show, or a show of artworks themed around light. But really, the experience here lies in the exploration of Niemeyer's masterpiece; inside and out, it's a joy to wander round, with a sculpture court set in gorgeous grounds offering endlessly fascinating views of the building.

See *Christ the Redeemer* in a new light in Rio de Janeiro

International Museum of Naïve Art (MIAN)

Rua Cosme Velho, 561, Cosme Velho –
22241-090, Rio de Janeiro, Brazil
T: +21 2205 8612/2225 1033

On the same street as the train that climbs the hill up to Rio's *Christ the Redeemer* is a quaint powder-blue building that offers a view of the city which, in some ways, is even more revealing than that offered from the famous statue. For here, in MIAN (The International Museum of Naïve Art), is a glorious collection of works by mostly Brazilian artists that offer a rich and playful insight into daily life in the city and the Carioca lifestyle of its inhabitants. One room is dedicated to naïve portrayals of forty of the city's most famous attractions, including Dalvan da Silva Filho's *Confeitaria Colombo* and *Réveillon* by Ozias, and it's here that you'll get the best views of the *cidade maravilhosa*, bar none. At the time of writing the museum had been forced to close due to lack of funds; it's to be hoped that at the time of your reading this, it will have reopened.

Inhotim Art Museum

Brumadinho, near Belo
Horizonte, Minas Gerais,
Brazil
inhotim.org.br

▲ Trek into the Brazilian rainforest for art in the jungle

Spread across 2,023 hectares/5,000 acres of botanical
gardens in the Brazilian state of Minas Gerais, the Inhotim Art
Museum is home to mining magnate Bernardo Paz's extensive
art collection, much of which was commissioned specifically for
this site. So in place of the minor works by major stars of old
that sometimes populate private collections, here are pieces
by Olafur Eliasson, Janet Cardiff and Cildo Meireles, as well as
pavilions by Doug Aitken (whose 2009 *Sonic Pavilion* is one
of the main attractions), Dominique Gonzalez-Foerster and
Steve McQueen, all creating a collection that is one of the most
compelling in South America. Aitken perhaps expresses it best
when he describes it as 'one of the few places in the world
where art can be created and exist in response to the landscape
and the culture. This is the museum as enabler'.

ABOVE Inhotim Art Museum is
a contemporary art gallery set in
stunning botanic gardens.

LEFT Museum Oscar Niemeyer,
designed by Oscar Niemeyer.

Bathe in mud and more at the Museo del Barro

Museo del Barro

Grabadores del Kabichu'i, Asunción, Paraguay
museodelbarro.org

It's not easy to find and has erratic opening hours, but step into the red clay building that houses the Museo del Barro (translated as the museum of clay, or mud) and you're in for a rare treat – described by the United Nations in 1989 as 'an institution organized around non-Western principles and subjects'. A collection of indigenous, folk art and contemporary artworks rub together in an unusually imaginative way, so here you'll find a room filled with colourful Jesuit figurines and traditional masks, there modern installations addressing contemporary political concerns, and in between hundreds of pieces of pre-Columbian clay artefacts and numerous items from the colonial era. The eclectic approach creates a wonderfully fresh and unstuffy mix.

▼ Survey towering silos of colour in Rosario

Museo de Arte Contemporáneo Rosario (MACRo)

Avenue de la costa Estanislao López 2250, S2000 Rosario, Santa Fe, Argentina
castagninomacro.org

While it's not unusual to see buildings in redeveloped docklands transformed into receptacles for art, it's less common to see them transformed into artworks per se. In Rosario, Argentina's third city, a cereal processing plant on the Paraná River has been reborn as a contemporary art museum, its silos a towering canvas for new commissions. The current design, by Ezequiel Dicristófaro, Juan Maurino and Maite Pérez Pereyra, was implemented in 2017. It covers the eight containers with an intersecting mesh of giant colour fields; its geometric abstraction mirrors previous designs since the silos' opening in 2004. This may not reflect the shock of the new, but it consolidates MACRo's identity as the focal point of downtown's new riverside. The scheme has also preserved the plant, an Art Deco landmark by Ermete de Lorenzi, then the province's Director of Public Works. Today, a glass elevator accesses the collection, with views to the city and estuary beyond.

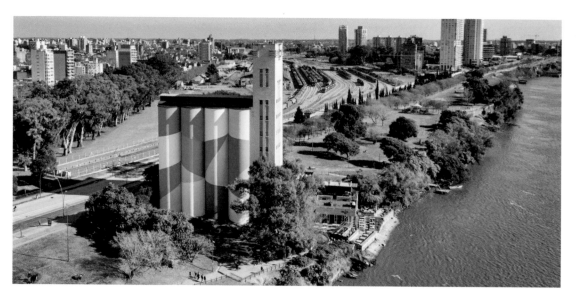

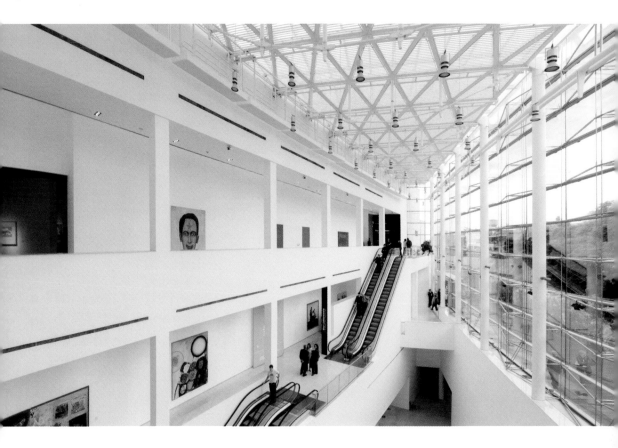

Museo de Arte
Latinoamericano de
Buenos Aires (MALBA)

Avenue Figueroa Alcorta
3415, C1425 CLA Buenos
Aires, Argentina
malba.org.ar

ABOVE The light-filled Museo
de Arte Latinoamericano de
Buenos Aires.

LEFT Aerial view of the bright
silos of the Museo de Arte
Contemporáneo Rosario.

▲ Follow an artistic timeline in Buenos Aires

Packed with snakes, pyramids, suns, ladders and other mystical
symbols, the small but vibrant watercolours of Argentine Surrealist
Xul Solar are endlessly fascinating, and just one of the delights
of the collection of twentieth-century Latin American art on
permanent display at this striking, light-filled museum in central
Buenos Aires. From early Modernism through Nuevo Realismo
in the 1930s to conceptual art in the 1970s, the collection pulls
in work by more than 200 artists, including Frida Kahlo, Diego
Rivera and Wilfredo Lam. Another Argentine great, Antonio Berni,
captures the era's dazzling experimentation: it's hard to believe that
Berni's Social-realist painting of striking workers, *Manifestación*
(1934), and his messy, chaotic collages of industrial waste from the
1960s are by the same artist. MALBA's temporary exhibitions are
always compelling, and the parkside café is a charming spot for a
post-show coffee or lunch.

◀ Join the truckers on a folk art trail

Shrines to La Difunta Correa

Region around Vallecito, San Juan province, Argentina

By definition, these things cannot be counted, but the thousands of roadside shrines to Argentina's unofficial saint La Difunta Correa may represent one of the largest bodies of folk art in the world. The story goes that in the 1840s a woman seeking her soldier husband in the north-western desert died of thirst. She was found by gauchos, dead, but still suckling her living son. Since then, travellers and pilgrims have created innumerable roadside shrines leading to her grave in north-western Argentina's Vallecito, San Juan province. Today it is primarily truckers who leave offerings of water bottles, hand-painted plaster figures, plastic flowers, nativity-like tableaux, paintings and, sometimes, lorry parts. In Vallecito itself, thousands of ex votos are explicitly crafted to represent petitions: perhaps for a cure, a car, a fridge; a sprawl of tiny houses forms an ad hoc model village. An artwork by default, not intention, inhabiting the space between beatification and litter.

James Turrell Museum

Bodega Colomé, Salta province, Argentina
bodegacolome.com/ museo-james-turrell

Seek out light unseen in a high-altitude vineyard

This is the world's only museum dedicated to James Turrell, the prodigious and prolific master of light art, so its location deep in the desert of northern Argentina could be considered inconvenient. But it's perfectly fitting for an artist whose palette is light, sky and earth, and whose scale is unbounded. It's here because the collector, Donald Hess, is a winemaker, and this is his high-altitude vineyard, its rarefied air as good for grapes as it is for the quality of light. The museum is divided into nine rooms holding works representing Turrell's long career. Some of them are site-specific, notably *Unseen Blue* (2002), an open-roofed atrium where visitors lie on mats to witness a dance between natural and artificial light. Call before coming (the road may not be open), and experience the fine arts of wine and hospitality as well, with a vineyard tour and a stay at the luxurious on-site estancia.

Museo a Cielo Abierto

Avenida Departamental 1390, San Miguel Región Metropolitana, Santiago, Chile
museoacieloabiertoensan miguel.cl

LEFT Small shrine to La Difunta Correa in Argentina.

BELOW Wall painting by the artist Payo, part of the Museo a Cielo Abierto in San Miguel.

▼ See art under the open skies of Chile

The transformative power of art is never more exciting than when it is seen in a successful renewal project such as this one. San Miguel's Museo a Cielo Abierto – or museum under the open skies – is a powerful community reactivation project that has seen one-time neglected areas of inner-city San Miguel in Santiago turned into a vast open-air urban art museum filled with some sixty large-scale murals created by emerging and established local and international artists. Themes are broad and often touch on the stories and histories of a working-class community that was all but abandoned after the 1973 coup, and to wander the invigorated, colourful streets is a treat, offering a real sense of the importance of public art and its ability to strengthen the connections within a community. On Chile's west coast, another museum of the open sky in Valparaíso offers equally engaging murals.

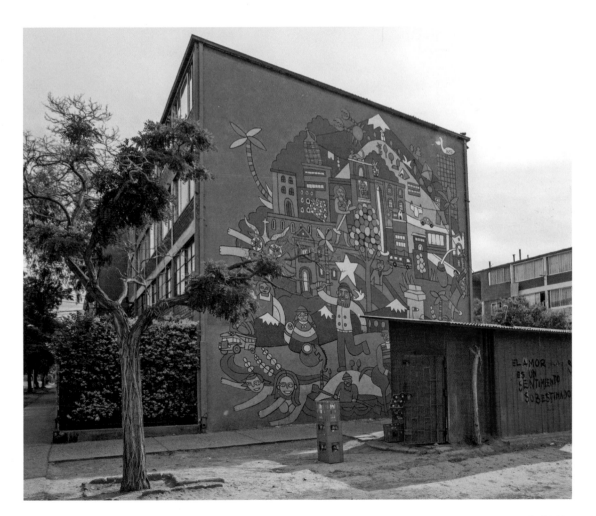

▶ Go head to head with the enigmatic *moai*

Easter Island

Chile
whc.unesco.org/en/list/715

Is it worth flying all the way to eastern Polynesia's Easter Island to stand in awe in front of the enigma that are the *moai* – the monolithic chiselled stone heads that have gazed out implacably from their *ahu* (platforms) for centuries? It really is. The fifteen-strong group facing inland at Ahu Tongariki, restored by Chilean archaeologist Claudio Cristino in the 1990s, includes the heaviest ever *moai* erected on the island, and will make you feel utterly insignificant – particularly when you take into account that hundreds of them were moved from the quarry in which they were created at Rano Raraku. But it's not just their scale that impresses; if the arresting flat planes seem familiar, it is because they are believed to have influenced Picasso's *Les Demoiselles d'Avignon* (1907), which effectively began the Cubist movement.

RIGHT The fifteen gigantic sculptures of *moais* at Ahu Tongariki.

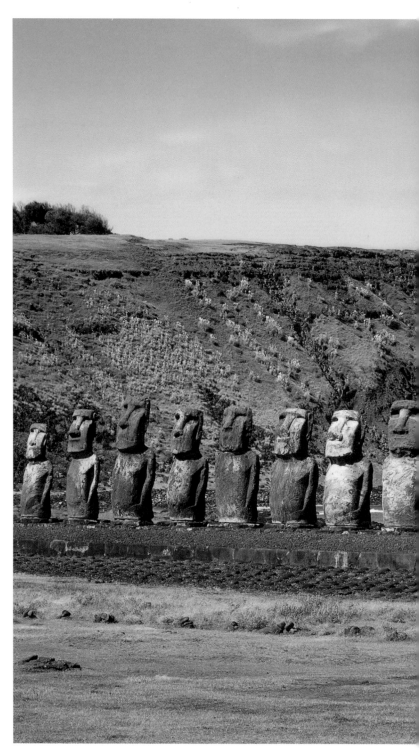

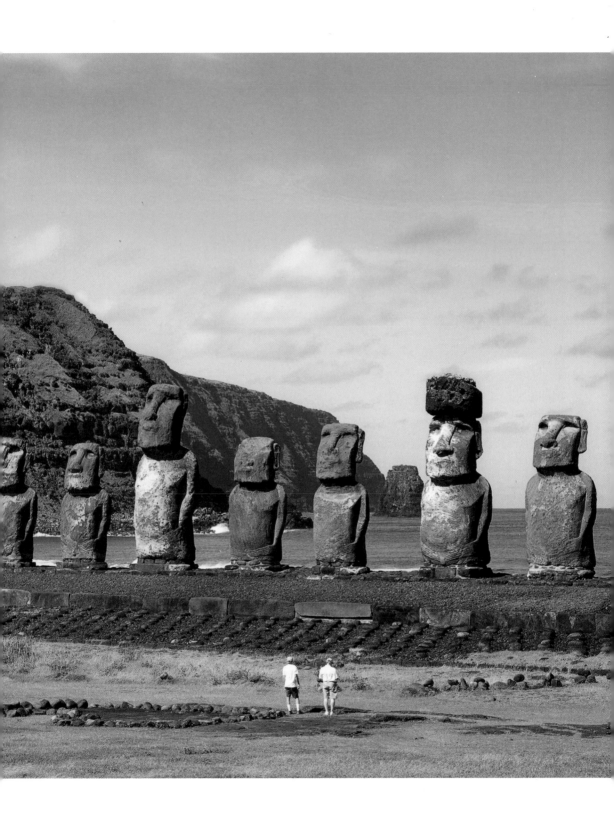

CHAPTER 3

Europe

Library of Water

Bókhlöðustígur 19, 340
Stykkishólmur, Iceland
*artangel.org.uk/project/
library-of-water*

Drink in Roni Horn's
Library of Water

American minimalist artist Roni Horn tapped into something universal and elemental when she realized her *Library of Water* (Vatnasafn), on Iceland's southwest coast. At the heart of the former library, Horn's *Water, Selected* takes the form of a beguiling long-term installation (begun in 2007), comprising twenty-four identical floor-to-ceiling glass columns containing water gathered as ice from twenty-four glaciers across the country. As with most Icelandic towns, the sea and the land are ever-present beyond the walls of the little library, and Horn's columns beautifully connect the inside space with the landscape, literally bringing the latter into the former as they refract and reflect the light on to a rubber floor embedded with weather-related words in Icelandic and English. Elsewhere, books and spoken testimonies gather together people's thoughts about the subject, but it is the purity of the columns that remains with you.

BELOW Reconstructed studio of Francis Bacon in Dublin City Gallery.

RIGHT *Sky Garden* (1992) by James Turrell at Liss Ard Estate.

◀ Bring home the Bacon

Dublin City Gallery

The Hugh Lane, Charlemont House, Parnell Square North, Rotunda, Dublin D01 F2X9, Ireland
hughlane.ie

By the time the painter Francis Bacon died in 1992, the chaotic studio in west London where he produced some of his most famous works contained over 7,000 items, including hundreds of books, thousands of photos (he never painted from life), slashed canvases, seventy drawings, paint tubes, magazines, newspapers and vinyl records. Bacon's heir, John Edwards, donated the entire contents (including the 'curated' dust!) to the Hugh Lane gallery in Dublin, Bacon's city of birth. A team of archaeologists and curators relocated the entire studio at a cost of £3 million – not bad value when you consider a museum offered $3m just for the studio door. It is a fascinating insight into the artist who once said (about this studio): 'This mess here around us is rather like my mind.'

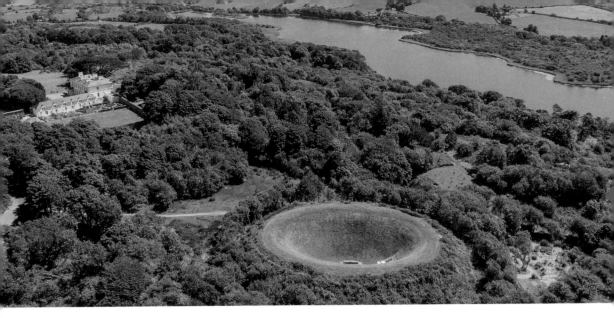

▲ See inside-out at the Irish Sky Garden

Liss Ard Estate

Castletownshend Road, Skibbereen, County Cork P81 NP44, Ireland
lissardestate.ie/skygarden

James Turrell's *Sky Garden* (1992) is less about 'seeing' than it is about 'feeling', a space in which natural light is experienced as a tangible material as we become aware of the limits of human perception – a state Turrell calls 'seeing yourself seeing'. Located near the town of Skibbereen in west Cork, the installation takes the form of an immense artificial crater, accessed through a stone arch. In an experience designed to resemble a birthing scenario, visitors enter and make their way along a long dark passageway before climbing some steps to enter a crater 25 m/82 ft in length and 13 m/43 ft deep. Designed to block all outside sound, the middle of the crater features the 'Vault Purchase', a stone plinth where you can lie down and contemplate the framing of the Irish sky in sublime silence. The installation gives an unparalleled view of what Turrell calls the 'celestial vault' of the sky above.

Follow the poetry of the human figure in Edinburgh and Liverpool

Scottish National Gallery of Modern Art

75 Belford Rd, Edinburgh EH4 3DR, UK
nationalgalleries.org

Crosby Beach

Merseyside, UK
visitliverpool.com

Edinburgh's river the Water of Leith is mostly hidden from view, offering, instead of water, a meandering walk down to the sea. It is here between the sea and the Scottish National Gallery of Modern Art that we find Antony Gormley's *6 Times* (2010), six life-size figures which mark out a walk to the sea through the undergrowth. Dwarfed by their surroundings, the eroding statues question how the human form fits in to the environment, making for a vulnerable and meditative work. In Liverpool, Gormley's *Another Place* (1997) – one hundred similar figures looking out to sea from Crosby Beach – is equally inquisitorial; as the isolated statues corrode in the salty air, some half-submerged and encrusted with barnacles, you can't help but wonder what they might be waiting for.

◀ Climb a stairway to heave

The Fruitmarket Gallery

45 Market Street, Edinburgh EH1 1DF, UK
fruitmarket.co.uk/scotsman-steps

Medieval Edinburgh perched on top of an extinct volcano is linked to the new town (eighteenth-century 'new') below by a series of steep roads, walkways and steps, among them the Scotsman Steps, which have connected North Bridge and Waverley Station since 1899. A century on, the steps had become the 'pishy steps' due to the stench of urine, which is where Martin Creed stepped in (excuse the pun) with a commission to overhaul the Grade I listed monument. *Work No. 1059* (2011) took a team of engineers, stonecutters and builders over two years to resurface the steps with 104 different and contrasting types of marble from around the globe. Creed, also a musician, has long been interested in how art is interpreted or re-interpreted, and with this perfectly integrated and pragmatic work of art the viewer – or traveller – 'recomposes' the work every time they walk up and down the steps. Brilliant.

Jupiter Artland

Bonnington House Steadings, Edinburgh EH27 8BY, UK
jupiterartland.org

Enter this woman-made grotto at your peril

On the outskirts of Edinburgh, an under-the-radar wonderland of outdoor sculpture celebrates some of the world's most important living sculptors and land artists with a collection of thirty-five permanent site-specific pieces set across 40.5 hectares/ 100 acres of meadow, woodland and indoor spaces. Whether through Edinburgh's winter gloom, spring rains, ethereal summer light or crisp autumn mist, it is a treat to see works by Cornelia Parker, Peter Liversidge, Jim Lambie, Andy Goldsworthy and Ian Hamilton Finlay, many of whom have strong links with the country. A highlight is Anya Gallacio's amethyst and obsidian grotto *The Light Pours Out of Me* (2012), an unsettling space that nods to the history of country house follies in Britain. The glistening crystal surfaces beg to be touched and stroked, but just like Gallacio's *Red on Green* (1992), in which an inviting carpet of 10,000 fresh roses hid a thorny underside, to do so could well be folly. Back on surface level, don't miss Christian Boltanski's *Animitas* (2016).

ABOVE The colourful steps of *Work No. 1059* (2011) by Martin Creed.

RIGHT The Black Hole Terrace at the Garden of Cosmic Speculation.

The Garden of Cosmic Speculation

2 Lower Portrack Cottages, Holywood, Dumfries DG2 0RW, UK
gardenofcosmic speculation.com

▲ Spend one day of the year on a futuristic golf course

The Garden of Cosmic Speculation is only open one day a year for charity (typically the first Sunday of May). Charles Jencks, who died in October 2019, along with his late wife, Chinese-garden designer Maggie Keswick Jencks, created it as a 12-hectare/30-acre garden designed to bring together the worlds of science, art and nature. It consists of a series of areas connected by bridges, lakes, steps and terraces, which tell the story of the creation of the universe. The Big Bang, bits of string theory, DNA helixes, fractal geometry and a smattering of black holes are presented horticulturally and challenge our idea of what a garden 'should' look like, creating one that's a perfect marriage of ideas and execution. The art critic Andrew Graham-Dixon, however, likened it to 'being on a futuristic golf course'.

Kelvingrove Art Gallery
and Museum

Argyle Street, Glasgow
G3 8AG, UK
*glasgowlife.org.uk/museums/
venues/kelvingrove-art-
gallery-and-museum*

BELOW East court of the
Kelvingrove Art Gallery
and Museum.

RIGHT Glass decoration by
Charles Rennie Mackintosh
at the Willow Tea Rooms.

▼ See red and so much more in Scotland

Looking like something out of TV series *The Crown* or a Jane Austen novel, the glorious red palace housing Kelvingrove Art Gallery and Museum is just as glorious inside, where twenty-two galleries are devoted to creativity and culture. Amid the natural wonders, technological achievements (don't miss the 1901 organ and 1944 Spitfire) and stunning crafts, the fine art on show ranges across everything from first-class Glasgow School pieces to French Impressionist and Renaissance paintings. Scottish work is, as you would hope, well represented, with highlights including *A Lady in Black* (*c*. 1921) by Francis Cadell and Joan Eardley's gorgeous *Two Children* (1963), just one of the many paintings she created themed around post-war urban childhood and Glasgow street children after moving to the city with her family in 1939. Influenced by Henry Moore and Stanley Spencer, her avant-garde works employ collage and brushstrokes to stunning effect.

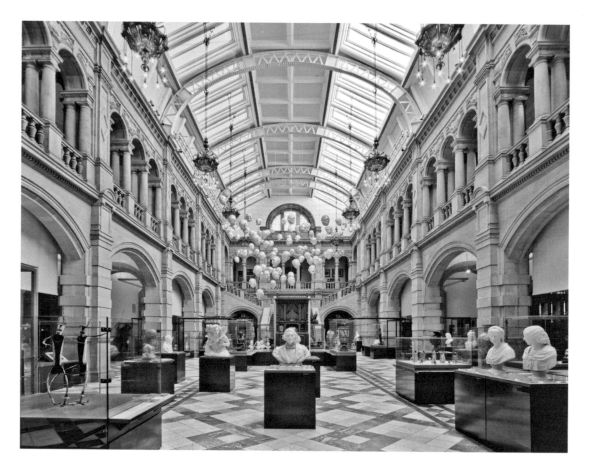

▲ Take tea with Glasgow's answer to Frank Lloyd Wright

Willow Tea Rooms

97 Buchanan Street, Glasgow G1 3HF, UK
willowtearooms.co.uk

It is ironic that by the time a disillusioned Charles Rennie Mackintosh died in London, he was unknown in his hometown of Glasgow, but by the end of the twentieth century he was lauded as the father of the Glasgow Style and a major influence on the Art Deco movement. While his greatest achievement, the Glasgow School of Art, is at the time of writing closed due to a fire, several of his other works are open. The most famous of these, and the most accessible (for the price of a cup of tea), is the Willow Tea Rooms, now called Mackintosh at the Willow, opened in 1903. It is the tearoom that is said to have defined Mackintosh's unique style. As well as designing the building, the stained-glass windows and the furniture, Mackintosh also created the cutlery, the waitresses' uniforms and even the typeface that is still used on today's menus.

Go west to explore the scenery and works of a landscape painter extraordinaire

Oriel y Parc

St David's, Pembrokeshire SA62 6NW, UK
pembrokeshirecoast.wales

Graham Sutherland was once as well-known an artist as Francis Bacon and Lucien Freud, his powerful, darkly dramatic Welsh landscapes and Second World War art bringing him such success that he was deemed one of Britain's leading modern artists in the post-war era. A good number of his works are held by the National Gallery of Wales in Cardiff, but a more rewarding location in which to see them is in Pembrokeshire in west Wales. Sutherland loved this area and painted a number of its brooding, surreal landscapes, bequeathing some of them to Wales with the proviso that they be seen in the place that had inspired them. Hence a number are often on show at the Oriel y Parc, a small gallery that sits sympathetically in the spectacular landscape of the Pembrokeshire Coast, and close to sites Sutherland captured at Clegyr Boia, Porthclais and Sandy Haven.

Various locations in
Yorkshire, UK

*yocc.co.uk and yorkshire.com/
inspiration/culture/david-
hockney-at-80*

▲ Follow in the footsteps of David Hockney in the Yorkshire Wolds

For more than five decades, Britain's most famous living artist has painted scenes from East Riding and the Yorkshire Wolds, the landscape surrounding his hometown of Bridlington in Yorkshire. In a landscape made up of large arable estates owned by families stretching back to the Middle Ages, muted colours and hues spread out like a patchwork quilt, only made up of neutral earth tones and myriad shades of green, white and grey rather than the candy-colour yellows, purples and oranges seen in Hockney's representations of the sites in works such as *The Road to York Through Sledmere* (1997), *Garrowby Hill* (1998), *Hedgerow, Near Kilham, October 2005* (2005), *Woldgate Woods* (2006) and *Bigger Trees Near Warter* (2007). Nearby, the Jacobean Burton Agnes Hall, owned by the same family for 400 years, is home to an art collection that includes Jean-Baptiste-Camille Corot, André Derain, Walter Sickert, Duncan Grant, Paul Cézanne, Paul Gauguin and Maurice Utrillo.

ABOVE *Garrowby Hill* (1998) by David Hockney

RIGHT The River Thames and Cookham Bridge in Berkshire – scenery which inspired the artist Stanley Spencer.

Be immortalized in iron at the Yorkshire Sculpture Park

Yorkshire Sculpture Park

West Bretto, Wakefield WF4 4LG, UK
ysp.org.uk

Set amid the parkland, pasture and woodlands of Wakefield's 202 hectare/500 acre Bretton Estate, the Yorkshire Sculpture Park is a delight whether you like sculpture or not. For more than forty years it has been sympathetically exhibiting the best of modern sculpture from around the world, from Henry Moore and Andy Goldsworthy to Alfredo Jaar and Yinka Shonibare. Temporary exhibitions by the likes of Giuseppe Penone, Joan Miró, Bill Viola, Isamu Noguchi and local lass Barbara Hepworth often result in permanent pieces being added to the gallery's collection. If you want to become part of that collection, you can, thanks to the cast iron *Walk of Art 2*. Devised by artist Gordon Young and designers Why Not Associates, this immortalizes supporters' names in forged nameplates which are added to a long carpet of cast iron winding its way through the park – for just £125 per name.

▼ Peek behind the scenes of Stanley Spencer's world in Berkshire

Various locations in Berkshire, UK

stanleyspencer.org.uk

Exploring the locations that have inspired an artist's oeuvre are always interesting, particularly when they're in as pretty a place as the Berkshire village of Cookham, where Sir Stanley Spencer lived for most of his life, painting many of the village's features and surrounding countryside. It's huge fun to wander, finding the spots from which he painted works like *Cookham Moor* (1937) and *The Angel Cookham Churchyard* (1934) and visiting the excellent Stanley Spencer Gallery, an appealing nineteenth-century chapel located in Cookham High Street. The gallery has a booklet detailing three Spencer discovery walks of between 30 and 90 minutes, and its permanent and temporary exhibitions are a must for any fans of the artist.

Henry Moore House, Studios & Garden

Dane Tree House, Perry Green, Hertfordshire SG10 6EE, UK
henry-moore.org

BELOW The treasures that can be found inside Henry Moore's Top Studio.

RIGHT The Marianne North Gallery at Kew Gardens.

▼ Immerse yourself in the world of Henry Moore

Hoglands, Henry Moore's home for more than forty years, is delightfully small-scale and domestic, so there's a real sense of the man himself in the rooms. Many of Henry's and his wife Irina's possessions remain – it's as though they've just left the room; you can only visit the house on a small guided tour, so the intimacy is preserved. No booking is required for the studios and garden, and you're free to wander the ample grounds. It's fascinating to see the hundreds of maquettes in his studios, and then view the full-scale sculptures outdoors. One final treat – in the sixteenth-century Aisled Barn are a set of unique tapestries, based on drawings by Moore.

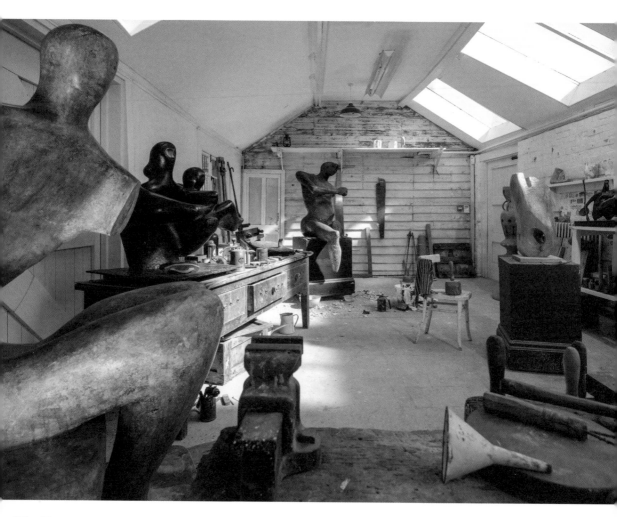

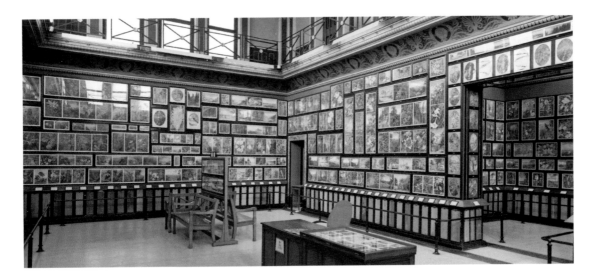

Find medieval romance in Birmingham

Birmingham Museum & Art Gallery

Chamberlain Square, Birmingham B3 3DH, UK
birminghammuseums.org.uk/bmag

The industrial heart of Midlands manufacturing may seem an incongruous place to uncover a romantic, mystical world inspired by nature and legend, but Birmingham's municipal art gallery boasts the largest collection of Pre-Raphaelite art in the world, from paintings, tapestries and drawings to stained glass, ceramics and furniture. With love lives as colourful as their depictions of flame-haired temptresses in medieval dress and knights in shining armour, the Pre-Raphaelites and their followers – the 'Brotherhood' was founded in 1848 by the artists John Everett Millais, William Holman Hunt and Dante Gabriel Rossetti – revolutionized the Victorian art world. Look out for Rossetti's *Proserpine* (1874, modelled on his muse and lover Jane Morris, wife of wallpaper maestro William) and work by Birmingham-born Edward Burne-Jones. Burne-Jones also designed the fine set of stained-glass windows in the city's cathedral, just around the corner from the museum.

▲ Travel the world in Kew Gardens

Marianne North Gallery

Royal Botanical Gardens Kew, Richmond, London TW9 3AE, UK
kew.org/kew-gardens/whats-in-the-gardens/marianne-north-gallery

Nothing can prepare you for what lies behind the façade of the colonial-style building that is the Marianne North Gallery in London's Kew Gardens. Named after the redoubtable nineteenth-century botanical artist, and designed at her behest by architectural historian James Ferguson, the double-height, light-filled space is stuffed to the gills with 832 of her paintings and some 200 timber samples she collected while travelling five continents. Packed together and beautifully offset by the elaborate wood-filled and tiled interiors, the works and panels combine to create a virtually solid wall of extraordinary images: here a view of swaying papyrus plantations or a colony of butterflies on a Brazilian palm leaf, there a landscape view of Mount Fujiyama framed by a climbing wisteria, alongside a scene of vegetation on the hills near the Papandayan volcano in Java. It will take your breath away, while simultaneously transporting you thousands of miles.

Autograph Gallery

Rivington Place, London
EC2A 3BA, UK
autograph.org.uk

Sign up for the Autograph experience

Describing itself as dedicated to sharing 'the work of artists who use photography and film to highlight issues of identity, representation, human rights and social justice', this modern, luminous David Adjaye-designed space in the heart of the creative hub of Shoreditch is always a sure bet for an exhibition that will leave you asking questions and wanting to know more about its themes and artists. The focus is very much on promoting the work of black and minority ethnic (BAME) artists, and most exhibitions feature a wide range of activities and events aimed at all ages, many of which are free.

The Royal Academy of Arts

Burlington House, Piccadilly,
London W1J 0BD, UK
royalacademy.org.uk

See art get democratic at the Royal Academy Summer Exhibition

The Royal Academy describes its annual Summer Exhibition as the world's oldest open submission exhibition – meaning that anyone can enter a work for consideration by the distinguished committee of Royal Academicians. The show has grown from the 136 works it comprised in its inaugural 1769 event to more than 1,000 paintings, prints and sculptures covering the walls and floors of the Royal Academy, chosen from a submission that is substantially larger than it was 250 years ago. One of the great joys of the exhibition is seeing work by one of contemporary art's greats, maybe Tracey Emin or David Hockney, alongside that of an unknown. The show is curated by an established art name each year – including in recent years Grayson Perry and Yinka Shonibare – adding to the excitement that surrounds selection.

Frieze Sculpture/Art Fair

Regent's Park, London, UK
frieze.com

Warm to the Frieze art party and sculpture trail

The annual art circus that is London's Frieze was opened in 2003 as a high-end event in a tent in Regent's Park aimed at selling artwork. Almost two decades on it attracts up to 100,000 visitors, drawn by a carnival atmosphere that's akin to Glastonbury filled with art and celebs rather than music and celebs. It's a lot of fun, but even more fun is Frieze Sculpture. This Instagrammer's paradise sees twenty-five pieces of outdoor art dotted across the park from July to early October, delighting groups of Londoners with an emphasis firmly on the playful yet insightful – like Brazilian artist Vik Muniz's full-size reproduction in 2019 of a 1973 Jaguar E-Type Matchbox toy car, complete with dents and chipped paint. With a selection policy that seeks out the humorous, the political and the downright fun, it's a perfect pop of culture on a sunny day.

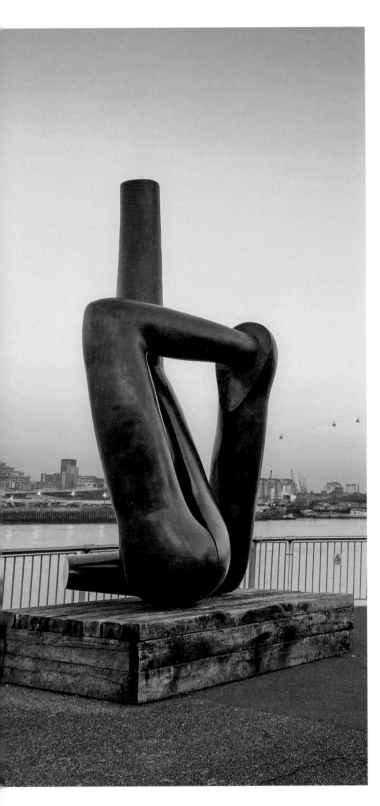

◀ Exercise body and mind with an art walk along London's Line

The Line

London, UK
the-line.org

Many towns and cities offer art trails that show famous views painted by artists or the sites of famous artworks, but in the London Line art walk, you actually get to walk a trail featuring original site-specific pieces meant to connect you with not just your immediate surroundings but also the site's history. The route runs between the Queen Elizabeth Olympic Park and the O2, following the waterways and the line of the Meridian, with artists such as Antony Gormley, Gary Hume and Richard Wilson delivering works that covertly or overtly reference their locations. Alex Chinneck's 35-m/115-ft high *A Bullet from a Shooting Star* (2015), for example, an upside down electricity pylon balancing on its tip as though shot down from the sky, alludes to the literally powerful past of the Greenwich Peninsula, and all the works tell fascinating stories about the little bit of London they occupy.

LEFT *Liberty Grip* (2008) by Gary Hume on Greenwich Peninsula, part of London's art walk, The Line.

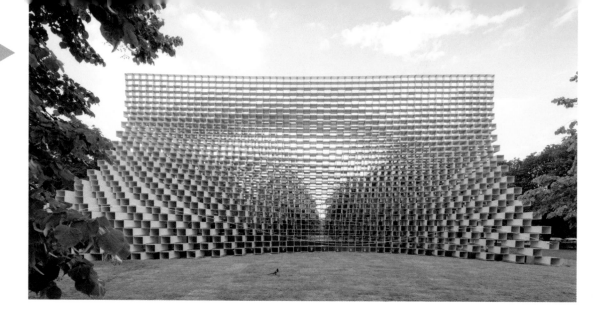

▲ See stunning structures come and go in Hyde Park

Serpentine Pavilion

Kensington Gardens, Hyde Park,
London W2 3XA, UK
serpentinegalleries.org

Each summer, the Serpentine Gallery commissions a temporary pavilion next to its permanent space in Hyde Park. Because it's temporary, the structure offers architects a great opportunity to play with light, shape and form while not being tied down by the constraints of a permanent structure, and unsurprisingly, they take to it like ducks to water. The very first one in 2000 set the bar high with Iraqi-British architect Zaha Hadid, and it has gone on to include some of the world's most gifted architects, among them Brazilian Oscar Niemeyer and Polish-American Daniel Libeskind in the early years, and more recently Mexican Frida Escobedo and Japanese Junya Ishigami. Each pavilion exists for just three months as an events space, but it is really an excuse for architects to express themselves as artists, with a great degree of freedom and experimentation encouraged (albeit with a limited budget) for its execution. The result is never less than fascinating.

Go beyond your comfort zone on a very different kind of art tour

Uncomfortable Art Tours

London, UK
theexhibitionist.org

Alice Procter is a woman with a mission. That mission is to call out some of our most venerated galleries and museums on how they acquire, display and contextualize their artworks. On her Uncomfortable Art Tours, held at London's National Gallery, National Portrait Gallery, British Museum, Victoria and Albert Museum, Tate Britain and Queen's House (part of the National Maritime Museum), she leads small groups around a selection of works, raising questions about Britain's ongoing inability to deal with its colonial past and reframe the relationship between our major art institutions and their roots and sponsorship. Whether examining such issues as the provenance of the work, the representation of key political figures, caption descriptions, positioning of the works in the spaces, portrait compositions or the funding of the spaces in relation to some of the works on display, Procter offers a fascinating and refreshingly different art tour.

Notre Dame de France

5 Leicester Place, London
WC2H 7BX, UK
ndfchurch.org

LEFT The 2016 design of the Serpentine Pavilion by Bjarke Ingels Group.

BELOW *The Crucifixion* (1960) by Jean Cocteau, in the Notre Dame de France.

▼ Be drawn into an outsider's view of the Crucifixion

In 1959 the creative polymath Jean Cocteau was asked to paint a series of murals for the rebuilt church of Notre Dame de France in London's raffish Soho area. The opium addict, homosexual, poet and filmmaker was also a Catholic, and it is this dichotomy which make the murals unique. In the frenzied nine days it took him to paint the trio of works, the strange frizzy-haired little avant-garde Frenchman was followed by an uptight British press who wrote about how he would talk to his creations – the Annunciation, the Crucifixion and the Assumption. The depiction of the Crucifixion is unique for *not* depicting Christ or, at least, only showing his bleeding (some say weeping) feet. When he finished the commission, Cocteau said he was sorry to leave the wall of that chapel that had 'drawn me into another world'.

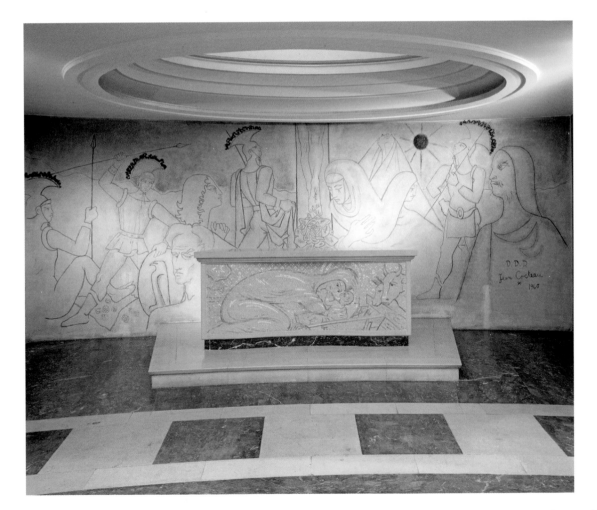

Tramshed

32 Rivington Street, London
EC2A 3LX, UK
*hixrestaurants.co.uk/
restaurant/tramshed*

ABOVE *Cock and Bull* (2012)
by Damien Hirst on display
at Tramshed.

RIGHT Admiring *Crossing the
Brook* (exhibited 1815) by
J.M.W. Turner at Tate Britain.

▲ Relish art that's jumped from the frying pan into the formaldehyde

Tramshed owner/chef Mark Hix once said: 'More people go through a restaurant in one day than might go through a gallery in a week.' In Tramshed, a casual chicken-and-steak restaurant, Damien Hirst's site-specific work, *Cock and Bull* (2012), is at the very least questionable. Part of Hirst's *Natural History* series of preserved animals, *Cock and Bull* depicts just that: a cockerel standing on a Hereford cow, pickled in formaldehyde and displayed in a monumental steel and glass tank suspended over diners' heads as they tuck in to … cock and bull. According to Hix, the cow was on its way to the slaughterhouse before being plucked out of obscurity to star in a multi-million pound work of art. The irony of the piece doesn't end there, as Tramshed also has a Hirst painting on display called *Beef and Chicken* (2012) depicting … well, we'll let you guess.

▲ Take a turn in Turner's world at Tate Britain

Tate Britain

Millbank, Westminster, London SW1P 4RG, UK
tate.org.uk/visit/tate-britain

Seen from the point of view of twenty-first-century art, it is hard to understand why the chocolate-box artworks of J.M.W. (Joseph Mallord William) Turner caused such a brouhaha in the late eighteenth century. To put the painter's loose brushwork and vibrant colours into context, and to see just how much they challenged the classical works of the Old Masters and prevailing style of the period in which Turner worked, you need to head to Tate Britain's Clore Gallery, home to the world's largest collection of his work. Here, changing displays encompass some of his greatest masterpieces – among them *Peace – Burial at Sea* (1842) and *Norham Castle, Sunrise* (1845). And while you're here, don't miss work by other game-changing and world-renowned British artists, including Francis Bacon, Sir John Everett Millais, L.S. Lowry, David Hockney, Chris Ofili, Bridget Riley, William Blake, Lucien Freud, Walter Sickert and Gilbert & George.

Find earthly delights with the help of Artangel

Various locations around London and beyond

artangel.org.uk

Artangel's motto is 'extraordinary art, unexpected places'. It is a bold claim, but one the arts organization has successfully achieved in more than its thirty years across site-specific projects in which Artangel has taken over empty prisons, abandoned post offices and even the inside of a Scottish mountain, made sculpture from solid air, and commissioned both a mile-high column of light and a thousand-year-long piece of music. Artists who have worked with Artangel read like a *Who's Who* of contemporary culture, among them P.J. Harvey, Laurie Anderson and Brian Eno, Rachel Whiteread, Steve McQueen and Matthew Barney. Some of the work is temporary, and much of it is in London (Roni Horn's *Library of Water* in Iceland is a notable exception – see page 84). Check the website if you're visiting the capital to see if anything is on. Whatever it is, it will almost certainly be extraordinary art in an unexpected place.

▶ Let your imagination take flight in the soaring space of Tate Modern's Turbine Hall

Tate Modern

Bankside, London SE1 9TG, UK
tate.org.uk/visit/tate-modern

When Tate Modern joined London's respectable pantheon of art galleries in 2000, its astonishing Turbine Hall played a large part in the favourable reviews of the transformation of the Bankside Power Station. At five storeys and with 3,400 m²/36,597 ft² of floorspace, it can accommodate installations and artworks that would be impossible to see in many other art galleries, and from its first exhibition, Louise Bourgeois' *I Do, I Undo, I Redo* (2000), artists have responded to it with inventive and imaginative commissions that have totally engaged audiences. Olafur Eliasson's *Weather Project* (2003–04), Carsten Höller's *Test Site* slides (2006–07), Miroslaw Balka's *How It Is* (2009) and Kara Walker's monumental *Fons Americanus* (2019) are just some of the shows that have wowed over 60 million visitors, but whatever you see will stay with you.

RIGHT Carsten Höller's *Test Site* (2006–07) in the Tate Modern Turbine Hall.

Sketch

9 Conduit Street, Mayfair,
London W1S 2XG, UK
sketch.london

▼ Take afternoon tea from a Shrigley at Sketch

Pretty in pink does not begin to describe the interior design of the ritzy Sketch tearoom and bar. Designed by India Mahdavi, it's as plush and sumptuous as you'd expect from a Michelin star-awarded space set across two expansive floors of a converted eighteenth-century building in the exclusive neighbourhood of Mayfair. But perhaps what you might not expect is the Gallery, which since its inception has featured a number of colourful artworks by David Shrigley. In its latest iteration, the acclaimed British artist has not only replaced his original 239 monochrome drawings on the walls of the restaurant with ninety-one colourful works, but added new ceramic tableware featuring his distinctive drawings and text in what has been described as a holistic interaction with chef Pierre Gagnaire's food. So if you're after a rare chance to sample a spot of site-specific sculptural art from which you can eat and drink, you know where to go.

BELOW David Shrigley artwork adorning the walls at Sketch.

Tate Modern

Bankside, London SE1 9TG, UK
tate.org.uk/visit/tate-modern

See Rothko's Seagram murals at Tate Modern

Tate Modern has many, many excellent rooms of art in which one could spend hours, if not days, but set yourself down in the so-called Rothko room and you can imagine immersing yourself in the nine artworks here for all time – which is exactly what the artist Mark Rothko intended, apparently creating the paintings – which were influenced by Michelangelo's Laurentian Library in Florence – as meditative objects of contemplation. In that respect, they're much better seen here, in a purposely built space, than their originally planned home of the Four Seasons restaurant in the Seagram Building on Park Avenue, New York, for which they were commissioned in the late 1950s.

Somerset House

Strand, London WC2R 0RN, UK
somersethouse.org.uk

Marvel at a Thames-side mini art tour

First-time visitors to the Courtauld Gallery are often astonished by the wealth of work on show here by A-list artists spanning half a millennium. Its collection is like a mini art tour through the modern era of art history, stretching from the early Renaissance into the twentieth century and taking in some of the world's most famous paintings, including an unrivalled collection of Impressionist and Post-Impressionist work. The largest collection of Cézannes in the UK is held here, and dotted among them are Edgar Degas, Claude Monet, Thomas Gainsborough, Peter Paul Rubens, Sandro Botticelli, Amedeo Modigliani, Francisco Goya … and all set across a beautiful eighteenth-century building on the banks of the Thames. And following a multi-million pound transformation, on reopening it's set to show an even greater variety of works from its collection.

Farleys House & Gallery

Farley Farm, Muddles Green, Chiddingly, East Sussex BN8 6HW, UK
farleyshouseandgallery.co.uk

Get a snapshot of life with Lee Miller

Everyone knows Lee Miller the war photographer, the model, the muse of Man Ray. But here in an everyday East Sussex countryside house, visitors are treated to a different side of Lee Miller – perhaps Lee Miller the whole. For this was the home she set up with the artist and art collector Roland Penrose in 1949, and where over the following thirty-five years the pair welcomed visitors from the upper echelons of the creative world – among them Leonora Carrington, Antoni Tàpies, Pablo Picasso, Max Ernst, Joan Miró and Man Ray. Works by many of them are still to be found in the eclectic, colourful rooms and gallery that make up Farleys, which is also the base of the Lee Miller Archives and The Penrose Collection. Book ahead to take a tour, and visit in the summer to enjoy a picnic in the sculpture garden.

Tour the art in Chichester Cathedral

Chichester Cathedral

The Royal Chantry, Cathedral Cloisters, Chichester, West Sussex PO19 1PX, UK
chichestercathedral.org.uk

Like most cathedrals, Chichester boasts historic carvings, paintings and stained glass, but it also holds some spectacular works of modern art, mainly thanks to the vision of Walter Hussey (Dean of Chichester 1955–77, who left his private collection to the city's Pallant House Gallery). Highlights include Graham Sutherland's striking painting *Noli Me Tangere* (1961) and Patrick Procktor's *Baptism of Christ* (1984), while some of the best stained glass here is twentieth century – *St John the Baptist* (1952) by Christopher Webb and, most gloriously, Marc Chagall's vivid interpretation of *Psalm 150* (1978). Equally eye-catching is the huge tapestry behind the high altar, designed by John Piper in 1966. To add to the embarrassment of riches, there's a Roman mosaic floor (under glass on the south aisle) and the medieval Arundel Tomb, which holds the carved figures of the Earl of Arundel and his wife, holding hands, and was the poignant inspiration for Philip Larkin's poem 'An Arundel Tomb' of 1956.

Bask in the glow of first-class sculpture lit by the unique light of Cornwall

The Barbara Hepworth Museum and Sculpture Garden

Barnoon Hill, St Ives, Cornwall TR26 1AD, UK
tate.org.uk/visit/tate-st-ives/barbara-hepworth-museum-and-sculpture-garden

A visit to the Barbara Hepworth Museum and Sculpture Garden is a unique opportunity to examine the life and work of one of Britain's supreme sculptors of the twentieth century. Hepworth lived and worked in Trewyn Studio from 1949 until her death in 1975, and there is an eerie sense of work waiting for her return alongside a collection that comprises some of her own personal favourite pieces. She first came to live in Cornwall with her husband, the painter Ben Nicholson, and their young family at the outbreak of the Second World War in 1939, and said: 'Finding Trewyn Studio was a sort of magic. Here was a studio, a yard and garden where I could work in open air and space.' The placement of work in the garden is pretty much as Hepworth left it, while the garden was designed by the artist with help from her friend, the South African composer Priaulx Rainier.

RIGHT Part of the decorated ceiling fn the Watts Chapel.

Uncover a Chagall masterpiece in a tiny Kentish church

All Saints' Church

Tudeley, Tonbridge, Kent TN11 0NZ, UK
tudeley.org

All Saints' Church in Tudelely, near Tonbridge in the county of Kent, has the distinction of being the only church in the world whose stained-glass windows are all by Marc Chagall, and the contrast between the humble church and the rich European modernism of the artist's swirling blues and golds is unmissable. The twelve hauntingly beautiful windows were brought about by the tragic death in 1963 of a young modern art lover, Sarah d'Avigdor-Goldsmid, whose parents commissioned the artist to design the large east window as a tribute to their daughter. Arriving at the medieval church in 1967 to install the window, Chagall apparently said, 'It's magnificent. I will do them all'. Sitting in this very little special church almost 60 years later to experience his vibrant colours and scenes filled with angels, mules, birds and horses, all traditional Chagall tropes of hope and joy, is magical.

▼ Meet George and Mary Watts in a Surrey village

Watts Gallery & Watts Chapel

Down Lane, Compton, Surrey GU3 1DQ, UK
wattsgallery.org.uk

Victorian artists G.F. (George Frederic) Watts and his wife Mary are brilliantly brought to life by a visit to Compton, the Surrey village where they lived and worked. He was a force of nature, a painter and sculptor nicknamed 'England's Michelangelo' who was keen to convey a moral or spiritual message in his work. In 1886 he married the much younger but similarly minded sculptor Mary Fraser-Tytler, who created the unique brick Arts and Crafts chapel, a small gem packed with symbolic meaning and hand-crafted details. Both artists are buried in the churchyard, near an Italianate red brick cloister of Mary's designing. The Watts Gallery has examples of drawings, paintings and sculptures from throughout George's long life, and an evocative recreation of his studio. There's also space devoted to Mary, notably an altarpiece she made for the military hospital in Aldershot. For full immersion, book a tour of Limnerslease, their Arts and Crafts home.

▶ Be transported to another world in São Bento station

São Bento train station

Praça de Almeida Garrett, 4000-069
Porto, Portugal
introducingporto.com/sao-bento-railway-station

Public transport hubs are wonderful places to find art contextualized in its environment, but not that many attempt to convey the entire history of their country. Welcome, then, to Porto's stunning São Bento station, where some 20,000 blue-and-white *azulejo* tiles do just that. Designed by architect José Marques da Silva in the Beaux Arts style in 1903, the architecture of the station itself is a treat, but it's the main hall tiles and large-scale panels of master tile painter Jorge Colaço, who worked on the station between 1905 and 1916, that are the true art here. Enter and be enthralled.

RIGHT *Azulejo* tiles depicting scenes of the history of Portugal in the São Bento train station.

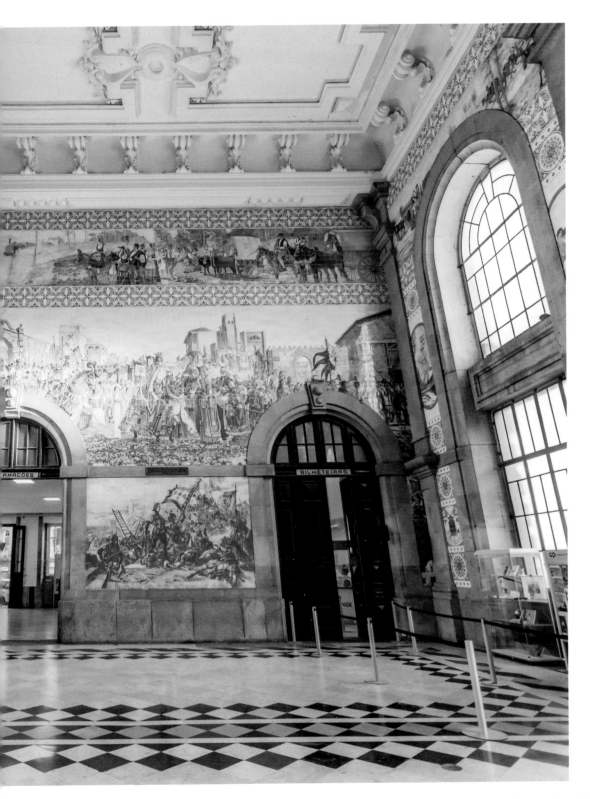

Casa das Historias Paula Rego

Avenida da República 300, 2750-475 Cascais, Portugal
casadashistoriaspaularego.com

Explore a rare female-focused art space in Portugal

The number of spaces dedicated exclusively to women artists can probably be counted on fewer than ten fingers, so it is a measure of the strength of Paula Rego that she is one of them. Spanning half a century of her output via a broad-ranging selection of paintings, drawings and etchings produced on a variety of media and using a wide range of techniques, the collection here clearly illustrates the constantly enquiring mind of this most prolific and fascinating artist. The etchings and drawings number more than 500, but it is the twenty-two paintings, loaned by the artist and spanning the 1960s through to the 1990s, that are the most arresting, from the darkly disturbing *Order Has Been Established* (1960) and *When We Had a House in the Country* (1961) to the absorbing *Operas* series (1982–83) and vibrant *Vivian Girls in Tunisia* (1984).

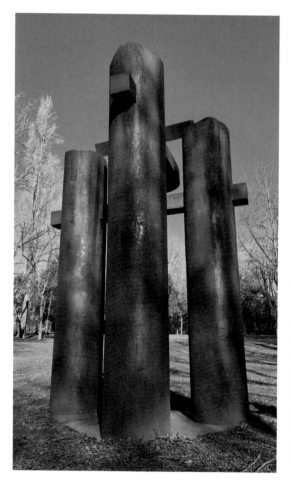

◀ Enjoy the elemental works of Basque sculptor Eduardo Chillida

Chillida Leku

Barrio Jauregui 66, 20120 Hernani, Spain
museochillidaleku.com/en/museo/el-jardin

The abstract steel and granite works of much-loved Basque sculptor Eduardo Chillida can be found in galleries as far afield as Berlin and Helsinki, Dallas and Doha, but are undoubtedly seen at their best here in this 11-hectare/27-acre outdoor museum. Amid rolling open parkland, fields and woodland surrounding a sixteenth-century Basque farmhouse, forty-three large-scale works can be touched, explored inside and out, and viewed against the expansive backdrop of the open skies and horizon – a relationship that emphasizes the natural elements and material of the artworks, each of which have a QR code so that visitors can learn more about them. Carefully selected works by guest artists such as Louise Bourgeois and Louis Kahn add to the appeal, which is capped by the hilltop farmhouse housing temporary exhibitions by Chillida and other artists.

Sorolla Museum

Paseo del General Martínez Campos 37, 28010 Madrid, Spain
culturaydeporte.gob.es/ msorolla/inicio

▲ Take an intimate look at a Spanish Impressionist at the Sorolla Museum

The home of Joaquín Sorolla – from 1911 until his death in 1923 – is now the perfect setting for a museum dedicated to the 'master of light'. The handsome rooms are a decent enough size to show off the Impressionist paintings to their best advantage, but not so big as to be soulless, and there is a genuine sense of domestic life. Many of the portraits feature Sorolla's wife and children, and much of the decor remains the same as when the family lived here. His studio is particularly impressive, a large, atmospheric room filled with paintings and the tools of his trade, and with the walls the same dark red as in Sorolla's day. The paintings are beguiling – *Strolling Along the Seashore* (1909) is pure sunshine and joy – but it's the setting you'll remember.

LEFT *Forest V* (1997) by Eduardo Chillida at Chillida Leku.

ABOVE Joaquín Sorolla's studio with *Strolling Along the Seashore* (1909) shown centre on the facing wall.

TRAIL: Velázquez in Spain

Spain's painters are among some of the most famous in the world, with Picasso undoubtedly the most famous of them all. But an earlier Spanish artist, the 'painter's painter', as Manet described him, was referenced numerous times by Picasso, who recreated many of his works. That painter is Spain's Golden Age maestro Diego Velázquez, whose *Las Meninas* (1656) is one of the country's most famous paintings. He is estimated to have only produced 110–120 paintings in his lifetime; below are some of the best, found in locations that take you on a fantastic Spanish treasure hunt.

Madrid

All the big-hitters are here in Spain's capital, with the Prado housing *Adoration of the Magi* (1619), *Las Meninas* (1656) and *The Triumph of Bacchus* (1626–28) amid a fine selection of the royal and commoner portraits for which Velázquez was so fêted, including Felipe IV, Mariana of Austria and an unnamed Apostle. Elsewhere in the city, the Thyssen-Bornemisza Museum has another Mariana of Austria and the Royal Palace houses the fine *Caballo Blanco* (c. 1650) and *El Conde-Duque de Olivares* (c. 1636). Some 50 km/31 mi away from the capital, the Monastery of San Lorenzo de El Escorial contains *Joseph's Tunic* (1630).

Seville

Velázquez was born in Seville, which owns, in the Museum of Fine Arts, the eloquent portrait of Don Cristóbal Suárez de Ribera, painted two years after the sitter's death if the painting's date of 1620 is correct. And at the city's Velázquez Centre, *Santa Rufina* (c. 1629–32) is an absolute must-see. Sadly, the *Waterseller of Seville* (1618–22) isn't in Seville, but at Apsley House in London.

Valencia

Despite Velázquez's fame as a leading portrait artist in the court of King Philip IV, the Baroque painter didn't produce many self-portraits. A notable one, however, can be found in the Museu de Belles Arts de València, which illustrates just why his artwork became a model for nineteenth-century Realists and early Impressionists.

ABOVE Diego Velázquez artworks displayed in the Prado, Madrid.

Barcelona

Velázquez was known as much for his religious paintings as his royal ones, and aside from the great examples to be found in Madrid, there's a wonderfully luminous one of San Pablo in the Museu Nacional d'Art de Catalunya.

Toledo

The stunning Cathedral Treasure-Museum here does not stop at Velázquez; it also houses works by, of course, El Greco, along with Francisco Goya, Titian, Raphael, Anthony van Dyck, Giovanni Bellini and Jusepe de Ribera. Packed together in a poorly lit sacristy, the artistry of the work can be hard to appreciate, but the power is undiminished.

Orihuela

In a sixteenth-century building in the small town of Orihuela near Alicante, the Diocesan Museum of Religious Art has something rather special. *The Temptation of St Thomas Aquinas* (1632) by Velázquez exhibits many of his technical skills, notably in depicting the saint's harrowing struggle against temptation and a fine creation of space in the composition.

OVERLEAF ▶
Detail of *Las Meninas* (1656)
by Diego Velázquez.

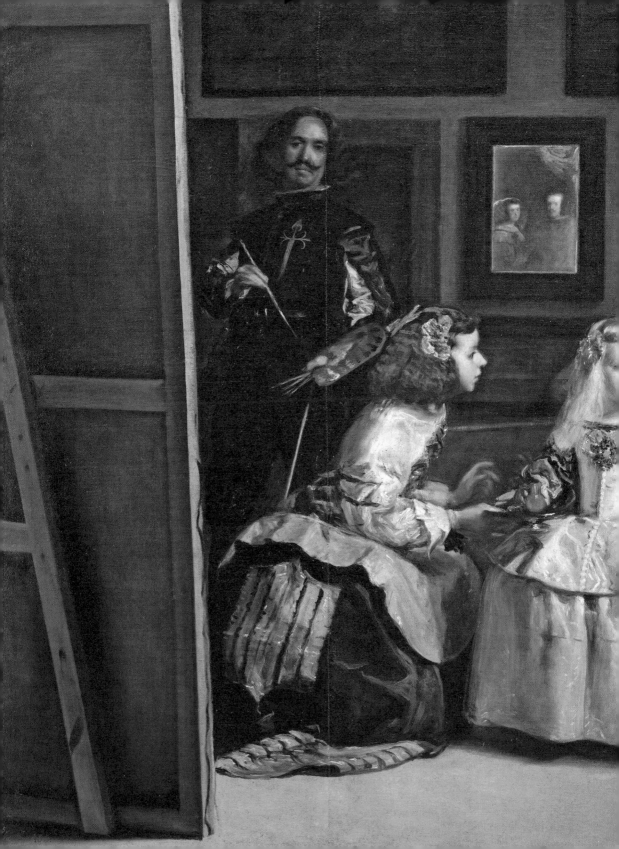

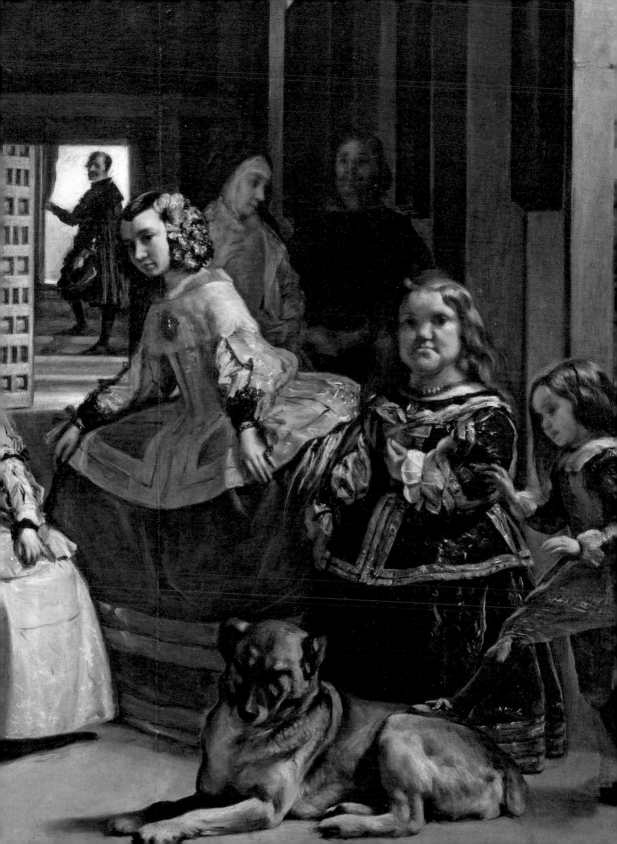

Find darkness and light in the Museo del Prado

Museo del Prado

Paseo del Prado, Madrid, Spain
museodelprado.es

Housed in a neoclassical building which opened as a museum of painting and sculpture in 1819, Madrid's – and indeed Spain's – foremost museum and art gallery is a beauty outside and in, where curated galleries house leading works by every Spanish artist of note, including El Greco, Diego Velázquez, Francisco de Zurbarán, Jusepe de Ribera and, best of all, Francisco Goya. All fourteen of the artist's disturbing Black Paintings (c. 1820–23) – actually painted as murals on the walls of his house – are displayed here; an intense collection that clearly illustrates the darkness felt by the ageing Goya in the wake of the Peninsular War (1804–14) and the horrors he'd witnessed during it. Panic, terror, fear, hysteria and bleak despair are all visible in these works, which take in the likes of the particularly horrific *Saturn Devouring His Son* and *Two Old Men Eating Soup*, an almost cartoonish meditation on greed and hunger. After seeing them, cheer yourself up with Velázquez's *Las Meninas*.

▼ Take a mind-trip into the head of Salvador Dalí

Dalí Theatre and Museum

Plaça Gala i Salvador Dalí, 5, 17600 Figueres, Girona, Spain
salvador-dali.org

The madness begins outside with giant eggs perched on top of red towers and baguette-headed statues on balconies welcoming visitors to the out-there universe of the most famous Surrealist artist in the world, Salvador Dalí, conceived and designed by Dalí himself in 1968. Inside, the world's largest collection of the moustachioed marvel include a large naked woman in Roman headdress posing stiffly on the hood of a classic car, a room paying homage to Mae West as a liveable apartment, and downstairs in the crypt, the artist himself. In total, around 1,500 of Dalí's works are housed here, making it the place to perhaps gain the best insight and understanding into the mind of this most imaginative artist. About 20 km/12½ miles away, his equally offbeat home and workshop at the coastal village of Portilligat are well worth a visit as well.

RIGHT Dalí Theatre and Museum with its large eggs on the parapets.

FAR RIGHT The Guggenheim Museum Bilbao building illuminated at night.

▲ Bask in the glow of Gehry's Guggenheim

Guggenheim Museum Bilbao

Abandoibarra Etorb. 2, 48009 Bilbao, Spain
guggenheim-bilbao.eus

King Juan Carlos I of Spain called Frank Gehry's Guggenheim Museum 'the best building of the twentieth century' when he inaugurated it on 18 October 1997, and more than two decades later it has stood the test of time so well that it's hard to disagree with him. Inside, the works are as impressive as you would expect from a Guggenheim collection, with installations such as Christian Boltanski's *Humans* (1994) using the curving spaces to great effect. However, it's the outdoor works that stay with you; though vastly different, *Maman* by Louise Bourgeois (1999) and *Puppy* by Jeff Koons (1997) interact beautifully and contrast starkly with the flowing titanium lines of the museum behind them. *Maman's* 9-m/30-ft high spider of bronze, marble and stainless steel menaces the building as though ready to pounce on it, while Koons's *Puppy*, an enormous terrier carpeted in bedding plants and flowers, simply wants to make you smile. A lot.

See the spiritual meet the historical in Toledo

Iglesia de Santo Tomé

Plaza del Conde 4, 45002 Toledo, Spain
toledomonumental.com/santo-tome

Thousands of churches are adorned with religious works, and many of the unmissable ones are included in this book, but perhaps if we only had time to see one, it would be El Greco's *Burial of Count Orgaz* (1586–88) in the Iglesia de Santo Tomé in Toledo. The massive sixteenth-century painting is universally regarded as El Greco's greatest masterpiece, exhibiting at its best the Mannerist's fluid distortions of the body and ability to imbue the complex composition's characters with emotional complexity. You'll find plenty of other El Grecos in Toledo, but the depth of detail in a work that juxtaposes so eloquently the ethereal heaven with the more naturalistic Earth could keep you enthralled for hours. Follow the fingers of El Greco's son, Jorge Manuel, to the left of St Stephen and feast your eyes.

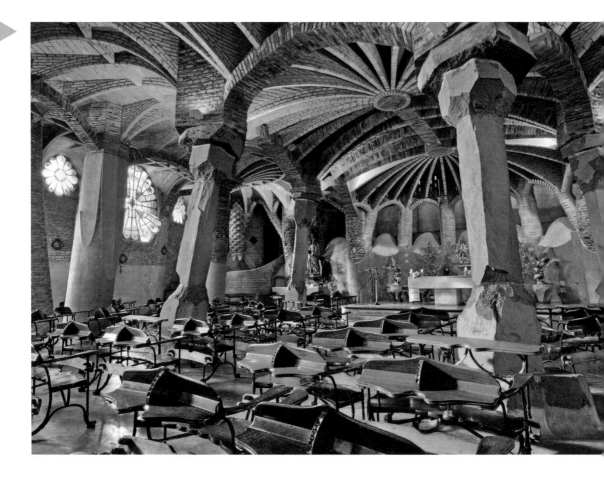

Colònia Güell

Carrer Claudi Güell, 6,
08690 Santa Coloma de
Cervelló, Barcelona, Spain
gaudicoloniaguell.org

ABOVE Colònia Güell church,
designed by Antoni Gaudí.

RIGHT Park Güell bench,
designed by Antoni Gaudi

▲ Find the foundations of the Sagrada Família in Colònia Güell

Antoni Gaudí's relationship with Barcelona is well documented, but to really understand how the man arrived at his unique visions, a trip to nearby Santa Coloma de Cervelló is a must. It is here, at the workers' colony of Colònia Güell, that he created the Crypt of Colònia Güell, an extraordinary work-in-progress model for the Sagrada Família, and just one part of a radical model for living conceived by the industrialist and philanthropist Eusebi Güell, who in 1890 reinvented the then-popular idea of rural and suburban workers' settlements with his own workers' colony. As a supporter of the Catalan Modernist movement, Güell asked his friend Gaudí to work on the colony's church, and the architect and artist proceeded to create many of the distinctive elements later incorporated into the more famous Sagrada Família, including leaning pillars and catenary arches, as well as the use of organic shapes and symbolism.

▶ Explore Europe's most surreal housing development at Park Güell

Park Güell

08024 Barcelona, Spain
parkguell.barcelona

On a sunny day in Barcelona, one of the loveliest things to do is to make your way to Park Güell on Carmel Hill, to be greeted by the colourful mosaic salamander El Drac – the dragon. This guardian to the park perfectly sets up what is to come, namely the fluid, organic forms of Antoni Gaudí set across a public park opened in 1926. Conceived by philanthropic businessman Eusebi Güell and Gaudí as a housing park along the lines of England's Garden Cities, it was meant to contain high-quality, high-tech homes with an artistic touch, but two show homes failed to find buyers and the park became what it is today. The jaw-dropping main terrace, with its sinuous serpent, is a lovely place from which to contemplate the surrounding gardens and trees, but don't miss the colonnaded footpaths, tiled mosaics, terraces, dragon fountain and other forms dotted around this most unique park.

Fundació Antoni Tàpies

Carrer d'Aragó 255, 08007
Barcelona, Spain
fundaciotapies.org

Pass under a cloud of spun steel to enter the original world of Antoni Tàpies

Set in a beautiful red brick and iron building designed by Catalan Modernist architect Lluís Domènech i Montaner and topped in 1990 with what looks like a cloud of spun steel (actually a sculpture entitled *Núvol i Cadira (Cloud and Chair)* to bring the elevation of the former editorial publishing house in line with those of its neighbours), the Fundació Antoni Tàpies is a delight both inside and out. Created by the painter and sculptor Tàpies in 1984 and opened in 1990, it could feel like a very egocentric project, but work here (mainly, though not exclusively, paintings and sculpture by Tàpies) is presented and contextualized so well that it doesn't feel like it at all. The elegant Eixample district setting, including Antoni Gaudí's Casa Batlló just two minutes away, adds to the appeal.

▲ Take Le Voyage à Nantes to make old and new art discoveries

Nantes, France

levoyageanantes.fr/en

There is something rather lovely about discovering first-class art in what might mistakenly be thought of as a second-class art destination. For a city of fewer than 300,000 people, Nantes definitely punches above its weight in the art stakes, a situation brought about by Napoleon Bonaparte, who chose it as one of fifteen provincial places to be given a 'mini Louvre', the Musée d'Arts de Nantes, in 1801, since when it's taken its art very seriously. So seriously, in fact, that since 2012 it has been holding a contemporary art festival that takes over the city, with artists from across the globe creating site-specific installations in canals, squares, museums, parks, restaurants and shops for Le Voyage à Nantes (LVAN). With many of the installations left in place, it makes a visit to this first-class city a fun art discovery all year round.

Go dizzy for new art in an old rotunda

Bourse de Commerce–Pinault Collection

2 rue de Viarmes, 75001 Paris, France
boursedecommerce.fr/en

France hasn't seen any huge artistic refurbishments along the lines of François Mitterrand's twentieth-century *Grands Projets* since, well, those *grand projets*. That's all set to change with the opening of French billionaire art collector François Pinault's Parisian museum, housed in the wonderful former stock exchange building near the Louvre. As with the collector's two galleries in Venice (Palazzo Grassi and Punta della Dogana), the classical rotunda has been restored by Japanese architect Tadao Ando, who has created seven galleries inside, connected via a circular walkway for viewing the nineteenth-century internal façade. The plan is to hold around ten exhibitions each year drawn from a collection Pinault has been amassing for four decades, bolstered by star loans. With the likes of Damien Hirst, Takashi Murakami and Urs Fischer in the mix, the shows are likely to be every bit as popular as Mitterrand's Musée d'Orsay *Grand Projet*.

Musée de Cluny (Musée national du Moyen Âge)

28 rue du Sommerard, 75005 Paris, France
musee-moyenage.fr

LEFT *Résolution des Forces en Présence* (2014) by Vincent Mauger at the Place du Bouffay, for Le Voyage à Nantes.

BELOW *À Mon Seul Désir* from *The Lady and the Unicorn* tapestries.

▼ Get acquainted with *The Lady and the Unicorn*

The Lady and the Unicorn (La Dame à la Licorne) tapestries in the Musée de Cluny are some of the loveliest surviving artworks from the Middle Ages. There are six panels, five of them thought to cover the senses (sight, touch, taste, smell and hearing), and one that is harder to categorise: *À Mon Seul Désir* ('to my only desire' or 'my desire alone') shows the lady with a necklace, attended by a maidservant and flanked by the lion and the unicorn. The meaning of this panel has been much debated but remains unknown. Simply unravelling the iconography in the tapestries would take hours, but meaning apart, there is so much here to delight. In 'Sight', the lady is holding up a mirror so that the unicorn can see itself reflected; the animals, including rabbits, foxes, dogs and birds are beautifully rendered, and the backdrop of plants and flowers is exquisite.

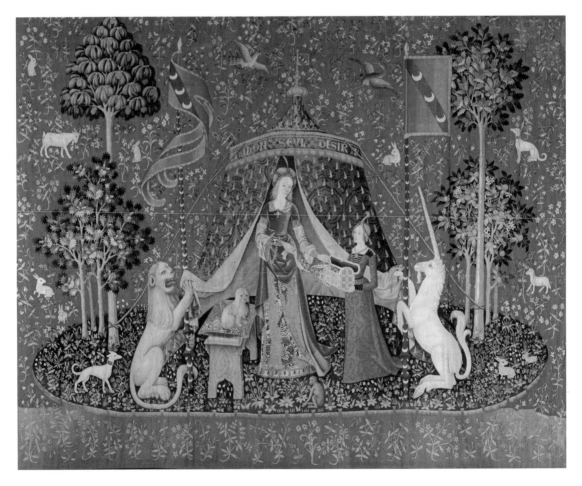

◀ Trip the light fantastic at the Atelier des Lumières in Paris

Atelier des Lumières

38 rue Saint Maur, 75011 Paris, France
atelier-lumieres.com

It is just one of fourteen spaces run by the dynamic and wildly successful Culture Spaces organization, but the Atelier des Lumières digital art museum is arguably the most popular and fun one. Don't take our word for it; since opening its doors in 2018, the restored nineteenth-century foundry has welcomed more than 1.2 million visitors a year. What do they come for? Arresting images old and new – from Vincent van Gogh and Gustav Klimt to new works by emerging digital artists – projected at more than 10 m/33 ft on to every available piece of floor and wall in the Hall of the Atelier, as well as immersive and interactive experiences in the studio and temporary spaces. The mix of such spectacular colours in such an architecturally mesmerizing space is unforgettable; mind-blowing doesn't begin to cover the effect.

LEFT Atelier des Lumières immersive exhibition featuring the work of Friedensreich Hundertwasser.

Opéra Garnier

Place de l'Opéra, 75009
Paris, France
operadeparis.fr/en/visits/
palais-garnier

▲ **Raise a glass to Chagall raising the roof**

Marc Chagall's 1964 redesign of the roof of Paris's Baroque opera house was announced in 1960. Conservatives responded with anger (and undertones of anti-Semitism) over the fact that a Russian émigré would touch a much-loved French icon. As a concession to this, Chagall announced he would not paint over the original roof, but rather cover it with a 242-m²/2,605-ft² canvas. Under constant attack, Chagall had to work on the canvasses in a secret location before assembling them at a military base under armed guard. His colourful masterpiece was a huge success and it quickly won over most of the doubters. He described the work as a representation of 'dreams and creations of actors and musicians' and did not ask for a single centime for the work, as it was his gift to Paris, where ironically he would always remain an outsider.

ABOVE Marc Chagall's frescoes, painted on the ceiling of the Opéra Garnier.

RIGHT The striking Louis Vuitton Foundation building.

▼ Be dazzled by the Louis Vuitton Foundation

Louis Vuitton Foundation

8 avenue du Mahatma Gandhi, 75116 Paris, France
fondationlouisvuitton.fr

Frank Gehry's striking building is as much a work of art as the pieces it contains – and there are some impressive artworks in this palace of curved glass. The evolving array of modern art is divided into four categories – Contemplative, Pop, Expressionist, Music and Sound – and ranges from paintings to film installations, soundscapes to sculpture. The soaring dimensions of the exhibition spaces mean that truly monumental works can be displayed here. Certain pieces have been commissioned for the foundation, including the colourful panels by Ellsworth Kelly that hang in the auditorium (music is a large part of the cultural offering). The art continues on the outdoor terraces, but here it has to compete with mesmerizing views across the Bois de Boulogne and beyond. The elements here – the park setting, the modern architecture and the art – are a potent combination, and leave a lasting impression.

Probably the best modern art collection in Europe? *Bien sur!*

Centre Pompidou

Place Georges-Pompidou, 75004 Paris, France
centrepompidou.fr

When Richard Rogers and Renzo Piano's multi-coloured, multi-cultural Centre Pompidou opened to the public in 1977, it was a revolution in art presentation and, indeed, with its inside-out design and colourful tubes for mechanical systems, architecture. Here was a radical new space, designed in a determinedly modern way, in which to fittingly display the largest collection of modern art in Europe, in the Musée National d'Art Moderne. More than forty years later it's not only stood the test of time but it's also become a national treasure, one housing a collection of 100,000+ works of art dating from 1905, including Fauvist, Cubist, Surrealist, Pop Art and contemporary works. Amid every big name from that period, perhaps *the* key piece to see is Marcel Duchamp's *Fountain*. Made in 1917, it caused as much of a revolution – this time in the perception and definition of art – as the Centre Pompidou would sixty years later.

▼ Make a case for cultural appropriation doing some good

Musée du Louvre

Rue de Rivoli, 75001 Paris, France
louvre.fr

More than 10 million people come through I.M. Pei's glass pyramid entrance to take in 2,500 years of human creativity (from the seventh century BC to the mid-nineteenth century) at this high church of art. Many head straight to big hitters like the *Mona Lisa* (c. 1503) and *Venus de Milo* (c. 100 BC), but among the 35,000-strong collection housed in the fortress and royal palace are many other standouts – among them Théodore Géricault's *The Raft of the Medusa* (1818–19), Titian's *Pastoral Concert* (1509) and Rembrandt's *Bathsheba at Her Bath* (1654). If we had to choose one work, though, the second-century AD double relief of a husband and wife from the Syrian site of Palmyra might be the one. While the practice of stealing antiquities from cultures unable to defend them is unacceptable, we must be grateful for the preservation of such astonishing objects, which will hopefully one day be returned to their native homes.

See art and commerce form a perfect union in Paris

Fondation Cartier pour l'art contemporain

261 boulevard Raspail, 75014 Paris, France
fondationcartier.com

You would expect a brand like Cartier to do art in an original and first-class way, and here in Jean Nouvel's airy, light-filled masterly architectural work, your expectations won't be disappointed. As with the building, the artworks housed within it are testament to how corporate patronage can be done really well, and whatever you see here will stay with you, partly for its content, but just as much for its presentation and design. Exhibitions, usually on for a few months, are mounted around individual artists or themes, and they're never less than sumptuous, whether a major retrospective of Malian photographer Malick Sidibé or an immersive experience such as *The Great Animal Orchestra*, inspired by the work of American musician and bioacoustician Bernie Krause. The foundation commissions work too, and puts on arresting touring exhibitions in innovative spaces that bear all the hallmarks of the home site's inventiveness.

LEFT One of the Palmyran treasures at the Louvre: a relief of Maliku and his wife Hadira (third century AD).

RIGHT Claude Monet's *Water Lilies* paintings curve around the walls of the Musée de l'Orangerie.

Musée de l'Orangerie

Jardin des Tuileries, Place de
la Concorde, 75001 Paris,
France
musee-orangerie.fr

▲ Float into a serene series of water lilies at the Orangerie

No art trip to Paris would be complete without a visit to the Musée de l'Orangerie in the corner of the Tuileries Gardens. The space, built in 1852 to protect the citrus trees of the garden in winter, now protects a number of other natural wonders, perhaps the most famous of which are the eight Claude Monet oil on canvas water lily murals displayed in two airy oval rooms lit by natural light from the skylights the artist insisted on. It is hard to convey the extraordinary beauty and impact of the panels – each 2 m/7 ft high and spanning 91 m/299 ft in length – which is why a trip here is so essential. Yes, go to Giverny to pay homage to the site of their creation, but here at the Orangerie, away from the teeming hordes and coachloads of tourists bustling around the gardens, you'll have an unforgettable art moment.

TRAIL: The many faces – and places – of Picasso

Pablo Picasso is unquestionably one of the most important artists in the history of Western painting. And thanks to his prolificity, his work can be enjoyed across the world. Here are some expected – and unexpected – places in which to enjoy it.

Musée Picasso

Paris, France

The big one, with more than 5,000 works housed in a magnificent Marais mansion. There are way too many don't-misses to list, covering all the key periods of his career, so just give yourself plenty of time to explore it all.

National Picasso Museum

Vallauris, France

Of the three museums dedicated to Picasso in the artist's adopted home of France, this one, in the grand sixteenth-century Château de Vallauris, is surely the most memorable in terms of the experience you take away with you. It's partly the terrific ceramics collection, which celebrates the crafts as practised by local artists as well as Picasso, but ultimately, it's the chance to spend time with his anti-war piece *La Guerre et La Paix* (*War and Peace*, 1954), covering every surface of the château's barrel-shaped Roman chapel.

Museo Reina Sofía

Madrid, Spain

Among its fantastic collection of modern and contemporary Spanish art are some one hundred works by Picasso, but of course the pièce de résistance is *Guernica* (1937). Almost ninety years on from the event it depicts – the bombing of the Basque village in 1937 during Spain's Civil War – the world's most famous piece of anti-war art still retains its emotional power.

Musée Picasso

Antibes, France

Picasso spent a very productive and happy few weeks here on the Côte d'Azur in 1946, using the Château Grimaldi the museum is housed in as his studio. The gorgeous location is just one reason to visit; the others are the twenty-three paintings and forty-four drawings Picasso produced here, all donated to the château on the condition that they remained on display.

Museu Picasso

Barcelona, Spain

The collection held across a series of medieval palaces here, where Picasso lived from the ages of fourteen to twenty-four, gives a great understanding of his development and growth as a major artist. The more than 3,000 works have a strong focus on the Blue period, but the highlight is perhaps his *Las Meninas* series (1957), fifty-eight works exploring Diego Velázquez's painting.

Museum Sammlung Rosengart

Lucerne, Switzerland

While not dedicated exclusively to the work of Picasso, the collection of art dealer Siegfried Rosengart and his daughter Angela includes thirty-two of his paintings and one hundred works in other media. Still running the museum, housed in an imposing neoclassical building, Angela presides over a collection that includes his 1950 *Portrait of a Painter* (after El Greco) as well as five portraits of her.

Museum Ludwig

Cologne, Germany

The arresting contrast of the Museum Ludwig's zinc-clad façade next to Cologne's Gothic cathedral is almost as special as what lies inside – a fine collection of twentieth-century art that neatly documents the major movements and players in that century … including close to 900 works by Picasso, the world's third-largest collection of his works. There's an equally amazing Russian avant-garde collection as well.

Hakone Open-Air Museum

Hakone, Japan

Just getting to this bucolic, sprawling sculpture park – Japan's first – is a treat, travelling on an old railway line up a mountain to connect with a cable car. Once here, a footpath winds its way past 120 modern and contemporary works (Auguste Rodin and Joan Miró among them), hot springs gurgling here and there. And the cherry on the cake? A two-storey Picasso Pavilion holding more than 300 of his works.

Museo Picasso Málaga

Malaga, Spain

Picasso's birthplace holds two spaces dedicated to its most famous son. This one houses 285 works which are either held in a permanent collection or used as the basis for engaging temporary exhibitions that contextualize his work in a wider creative and cultural arena; for example in shows about Fellini and Picasso, and the relationship between Picasso's art and German art.

OVERLEAF ▶
The Musée Picasso, Antibes, Frances

Musée Picasso, Antibes

▶ Find echoes of Vincent van Gogh in Arles

Fondation Vincent van Gogh Arles

35 rue du Dr Fanton, 13200 Arles, France
fondation-vincentvangogh-arles.org

Vincent van Gogh created more than 200 paintings in this pretty Roman town between February 1888 and May 1889, but none remain. So why come here? Because to be in the town that so inspired him, from the magnificent Les Arenes amphitheatre and the Trinquetaille Bridge that resulted in the eponymous paintings to the hospital where his ear was stitched up, is to get a very real sense of the artist in situ. The Fondation Vincent van Gogh, opened in 2014 to honour the artist, houses a collection of works by contemporary artists conceived in homage to him, including Francis Bacon, Roy Lichtenstein and David Hockney, and holds intriguing themed or monograph exhibitions related to Van Gogh and often incorporating his works.

Museum of Montmartre

12 Rue Cortot, 75018 Paris, France
museedemontmartre.fr/en/le-musee

Do the fandango amid a bohemian rhapsody

In the nineteenth century, 12 Rue Cortot was the home of several Impressionists and a smattering of Fauves. Pierre-Auguste Renoir, Maurice Utrillo, Suzanne Valadon and Raoul Dufy, among others, lived and worked here, smack bang in the creative hub of Montmartre. They drank at Lapin Agile (still around the corner), danced at Moulin de la Galette (where Renoir painted *Le Bal du Moulin de la Galette*, 1876) and were entertained at Le Chat Noir. Paris was never so exciting and Rue Cortot was the bohemian's headquarters. Now a museum that includes work by Henri de Toulouse-Lautrec, Amedeo Modigliani, Valadon and Utrillo, as well as the renovated studios of the latter two, it tells the story of Montmartre's golden age. The gardens, where Renoir painted *The Swing* in 1876 (still here), also house Paris's last working vineyard, producing what the *New York Times* called 'the most expensive bad wine in the city'.

Musée d'Orsay

1 Rue de la Légion d'Honneur, 75007 Paris, France
musee-orsay.fr

▲ View world-famous Impressionist paintings in a former train station

Only converted into an art gallery in 1986, the former Art Nouveau train station that is the Musée d'Orsay quickly established itself as one of Paris's best, which is saying something in a city arguably filled with the best galleries in the world. In a soaring space of beauty and elegance, Edgar Degas's ballerinas and Henri de Toulouse-Lautrec's cabaret dancers twirl and dip, and Vincent van Gogh's *Starry Night Over the Rhône* (1888) and Claude Monet's gardens at Giverny offer dazzlingly expressive representations of the natural world. However, perhaps the key artist to explore here among the crème of the Impressionist, Post-Impressionist and Art Nouveau movements is Paul Cézanne. Said to have bridged the gap between nineteenth-century Impressionism and radical modern twentieth-century practices, his nearly sixty works on show here beautifully illustrate exactly how they did that – particularly in *La Maison du Pendu* (or *The House of the Hanged Man*) from 1873.

ABOVE *La Maison du Pendu* (1873) by Paul Cézanne.

LEFT View of the Fondation Vincent van Gogh Arles's courtyard.

◀ Explore da Vinci's world at Clos Lucé

Clos Lucé

2 Rue du Clos Lucé, 37400 Amboise,
Val de Loire, France
vinci-closluce.com

Copies of Leonardo da Vinci's world-famous *Mona Lisa* (*c.* 1503) can be seen in their hundreds across the globe, but here in the Loire Valley one can be seen in the very spot where the polymath – and the painting itself – once stood. Clos Lucé is famous for being the official residence of da Vinci between 1516, when he arrived at the invitation of King Francis I of France with three of his paintings – *Mona Lisa*, *The Virgin and the Child with Saint Ann* (*c.* 1503) and *Saint John the Baptist* (1513–16) – and 2 May 1519, when he died in the house. Today, the Clos Lucé is a Leonardo da Vinci museum, housing forty 1:1 scale models of his machines, a living workshop and, *bien sur*, a copy of *La Giaconda*, painted in 1654 by Ambroise Dubois. In the garden, forty translucent canvasses suspended in the trees make it a fine spot in which to sit and contemplate the magnificent surroundings.

LEFT Life-size models based on Leonardo da Vinci's inventions are dotted around the gardens at Clos Lucé.

Grotte Chauvet 2 Ardèche

Ardèche, France
*en.grottechauvet2ardeche.
com/home-page*

BELOW Replica of the animal
paintings in the Chauvet caves.

▼ Travel way back in time at Chauvet

Access to authenticity in prehistoric art can be difficult as we tr
to ensure these early wonders of creativity and expression are
preserved for future generations. And so, no, you can't see the
30,000-year-old Chauvet cave paintings in their original forms.
But in 2015 an excellent replica of the whole site opened less
than a kilometre/0.6 miles away from the original in the larges
decorated cave replica in the world. It has faithfully reproduced
the representational images of not only familiar herbivores four
in other sites, like bison and horses, but also predatory beasts
such as cave lions, panthers, bears, cave hyenas and even, it's
thought, rhinos. Handprints, abstract imagery and techniques
and subjects (such as animals interacting with each other) rare
found in other cave art make Chauvet a very special cave art si
and in this carefully considered replica you will come as close a
it's possible to get to the real thing.

Notre Dame du Haut

13 rue de la Chapelle,
70250 Ronchamp, France
collinenotredameduhaut.com

Discover Le Corbusier's take on art and religion at Ronchamp

While generally not including architecture as art, we've made an exception here for Le Corbusier's 1954 Chapelle Notre Dame du Haut in Ronchamp. Why? Because, thanks to its flowing curves and monumental concrete roof held aloft by hidden columns that raise it 10 cm/4 in above the stark white, entering the chapel is definitely akin to the experience of encountering a great work of sculpture. Colour makes its mark inside, with a chapel painted bright red, the sacristy in violet, and a series of irregularly placed windows glazed in a mixture of clear and coloured glass. The Fondation Le Corbusier is at pains to point out that 'this has no connection to stained glass … but glazing through which one can see the clouds, or the movements of the foliage and even passers-by'.

Chapelle du Rosaire de Vence

466 avenue Henri Matisse,
06140 Vence, France
chapellematisse.fr

Undergo a religious conversion courtesy of Matisse

When the sunlight streams across the floor of the Chapelle du Rosaire de Vence, even the most ardent atheist or agnostic might experience a spiritual reaction akin to a religious experience. It's all down to the three beautiful sets of stained-glass windows designed by Henri Matisse and realized as an integral part of this small Catholic chapel between 1947 and 1951. Using just three colours – yellow, green and blue – Matisse created designs that flood the whitewashed walls with abstract blocks of joyful light and colour, contrasting arrestingly with black line paintings on the walls and the grid of the floor. Taken as part of a whole that also includes the interior furnishings, priests' vestments and even the architecture of the chapel, the effect is one of harmony and beauty.

BRAFA (annual fair in January)

Tour & Taxis, Avenue du Port 88, 1000 Brussels, Belgium
brafa.art

See Brussels flex its art muscles

BRAFA is one of the oldest (founded in 1956) international art fairs, as well as being one of the most prestigious and well-stocked. A recent BRAFA fair showcased a newly discovered Rubens, a seriously good Magritte and some wonderful Ugo Rondinone works. There is 'affordable' work here, but it's all museum-quality and you're not going to pick up a bargain. You will, however, expand your knowledge of art as BRAFA hosts several workshops and art talks by experts. Its eclecticism means an engaging selection that mixes art and mid-century furniture with ceramics, glassworks and jewellery, but the main thing that stands out is the friendliness of the exhibitors, who are more than willing to chat with you about art, unlike at many other art fairs.

◀ Gaze skywards for a glimpse of Jan Fabre's glittering Heaven of Delight

Royal Palace of Brussels

Rue Brederode 16, 1000 Brussels, Belgium
monarchie.be/nipolymath

Visual artist, theatre artist and writer Jan Fabre has used many materials to create art in his forty years of practice, including ham, sperm and menstrual blood. In 2002, commissioned by Queen Paola of Belgium to create a piece in the Royal Palace, he turned to one that has played a large part in his life and work – the insect, specifically in this case the jewel beetle. Or even more specifically, 1.6 million wing-cases of jewel beetles. With a team of twenty-nine assistants he adorned the ceiling and one of the three chandeliers of the Hall of Mirrors with their shields, creating an iridescent glittering artwork filled with motifs connected to Belgium's controversial colonial history in the Congo, including giraffes' legs, severed hands and skulls – a fitting retort to a space commissioned by King Leopold II, the man who claimed the Congo.

FOMU – Fotomuseum Antwerpen

Waalsekaai 47, 2000 Antwerp, Belgium
fomu.be

Picture this (and that) in Antwerp

When it comes to visual culture, Antwerp may be best known internationally for its contributions to the worlds of painting (Rubens) and fashion (the Antwerp Six), but the city has fingers in other pies as well. Tucked behind a warehouse near the River Scheldt, FOMU is dedicated to exploring and encouraging photography in Flanders and the wider world, with one of the most important photography archives in Europe (both images and equipment) alongside lectures, workshops and two cinemas. The museum's temporary exhibitions are the real draw, however, mixing solo shows by Belgian heavyweights (Stephan Vanfleteren, Harry Gruyaert) with serious but entertaining overviews (the history of the moon in photography) and showcases for new talents. Diverse, thought-provoking and passionate: if only every museum was like this.

Ghent Altarpiece

St Bavo's Cathedral, Sint-
Baafsplein, 9000 Ghent,
Belgium
sintbaafskathedraal.be

LEFT Jan Fabre's *Heaven of
Delight*, a permanent installation
at the Royal Palace of Brussels.

BELOW The Ghent Altarpiece
(completed 1432) by Hubert
and Jan van Eyck.

▼ Adore the Mystic Lamb in Ghent

It's a miracle that the Ghent Altarpiece is still with us: over the
centuries it has been attacked by religious fanatics, broken up,
confiscated as war booty, sold and even stolen by the Nazis – only
to be recovered by the 'Monuments Men' at the end of the Second
World War. One panel has never been found, but thankfully the
rest of the eighteen-panel work, completed in 1432 by brothers
Hubert and Jan van Eyck, can still be viewed in its original setting
in St Bavo's Cathedral, Ghent. In fact, after a painstaking seven-
year restoration, it is looking more miraculous than ever. The
glowing colours and attention to detail – witness the gleaming
gemstones and intricate hairstyles, and the remarkably humanoid-
eyes of the Mystic Lamb itself – are still astonishing. And the van
Eycks' new-found realism when it came to painting people and
nature was a real game-changer, transforming Western art forever.

Let the art of a cathedral grow on you in Almere

The Green Cathedral

Almere, Netherlands
landartflevoland.nl/kunstwerken/marinus-boezem-de-groene-kathedraal

Exhibiting a more whimsical and approachable aspect than the machismo created by many other land artists, Marinus Boezem's living land art project, *The Green Cathedral*, mimics the architecture of the famous Notre-Dame de Reims cathedral with 178 strategically placed Italian poplars. Planted by Boezem in 1987, the now mature trees majestically rise up some 30 m/98 ft, covering a space that is almost 50 m/164 ft long and 75 m/246 ft wide. Like its bricks and mortar counterpart, it is a beautifully tranquil spot, and nearby an oak and hornbeam forest clearing in the shape of the cathedral provides a pleasing contrast to the poplars.

Take time to draw breath in a cigar-filled smorgasbord

Cigar Band House (next to the Volendam Museum)

Zeestraat 41, 1131 Volendam, The Netherlands
volendamsmuseum.nl

Nico Mollenaar, a retired monk from Volendam, a small fishing village just outside Amsterdam, began collecting cigar bands in 1947. He cut off the ends and used the medallions to decorate his house in a series of painstakingly created mosaics that covered the walls, tables and even chairs. By the time he died in 1965, he had collected 7 million bands … but the story does not end there. His neighbour, Jan Sombroek Cas, took over and collected 4.5 million more, and used them to achieve Nico's dream of a folk art fantasy – a total of 11.5 million cigar bands used as an art material to form a mosaic smorgasbord of scenes of Volendam life. And in a nod perhaps to the international visitors he expected, he added global tourist attractions such as the Leaning Tower of Pisa, the Statue of Liberty and the Manneken Pis. A remarkable feat.

The Kunstmuseum Den Haag

Stadhouderslaan 41,
2517 HV Den Haag, The
Netherlands
kunstmuseum.nl

ABOVE *Victory Boogie-Woogie*
(1944) by Piet Mondrian.

LEFT *The Green Cathedral*
(planted 1987) by
Marinus Boezem.

▲ Square up to Mondrian in The Hague

How could you not want to see a work of art called *Victory Boogie-Woogie*? Especially when you know it was the last, unfinished artwork by the De Stijl poster boy and abstract pioneer Piet Mondrian. The jazzily titled piece of 1944 is just one in the largest Mondrian collection in the world, and it is a treat to see so many of his geometric works together, offering not only a great insight into the Dutch artist's unique path to abstraction, but also the joyful pizazz of a body of work composed of just the three primary colours – red, yellow and blue – which briefly reflected the tentative hope of peace and happiness in post-war Europe.

▶ Commune with a tiny natural marvel at the Mauritshuis

Mauritshuis

Plein 29, 2511 CS Den Haag, The Netherlands
mauritshuis.nl

Until 2014, the main reason art fans made the short break from the Van Goghs in Amsterdam to enjoy the quiet delights of The Hague's Mauritshuis was to see Johannes Vermeer's luminous *Girl with a Pearl Earring* (c. 1665) and Rembrandt's *The Anatomy Lesson of Dr Nicolaes Tulp* (1632). Then came Donna Tartt's 2013 novel, *The Goldfinch*, a loving elegy to the tiny painting of the bird by Carel Fabritius of 1654, also housed in the peaceful, compact Hague museum. Even if you haven't read the novel or seen the film, the oil painting, a panel of just 33.5 x 22.8 cm/13⅕ x 9 in, is a beautifully beguiling one, not least for its poignant subject, chained to a feeder attached to a wall, created in a trompe-l'œil style that makes it a unique piece in Dutch Golden Age painting. And don't miss the separate Prince William V Gallery, which houses more than 150 old masterpieces from the Mauritshuis collection.

Regard Rembrandts and lots more at the Rijksmuseum

Rijksmuseum

Museumstraat 1, 1071 XX Amsterdam, The Netherlands
rijksmuseum.nl

The history of Dutch arts and crafts is told beautifully in this Amsterdam museum, with the likes of Johannes Vermeer, Jan Steen, Vincent van Gogh and Rembrandt represented by some of their most important works. Rembrandt's huge *Night Watch* of 1642 and Vermeer's *Milkmaid* of c. 1660 are undisputed Golden Age icons, and you'll be one of hundreds paying homage to them. Elsewhere, however, an elegant collection of Delft Blue pottery illustrates the skill of sixteenth- and seventeenth-century Dutch potters, and miniature silverwork, musical instruments, glass, porcelain, dolls' houses and ship models survive to attest to the importance of Dutch creativity through the ages.

Kröller-Müller Museum

Houtkampweg 6, 6731 AW Otterlo, The Netherlands
krollermuller.nl/en/sculpture-garden

LEFT *The Goldfinch* (1654) by Carel Fabritius.

BELOW View from inside the Rietveld pavilion at the Kröller-Müller Museum.

▼ Discover the life and times of Van Gogh

The obvious place to pay homage to one of the greatest ever Dutch painters is the Van Gogh Museum, where the artist's difficult life and tragic death are perfectly explored through displays and works that chart his emotional state via more than 200 canvases, 400 drawings and 700 letters. But for a quieter encounter with the works and mind of this tortured genius, the Kröller-Müller museum in Gelderland is the place to head. Here you'll find the world's second-largest collection of the Post-Impressionist painter's work in a tranquil environment that makes contemplation and enjoyment of his ninety paintings and 180+ drawings a special experience, one heightened by the presence of first-class works by contemporaries such as Piet Mondrian, Pablo Picasso, Claude Monet and Georges Seurat. And there's more; outside, in the surrounding park, one of Europe's largest sculpture gardens includes a stunning piece by Jean Dubuffet, and an equally stunning 1960s pavilion by Gerrit Rietveld.

Alte Nationalgalerie

Bodestrasse 1–3,
10178 Berlin, Germany
smb.museum/museen-
und-einrichtungen/alte-
nationalgalerie

ABOVE The Abbey in the Oakwood (1809–10) by Casper David Friedrich.

RIGHT A version of Mother with her Dead Son by Käthe Kollwitz, installed in the Neue Wache in 1993

▲ Find bucolic Germany at its most haunting in Berlin

What a turbulent time the reputation of Casper David Friedrich has had; regarded as the finest painter of Romantic landscapes in the world during his early years before obscurity in death, then a renewed appreciation in the twentieth century that would lead to vilification for having found favour with the Nazis, and finally, in the latter half of the twentieth century, a re-evaluation that has brought him new-found respect for an expressive style and use of symbolism. To see his works contextualized in the wider canon of German painting, Berlin's Alte Nationalgalerie is the place to head. Here The Abbey in the Oakwood (1809–10), The Monk by the Sea (1808–10), Moonrise over the Sea (1822) and Man and Woman Contemplating the Moon (c. 1824, supposedly the inspiration behind Samuel Beckett's Waiting for Godot) illustrate the tropes of loneliness, desolation, darkness and mortality that were the signature style of this most accomplished of German Romantic painters.

See a modern master restored to its Modernist glory

Neue Nationalgalerie

Potsdamer Strasse 50,
10785 Berlin, Germany
*smb.museum/en/
museums-institutions/neue-
nationalgalerie/home*

As part of the National Gallery of the Berlin State Museums, the Neue Nationalgalerie shows a rotating selection of modern art drawn from an impressive collection, with a strong focus on German Expressionism – Ernst Ludwig Kirchner, Max Beckmann and Otto Dix can all be found here. But it's perhaps the building they're housed in that is the most exciting piece of art here; the sleek glass box was designed by Ludwig Mies van der Rohe and opened in 1968. It is a perfect example of his work, with the light playing off the floor and animated red LCD tracks on the ceiling creating a light installation to rival that of Dan Flavin. At the time of writing it was closed and being modernized by British architect David Chipperfield; with a focus on restoration, it's likely that when it does reopen, its gleaming glass façade, steel beams and original fittings will look as futuristic as they must have done to young Germans in the flower power era.

▶ Enter a guardhouse to see a different side of Berlin's history

Neue Wache

Unter den Linden 4, 10117 Berlin, Germany
visitberlin.de/de/neue-wache

Inside a former German Greek Revival nineteenth-century Prussian guardhouse which has housed four memorials since 1931, lies an artwork which, perhaps more than any other memorial in a city where the dead can almost be felt in its fabric, evokes a very real sense of pity and sorrow, its siting under an oculus opening it to the elements (symbolizing the suffering of civilians during the Second World War), making its vulnerability literally palpable. The *Pietà*-type piece, *Mother with her Dead Son*, by Käthe Kollwitz, was informed to some extent by the death in the First World War of Kollwitz's son Peter, and she began work on the first, much smaller, version of it on the anniversary of his death – 22 October 1937. The history of both the space and the piece are fascinating, so do read up on them before visiting, if you do visit – and everyone should.

Train your eyes on a modern collection at Berlin's Hamburger Bahnhof

Hamburger Bahnhof

Invalidenstrasse 50–51, 10557 Berlin, Germany
smb.museum/museen-und-einrichtungen/hamburger-bahnhof/home

The Hamburger Bahnhof literally was once a *bahnhof*, or train station, but unlike Paris's Musée d'Orsay, its reinvention as an art gallery in 1996, 150 years after it was opened as the terminus for the line between Hamburg and Berlin, was as the home of a markedly modern collection, all of it post-1960. The late neoclassical architecture creates a striking counterpoint to the work, which in 2004 was significantly bolstered by the long-term loan of the Friedrich Christian Flick Collection, dedicated to art from the last decades of the twentieth century by the likes of Dan Graham, Cindy Sherman and Katharina Fritsch. Taken together with the museum's other holdings in contemporary art, it all combines to create one of the most eclectic contemporary art collections in Europe.

Celebrate the Bauhaus Centenary in Germany

Temporary Bauhaus-Aarchiv/Museum für Gestaltung

Knesebeckstrasse 1–2, Berlin-Charlottenburg, Germany
bauhaus.de

2019 was the centenary of the founding of the Bauhaus, and Germany celebrated it with the opening and commencement of work on three new museums dedicated to the globally influential avant-garde movement at Dessau, Weimar and Berlin. The latter of these, the Bauhaus Archiv/Museum für Gestaltung, will eventually be unveiled with a brand new museum and major renovation of Walter Gropius's iconic building, adding a new research archive and library to the world's most extensive collection of materials on the history of the Bauhaus. Until it opens, the collection can be seen at the appropriately named Temporary Bauhaus-Archiv.

Let there be pixelated light

Cologne Cathedral

Domkloster 4, 50667 Cologne, Germany
koelner-dom.de

Thirteenth-century Cologne Cathedral was hit more than seventy times by Allied bombing in the Second World War, yet miraculously survived while the rest of Cologne was flattened. Many of its medieval windows had been placed in storage but some were lost to the bombing, including those in the south transept. The agnostic artist Gerhard Richter would not be every Catholic's first choice to redesign those windows (and many objected) in 2007, but he was an inspired choice. Having struggled with his initial designs, Richter decided to use an abstract design. The window has 11,500 25.8-cm^2/4-in^2 pieces of blown glass, or 'pixels', in seventy-two colours reproduced from the cathedral's other windows, placed randomly using a computer program. The result is a masterpiece of kaleidoscopic art which ties in the secular with the religious and the medieval with the modern. Try to visit on a sunny day.

Würzburg Residenz

Residenzplatz 2,
97070 Würzburg, Germany
residenz-wuerzburg.de

BELOW The magnificent ceiling frescoes above the stairwell at the Würzburg Residenz, painted by Giovanni Battista Tiepolo and his son.

▼ Turn your eyes heavenward for a different world view

Sitting atop the Bavarian town of Würzburg, the eighteenth-century Baroque Residenz Palace is as ornate as they come, with Rococo elements and gilt galore. In keeping with the grand design, the palace's Imperial Hall and lofty stairwell are painted with two magnificent ceiling frescoes by Venetian artist Giovanni Battista Tiepolo. The hall's allegorical and historical scenes by both Tiepolo and his son Giandomenico so impressed Prince-Bishop Carl Philip von Greiffenclau that he invited them to decorate the stairwell as well, where their gloriously fanciful portrayal of the mythical and real worlds, embellished with everything from Greek deities, nymphs and flying horses to hordes of elephants, pyramids, alligators and different representatives of the world's cultures, constitutes a unique physical and cultural view of the world in the eighteenth century.

Iwalewahaus

University of Bayreuth,
Wölfelstrasse 2,
95444 Bayreuth, Germany
iwalewahaus.uni-bayreuth.de

Explore African Modernism in an unlikely Bavarian setting

Beyond the façade of this traditional Baroque building in the heart of the Bavarian university town Bayreuth lies an unlikely find, one that examines an often hidden aspect of twentieth-century creativity, with an absorbing collection of modern and contemporary visual arts from Africa, Asia and the Pacific area. Founded by Ulli Beier, it houses a fine collection of twentieth-century African Modernism, centred largely around the output of Nigeria's Nsukka-school and Oshogbo artists of the 1960s, along with art from Sudan, Mozambique, Tanzania, Democratic Republic of Congo, Haiti and India. It's special because it offers a rare chance to see the art that engaged with colonialism and post-colonialism during a period of great flux, and at the height of national independence for many African countries, which, as well as enabling visitors to engage with the artists' responses to those changes, raises many interesting questions about colonial and post-colonial appropriation.

Museum Tinguely

Paul Sacher-Anlage 2,
CH-4002 Basel, Switzerland
tinguely.ch

Listen to the sound of music in Switzerland

Anyone who has ever been to the Centre Pompidou in Paris will be familiar with the work of Jean Tinguely, whose *Stravinsky Fountain* (1983), created with his wife and fellow artist Niki de Saint Phalle (see page 174), playfully decorates the plaza outside the art space. Less well known are his *Méta Harmonies* sound sculptures (1978–85), because he only ever built four of them. These colossal pieces, meticulously built from scrap metal and odd found objects, have degraded over time to the point where it has become increasingly rare to see them, and even more rare to hear them in action. Except at the Museum Tinguely, where in 2018 *Méta Harmonie II* (1979), having run for thirty-eight years before having to be shut down, was reinstalled after a careful renovation by the art research institution Schaulager, so that visitors can once again delight in the whole harmony – and occasional discordant disharmony – of the sounds it makes. It's the acme of a wonderful collection by this most joyful of sculptors.

RIGHT The Fondation Beyeler building, set in idyllic surroundings.

Sample big cheeses in Switzerland

Art Basel

Switzerland
basel.com

Art fairs are a great way of seeing – and learning – what's current in the art world, with free guided tours, talks and events that give you a great insight into the state of contemporary art. Art Basel is one of the originals and was launched in 1970 with a strong curatorial perspective that has proven to be very exportable – Art Basel now takes place annually in Miami Beach and Hong Kong (China) as well. Here, in its original form, it is such a powerhouse that the whole city attracts top-notch shows throughout its duration, so apart from the 300 galleries that show as part of the fair, there are thirty-seven major museums to visit, all with their own big shows. Add in a clutch of satellite fairs – 'Liste' shows seventy of the 'younger generation' galleries, 'Photo Basel' shows about thirty galleries and 'Volta' has an emphasis on 'discovery' – and there's no time to rest. Put on your trendiest sneakers and get moving.

▲ Take a turn or two in a bucolic Swiss art scene

Fondation Beyeler

Baselstrasse 101, CH-4125 Riehen, Switzerland
fondationbeyeler.ch

Set amid fields of flowers and rolling parkland in the Basel suburb of Riehen, the Renzo Piano-designed Fondation Beyeler is a beauty. The glazed façade looking squarely out over cornfields and vines stretching towards Tüllinger Hill draws your gaze out continually, heightening the beauty of the work surrounding you when your eye comes back into the space. Some of the twentieth century's most important artists exhibited here, include Pablo Picasso, Paul Cézanne, Mark Rothko, Marc Chagall and Vincent van Gogh, but keen art collectors and dealers Hildy and Ernst Beyeler, who amassed the works, have also brought into the mix tribal art from Africa, Alaska and Oceania. And they are constantly adding to the collection, with recent acquisitions by the likes of Tacita Dean, Louise Bourgeois, Olafur Eliasson and Jenny Holzer. It ensures there is always something new and wonderful to look at – beyond the changing seasons and light outside, of course.

▶ Get into outsider art in Switzerland

Collection de l'art Brut

Avenue Bergières 11,
1004 Lausanne, Switzerland
artbrut.ch

Artist Jean Dubuffet was a keen fan of outsider art, or *art brut*, which he defined as 'pieces of work executed by people untouched by artistic culture, in which therefore mimicry … plays little or no part, so that their authors draw everything from their own depths and not from clichés of classical art or art that is fashionable'. From 1945 he set about making a collection of such works, created by artists on the fringes of society and outcasts, many of whom were inmates of various psychiatric hospitals. Decades later the collection he donated to the City of Lausanne in 1971 – then comprised of 5,000 pieces by 133 creators, now expanded to more than 70,000 works by 1,000 creators – remains an utterly absorbing body of work that champions the imagination, latent skills and expressive abilities of the artist in all of us.

RIGHT *Couronne d'épines de Rosalie en forme de coeur* (1922) by Adolf Wölfli.

Drink in some twenty-first-century wonders in a twelfth-century monastery and brewery

Muzeum Susch

Sur Punt 78, 7542 Susch, Switzerland
muzeumsusch.ch

You don't expect to find cutting-edge art in a pretty Alpine village, but then everything about Muzeum Susch is unexpected. Established by the Polish tech entrepreneur and art collector Grażyna Kulczyk, the art centre occupies a twelfth-century monastery and brewery, as well as part of the mountain behind it, which has been drilled into to make space for the galleries. With a focus firmly on female artists – the inaugural exhibition in 2019, *A Woman Looking at Men Looking at Women*, had the stated aim of exploring 'the notion of the feminine in its diverse facets' – the space is utterly unique. Excellent permanent site-specific works by a strong group of conceptual artists, many of them female, include Helen Chadwick's *Piss Flowers* (1991), looking like so many giant edelweiss, which were cast in bronze from patterns created by Chadwick peeing in the snow.

▲ Break bread with the best in Milan

Museo del Cenacolo Vinciano

Piazza Santa Maria delle Grazie 2,
20123 Milan, Italy
cenacolovinciano.org

Book well ahead for this art experience that is more than worth the wait – and the entry fee. We'd even go so far as to say Leonardo da Vinci's mural masterpiece, *The Last Supper*, painted in the late fifteenth century and housed in the refectory of the church of Santa Maria delle Grazie, the Cenacolo Vinciano, is worth a trip to Milan even if you see nothing else during your stay. Once inside, you're given plenty of time to take in the majestic mural and its details – or, if you're a fan of Dan Brown's *The Da Vinci Code*, to try and work out for yourself whether the apostle to Christ's left really is Mary Magdalene. In Florence, Andrea del Castagno's version (*c.* 1450) at the Cenacolo di Sant'Apollonia offers a great chance to compare the two contrasting styles; where Leonardo's attempts to convey the 'motions of the soul' through postures, gestures and expressions create an ethereal, otherworldly piece, Castagno's is determinedly naturalistic.

Metropoliz Museum
of the Other and the
Elsewhere (MaaM)

913 Via Prenestina, Rome,
Italy
facebook.com/museoMAAM

LEFT *The Last Supper* (1495–98)
by Leonardo da Vinci.

BELOW MaaM has transformed
a squatted-in factory into a place
of art.

▼ Make for Rome's illegal museum to protect a unique symbiotic relationship

In a former salami factory in a Roman suburb live the 'Metropolizians',
a group of 200 or so squatters, seventy of whom are children.
They are migrants from all over the world who live and work in
the Metropoliz Museum of the Other and the Elsewhere (MaaM),
founded by curator Giorgio de Finis in 2011. De Finis began to
organize events and performances in the space and now, ten years
on, it features murals, paintings and site-specific installations by
more than 300 artists from around the world, some of whom are
household names – even Michelangelo Pistoletto has shown here.
In a powerful example of the symbiotic nature of viewer and artist,
although the squat is illegal, visitors to the art space add some form
of legitimacy and therefore the residents get a degree of protection
from eviction.

TRAIL: Rome's best religious art in churches

Italy's Vatican City houses some of the world's best Christian art, in places such as the Sistine Chapel, the Pinacoteca Vaticana and Vatican Museums. But it's beyond the holy city, in Rome's quieter religious spaces, that you'll really understand the power and majesty of religious art. Follow our trail to find the best.

Santa Maria della Vittoria

Via Venti Settembre

Bernini's *Ecstasy of Saint Teresa* statue (1647–52), representing Spanish Carmelite nun Teresa of Ávila during a moment of religious ecstasy with an angel, is sexily sensuous and still quite shocking.

San Francesco a Ripa

Piazza di San Francesco d'Assisi

Even more provocative than his St Teresa statue is Bernini's 1674 sculpture of *Beata Ludovica Albertoni*. Unsurprisingly, her clear state of ecstasy makes her one of his most controversial works.

San Pietro in Vincoli

Piazza di San Pietro in Vincoli

Head here to see Michelangelo's unique statue of Moses (1513) with horns on his head (a result of a mistranslation in the Bible, in which the words 'rays of light' were interpreted as 'horns').

Santa Maria in Trastevere

Piazza di Santa Maria in Trastevere

OK, this one is pretty popular, but worth the hordes for its stunning thirteenth-century mosaics by Pietro Cavallini depicting the life of the Virgin Mary. More Byzantine mosaics can be found at San Clemente and Santa Costanza.

Basilica of Santi Quattro Coronati

Via dei Santi Quattro

This cloistered convent dating from the twelfth century is a beauty by any standard; add in an incredibly vivid cycle of thirteenth-century frescoes in the Chapel of St Sylvester and you have a truly remarkable space.

Santa Cecilia in Trastevere

Piazza di Santa Cecilia

A ninth-century mosaic, thirteenth-century frescoes by Pietro Cavallini and a famous seventeenth-century sculpture of Cecilia by Stefano Maderno are just some standouts in this preposterously pretty church.

Santa Prassede

Via di Santa Prassede

It doesn't look like much outside, but like a tarnished jewellery box this ninth-century church (just two minutes away from the world-famous Basilica Papale Santa Maria Maggiore) sparkles with frescoes and mosaics inside.

San Lorenzo fuori le Mura

Piazzale del Verano

This fifth-century church features thirteenth-century mosaics outside and frescoes depicting the life of St Lawrence, martyred in AD 258, inside.

San Luigi dei Francesi

Piazza di San Luigi dei Francesi

Head to the famous Contarelli Chapel to see the luminous paintings that form Caravaggio's *St Matthew Cycle* (1599–1602) and then to the Polet Chapel to see Domenichino's *Histories of Saint Cecilia* frescoes (1612–15).

See page 156.

Sant' Agostino

Via di Sant'Eustachio

Come for Caravaggio's eloquent *Madonna di Loreto* (1604), but don't miss Raphael's fresco of the Prophet Isaiah (1512) and Jacopo Sansovino's *Madonna del Parto* (1518) based, supposedly, on a statue of Agrippina holding Nero.

Santo Stefano Rotondo

Via Santo Stefano Rotondo

Rare seventh-century mosaics and thirty-four sixteenth-century graphic frescoes portraying thirty-four scenes of martyrs being tortured feature in this unusual round church.

Santa Maria sopra Minerva

Piazza della Minerva

This rare Roman Gothic church steps away from the Pantheon is a riot of colour, from its cobalt blue ceiling with gilded stars to its Filippino Lippi frescoes. It has sculptures by Michelangelo and Bernini (the elephant in front of the church) too.

Santa Maria del Popolo

Piazza del Popolo

A minor basilica with some seriously major works, among them two Caravaggios (the *Conversion of Saint Paul*, 1600 and the *Crucifixion of Saint Peter*, 1601) either side of Caracci's 1601 *Assumption of the Virgin*, and paintings by Raphael, Bramante, Bernini and Pinturicchio.

OVERLEAF ▶
The central altar in the Basilica di Santo Stefano Rotondo al Celio.

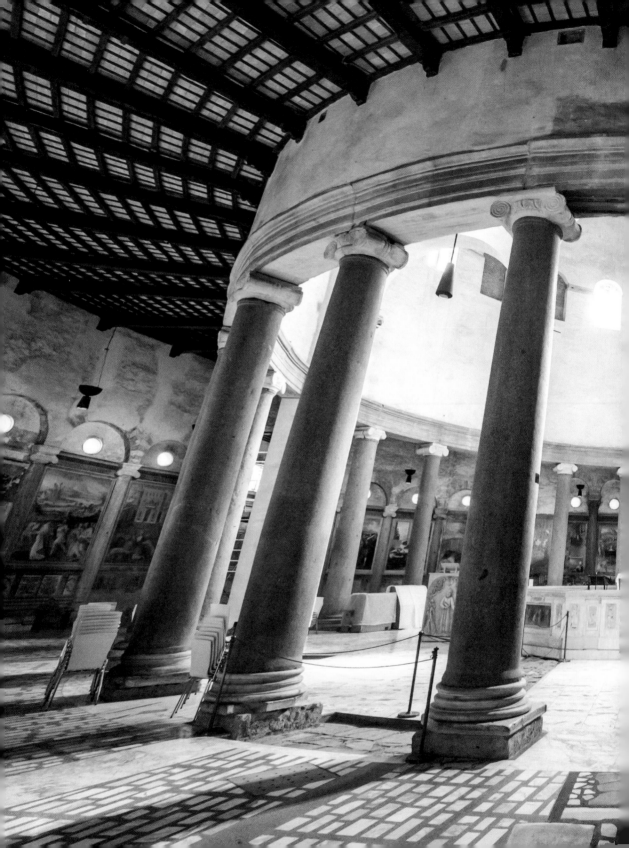

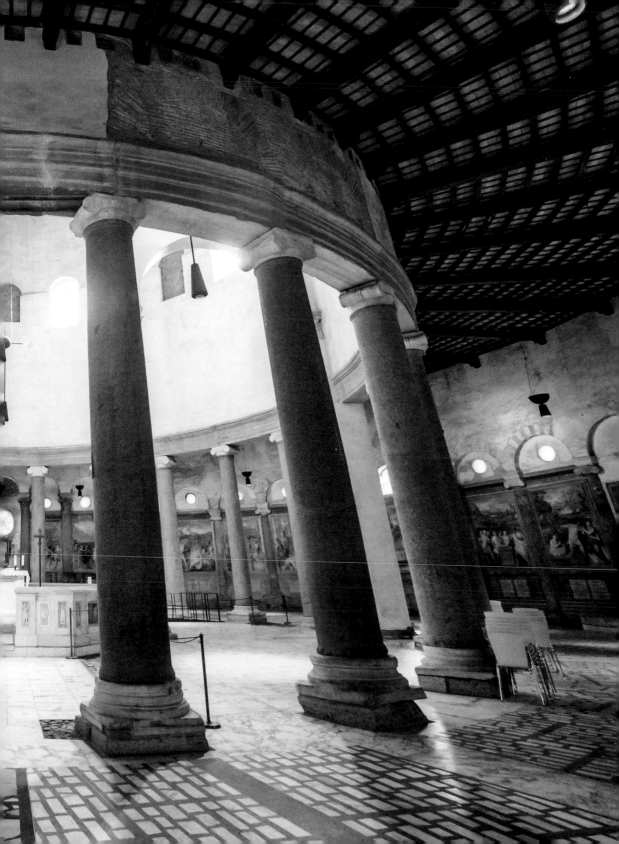

▶ Give your neck a break from the Sistine Chapel

Vatican Museums

00120 Vatican City, Italy
museivaticani.va

The modern art collection in the Vatican is often overshadowed by the draw of the Sistine Chapel. It naturally has a religious theme, but beyond that you're likely to be pleasantly surprised by the modernity of the works. Here is an astounding *Pietà* by Vincent van Gogh painted just before he died in 1890, there a study of Diego Velázquez's 1650 *Portrait of Innocent X* by militant atheist Francis Bacon, who worshipped the work but famously did not visit it on his many visits to Rome, instead basing his numerous re-workings on a postcard of it. The absolute highlight, though, is the Henri Matisse room/chapel, featuring large-scale preparatory sketches related to the planning phase of the Chapelle du Rosaire de Vence (see page 135).

San Luigi dei Francesi

Piazza di S Luigi dei Francesi, Rome, Italy
saintlouis-rome.net

Find revelations, martyrs and gospels in a tiny chapel in Rome

Halfway between Piazza Navonna and the Pantheon is the French church San Luigi dei Francesi, home to the spectacular triptych (1599–1600) by Caravaggio in the tiny Contarelli Chapel. Focusing on the life of St Matthew, *The Calling, St Matthew and the Angel* and *The Martyrdom* combine to create, quite simply, a masterpiece. In the first a beam of light by-passes Christ's floppy Michelangelo-like hand and picks out Matthew in the crowd, who seems to be saying 'Who, me?' In *St Matthew and the Angel*, an angel watches him write his gospel. This was a second attempt for Caravaggio, his first attempt having been rejected for being too 'realistic', as it showed the angel dictating to an illiterate St Matthew … not 'saintly' enough for the church! Sadly, version one was lost in the Second World War. *The Martyrdom* is a *chiaroscuro* master class in composition (with a Caravaggio selfie).

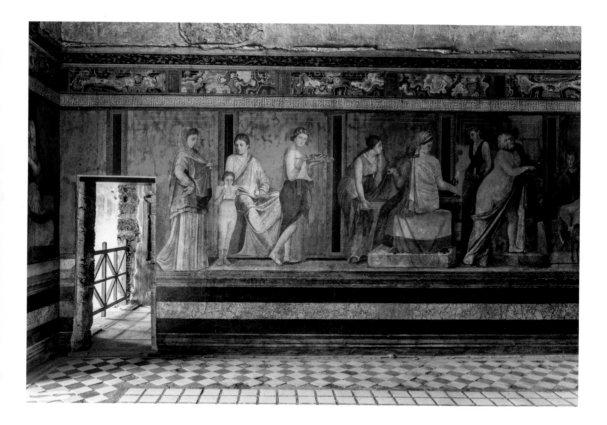

Via Villa dei Misteri

Pompeii, Italy
pompeiisites.org

LEFT *Pietà* (1890) by Vincent van Gogh.

ABOVE Frescoes in the Villa of the Mysteries, which may depict scenes of a bride being initiated into the Bacchic Mysteries.

▲ Wander and wonder among the wall murals of Pompeii's Villa of the Mysteries

The site and sight of Pompeii never fails to amaze, with its preserved artefacts, streets and piazzas chillingly bringing to life the terrible deaths of some 2,000 inhabitants of the Roman town when Vesuvius erupted in AD 79. There are many memorable sights, but the most impressive in art terms has to be the series of frescoes in the Villa of the Mysteries, some of the best surviving examples of Ancient Roman painting. What makes the paintings stand out from the crowd is their enigmatic subject matter, the accepted interpretation of which is the initiation of a woman into a cult of the wine god Bacchus, although other theories challenge this. While meaning and symbolism may be contested, what is not is the skill and dexterity of the artists who painted these stunning works, replete with figures exhibiting expressions ranging from contentment and lust to horror and panic.

◀ Hop on the metro to find Naples's underground art scene

Various locations across Naples, Italy

anm.it

Think Naples, think Pompeii and classical art, right? Not necessarily. The city's Art Stations programme has been running for a while now, with some inventive and original results. Across its metro network, international artists, designers and architects – including Alessandro Mendini, Anish Kapoor, Gae Aulenti, Jannis Kounellis, Karim Rashid and Sol LeWitt – have been commissioned to design stations such as the funky purple space of Toledo station, created by Spanish architect Oscar Tusquets Blanca, themed around water and light. The initiative, curated by art critic and former Venice Biennale director Achille Bonito Oliva, includes two mosaics by the South African artist, William Kentridge, as well as light panels by Robert Wilson and works by Francesco Clemente, Ilya and Emilia Kabakov, Shirin Nehsat and Oliviero Toscani.

Museo e Real Bosco di Capodimonte

Via Miano 2, 80131 Naples, Italy
museocapodimonte. beniculturali.it

Read a dramatic Baroque biography in Naples

At the time of writing, London's National Gallery contained just twenty-one paintings by women (in a collection of more than 2,300), so the fact that *Self-Portrait as St Catherine of Alexandria* (*c.* 1615–17) by Artemisia Gentileschi is one of them says much about this artist's work and standing as one of the most important Baroque painters of the seventeenth century. Her turbulent life – including being raped in her teens – had a huge influence on her work, which often depicted strong women as the main protagonists, as seen in *Judith Slaying Holofernes* (1610) at the Capodimonte in Naples, where she lived and worked for more than two decades. The painting, filled with darkness and blood as two women hold down a man while one cuts his throat, has been read by many as biographical, a self-portrait of Gentileschi exacting revenge on her rapist, and while that's just supposition, there is no doubting this female artist's strengths as both a technician and creative narrator.

Uffizi Gallery

Piazzale degli Uffizi 6,
50122 Florence, Italy
uffizi.it

LEFT Toledo Metro Station
in Naples.

BELOW *Venus of Urbino* (1534)
by Titian.

▼ Find a fistful of firsts at the Uffizi

Among the 1,500-odd masterpieces bequeathed to this 101-room palace-museum by the Medici family are ground-breaking, innovative works that have intrinsically shaped the history and path of art over five centuries. There are many to choose from, including Michelangelo's *Doni Tondo* (*c*. 1506–08), an extremely rare panel painting of the holy family flanked by the perfectly formed naked torsos of a group of young men, and Parmigianino's *Madonna with the Long Neck* (1534–35), which features some radical approaches to composition, perspective and form. However, the standout is perhaps Titian's *Venus of Urbino* (1534). It was deemed utterly shocking at the time of its creation, its obvious eroticism and overt sexuality creating a lasting legacy that has threaded through art practice ever since.

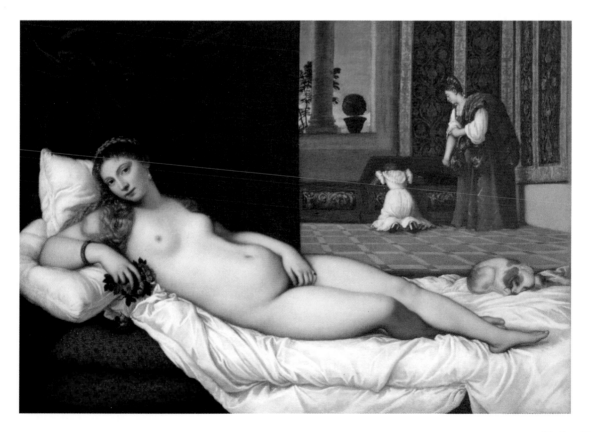

Brancacci Chapel

Piazza del Carmine,
50124 Florence, Italy
*museumsinflorence.com/
musei/Brancacci_chapel*

▼ See how a Renaissance man learned from a young master

While the frescoes of the Brancacci Chapel in the Church of Santa Maria del Carmine are by three artists – Masaccio, Masolino and Filippino Lippi – there is no doubt whose contribution shaped the direction of art and influenced generations of artists for centuries; beginning with the young Michelangelo, who was one of the many artists who trained by copying Masaccio's work on the chapel, begun around 1425 and taken from the stories of St Peter. While all the work is mesmerizing, Masaccio's *Expulsion from the Garden of Eden* (1425) – dramatic with a sense of sculptural presence – is a multi-layered piece with areas of colour and forms shaped and defined by scientific perspective and the play of natural light and shade on them, its physical realism and naturalism heightening the drama and emotion in a way that brought something very new to art. On Masaccio's death at just twenty-seven, the work was completed by Lippi.

BELOW The highly decorated interiors of the Brancacci Chapel.

Museo del Duomo

Piazza del Duomo,
50122 Florence, Italy
museumflorence.com

Scale the king of domes at the Museo del Duomo

Tucked away in Florence, the Museo del Duomo often gets overlooked because it sits in the shadow of the Brunelleschi masterpiece it celebrates. While many people come here to see the original *Gates of Paradise* (1425–52) by Ghiberti (preserved in nitrogen), which of course are spectacular, the museum has so much more to offer. A late *Pietà* of 1547–55 by Michelangelo (he was eighty when he completed it) is wonderful and features a self-portrait in the form of Nicodemus. The real highlight, however, is a wonderful exhibition on the construction of the dome, with the original tools, pulley systems and hoisting wagons used by the world's first modern engineer. You can finish off with a spectacular view of the Duomo itself from the third-floor, open-air Terrazza Brunelleschi.

Basilica of St Francis of Assisi

Piazza San Francesco 2,
06081 Assisi, Italy
sanfrancescoassisi.org

Find the spirit of St Francis in Assisi

Religious art at its very best is the mainstay of Assisi, where the Basilica of St Francis of Assisi is packed with beautifully preserved thirteenth- and fourteenth-century frescoes honouring the life of the saint who lived and died here. Set across the two basilicas are frescoes by Cimabue, Simone Martini, Pietro Lorenzetti and, the highlight of a trip here, Giotto, whose series of twenty-eight frescoes along the lower part of the Basilica Superiore's nave illustrating the major events in the life of the saint are unforgettable. The authorship may be disputed, but the glorious luminosity and spirituality of the work are not.

The Basilica of San Francesco

Piazza San Francesco,
52100 Arezzo, Italy
*polomusealetoscana.
beniculturali.it/index.
php?it/176/arezzo-basilica-
di-san-francesco*

Spot the anomalies in Piero della Francesco's greatest work

Thanks to the fact that only twenty-five people are allowed in at any one time, being in the presence of Piero della Francesca's *Legend of the True Cross* (1447–66) is an intensely intimate experience. It's arguable that it would be anyway, so absorbing is it. Block out your fellow worshippers in the *cappella maggiore* of Arezzo's church of San Francesco and the lucid colours and perfect proportions of the fifteenth-century cycle will leave you utterly entranced … but amused too, particularly if you know your art history. For this medieval 'history' of the cross, from its planting of the tree by the son of Adam on his father's grave to the Emperor Constantine carrying it into battle, is filled with unexpected references, including the Queen of Sheba in rich Renaissance-style gowns and King Solomon's palace seemingly modelled on the designs of notable Renaissance architect Leon Battista Alberti.

▶ Gaze through walls of steel in Puglia

Archaeological Park of Siponto

Viale Giuseppe di Vittorio, s.n.c., 71043
Manfredonia, Italy
musei.puglia.beniculturali.it/en/musei/parco-archeologico-di-siponto

Visitors to a couple of recent Coachella festivals might be forgiven for thinking they'd done a few too many mushrooms when confronted with the work of Edoardo Tresoldi. The Italian installation artist is renowned for making the most magical structures imaginable, and his Coachella pieces were no exception. They were, however, temporary. To see a permanent Tresoldi installation, head to the Archaeological Park of Siponto, where the artist has reinterpreted a space once occupied by an ancient early Christian church next to an existing Romanesque one. His delicate, ethereal-looking yet intensely present installation brings together wire mesh, light and space to present a piece that both looks there and not there, like a twenty-first-century mirage or an echo of Romanesque architecture sketched over medieval remains and writ large on the landscape. It will almost certainly leave you thinking you might have done one too many mushrooms (or glasses of wine) as well.

RIGHT *Basilica di Siponto* by Edoardo Tresoldi.

Venice Biennale

Venice, Italy
labiennale.org

▲ Beat a path to the best Biennale in the world

When it comes to art fairs, the gold medal surely has to go to the grand old Art Biennale of Venice. It literally is grand and old; founded in 1895, the official Gardini site alone houses thirty full-size pavilions offering a century of architectural styles forming a fascinating artwork in their own right. Housed within them are the official art entries from twenty-nine countries and a multinational themed exhibition curated by the Biennale's director, but beyond the Arsenale site, across Venice's buildings (and even in its canals, where Lorenzo Quinn's *Support* of 2017 and *Building Bridges* of 2019 delight and appal in equal measure), are hundreds of official and unofficial pavilions, exhibitions and events that combine to create the biggest art show on earth. They offer not just an opportunity to see trends in contemporary art but also interiors usually hidden, creating a razzamatazz art experience whose highlight is the only art here that is certain to positively unite critics and art fans alike ... Venice itself.

Peggy Guggenheim Collection

Dorsoduro, 701-704, 30123
Venice, Italy
guggenheim-venice.it

Imagine a pyjama party in Peggy Guggenheim's palace

Once the last visitors have departed from the beautiful Venetian Grand Canal palace containing the sumptuous Peggy Guggenheim Collection, a very curious activity takes place. Each artwork, from the Picassos (*The Poet*, 1911 and *On the Beach*, 1937) and the Brâncuşis (*Maiastra*, 1912 and *Bird in Space*, 1932–40) to the de Chiricos (*The Red Tower*, 1913 and *The Nostalgia of the Poet*, 1914) and the Mondrians (*Composition No. 1 with Grey and Red 1938* and *Composition with Red 1939*) via the Kandinskys (*Landscape with Red Spots, No. 2*, 1913 and *White Cross*, 1922) and the Pollocks (*The Moon Woman*, 1942 and *Alchemy*, 1947), is delicately clad in its own fitted sleeve, as soft as a pyjama top, with the picture of the artwork printed on it. Why? To protect the works from the bright light that floods the space when the staff open the blinds the following morning. Sweet.

▶ Shine a light on the dark ages in Ravenna

Ravenna, Italy

turismo.ra.it/eng/

For the best encounter with early Christian art you'll ever have, beat a path to the small town of Ravenna in Italy's Emilia-Romagna region, where eight World Heritage sites attest to the city's importance in the aftermath of Rome's decline. The Basilica of San Vitale is undoubtedly the star of the show, in part for the Baroque frescoes in its cupola and niches, but mostly for earlier mosaics of colourful Bible scenes amid vibrant, delightful scenes of nature. Natural motifs are prominent too in the Chapel of Sant'Andrea, where flowers, figures of Christ and at least ninety-nine species of birds dazzle. The Byzantine-style mosaics in the Basilica of Sant'Apollinare in Classe are similarly dazzling, as are those in the Mausoleum of Galla Placidia, built in the mid-fifth century and containing some of the oldest mosaics in the city. And lastly, the domes of the two baptisteries – Ortodossi and Ariani – are well worth suffering a crick in the neck for.

Go head to head with Caravaggio in Valletta

St John's Co-Cathedral and Museum

Triq San Gwann, Il-Belt Valletta, Malta
stjohnscocathedral.com

Murder, mayhem and madness surrounded the life and work of Michelangelo Merisi, better known as Caravaggio, and played no small part in the creation of his two masterpieces, *The Beheading of St John the Baptist* (*c.* 1607) and *St Jerome Writing* (*c.* 1605), preserved in Malta's St John's Co-Cathedral in Valletta. In May 1606, whilst working in Rome, one of the artist's many brawls resulted in him killing a man and he fled first to Naples, then to Malta, where he became the court painter for the Order of St John of Jerusalem. It wasn't to last. Soon Caravaggio's violent nature got him into trouble again, and in front of the dramatic brutality of *The Beheading of St John the Baptist*, the troubled artist was expelled from the Order after one violent incident too many. The painting is the only one Caravaggio ever signed and its extreme contrasts of light and dark, a technique that would come to be known as *chiaroscuro*, would have a formative influence on the ensuing Baroque art.

▼ Marvel at the Beethoven Frieze

Secession

Friedrichstrasse 12, 1010 Vienna, Austria
secession.at

Gustav Klimt's fascinating, feverish *Beethoven Frieze* is housed in an equally alluring building, the Secession (headquarters of the Secessionist art movement). His interpretation of the 'Ninth Symphony' was painted for the 14th Secessionist exhibition (conceived as a tribute to the composer) in 1902, but not shown again until 1986. It's a dramatic, unsettling work, running 34 m/111.5 ft across three walls, and packed with symbolism. The frieze shows mankind's search for happiness, with the forces of light and darkness – including a knight in shining golden armour and a terrifying giant, Typhoeus – vividly portrayed, and ends with an exquisite scene of joy and salvation.

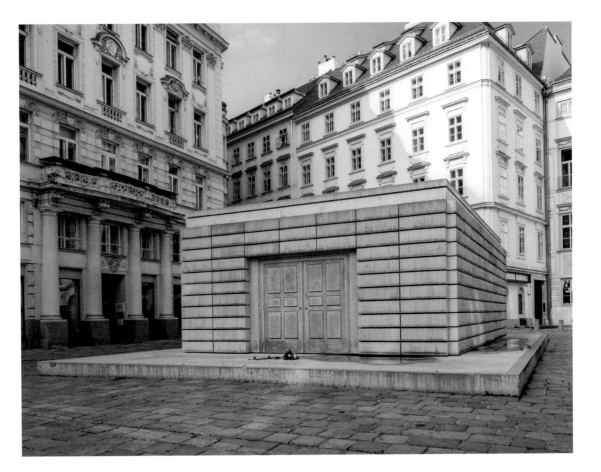

Rachel Whiteread
Holocaust Memorial

Judenplatz, 1010 Vienna,
Austria
*visitingvienna.com/sights/
museums/holocaust-
memorial/*

ABOVE Judenplatz Holocaust
Memorial (2000) by
Rachel Whiteread.

LEFT Detail from the *Beethoven
Frieze* by Gustav Klimt.

▲ Reflect on Austria's sombre twentieth-century history in Vienna

Vienna is home to some of the most magnificent art in Europe, but very little of it is post-Second World War, and even less deals with the horrific events of that war. British sculptor Rachel Whiteread's Holocaust Memorial, Austria's first memorial to its 65,000 Jews murdered in the Holocaust, is the very honourable exception. Set in the small, unprepossessing Judenplatz, *Nameless Library*, a steel and concrete inverted library of stark lines with no means of ingress and thousands of book spines facing inwards so that their identities remain unknown, symbolizes the huge numbers of Holocaust victims and the untold stories of their lives in a brutally effective manner. According to Whiteread, it aims to 'invert people's perception of the world and to reveal the unexpected'. The location has its own particular resonance: the memorial sits on top of the excavated remains of a Jewish synagogue destroyed in a pogrom nearly 600 years ago.

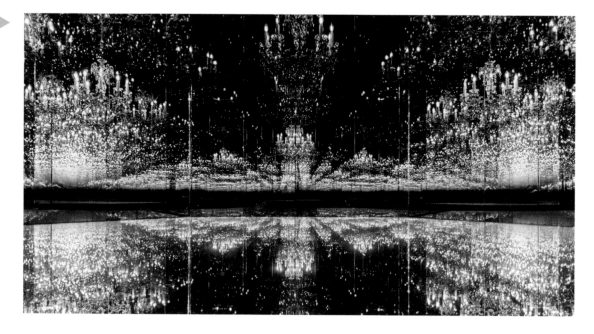

Get to know Egon Schiele at the Leopold Museum

Leopold Museum

MuseumsQuartier, Museumsplatz 1, 1070 Vienna, Austria
leopoldmuseum.org

This temple to nineteenth- and twentieth-century Austrian art holds one of the largest Egon Schiele collections in the world, with forty-two paintings and 184 drawings, watercolours and prints, as well as a wealth of ephemera. Rudolf and Elisabeth Leopold amassed thousands of pieces over five decades, and the cream of their collection is shown at the Leopold Museum. Opened in 2001, its austere, sensitively lit interiors are ideally suited to viewing Schiele's work. The artist was infamous for explicit and transgressive paintings such as *Seated Male Nude (Self-portrait)* of 1910 and *Cardinal and Nun (Caress)* of 1912, but also on permanent display are some of his most bewitching landscapes, such as *Setting Sun* of 1913. The on-site Egon Schiele Documentation Centre – open by appointment – provides online access to Schiele's writings and correspondence.

▲ Wander seventeen Chambers of Wonder at Swarovski Crystal Worlds

Swarovski Kristallwelten

Kristallweltenstrasse 1, 6112 Wattens, Austria
swarovski.com/kristallwelten

What aliens landing in the Tyrolean countryside around Wattens would make of the giant grass-covered head spouting water from its mouth into a glistening mirror pool that is the entrance to Swarovski Kristallwelten is anyone's guess. But it's as nought compared to what they'd make of the contents beyond the gaping mouth. For here lie seventeen Chambers of Wonder containing all manner of installations and sculptures created using Swarovski crystals to jaw-dropping effect, including showstoppers like Yayoi Kusama's *Chandelier of Grief* (2018), *Silent Light* by Alexander McQueen and Tord Boontje (2020), South Korean artist Lee Bul's trippy *Into Lattice Sun* (2015) and *Crystal Dome* (1995), where music by Brian Eno – and mirrors – make it a popular wedding site.

Vigeland Sculpture Park

Frognerparken, 0268 Oslo,
Norway
vigeland.museum.no

LEFT *Chandelier of Grief* (2016)
by Yayoi Kusama, installed at
Swarovski Kristallwelten.

BELOW *Wheel of Life* (1933–34)
by Gustav Vigeland.

▼ Park yourself in front of the emotional work of Gustav Vigeland

Sculptor Gustav Vigeland's skills clearly were not limited to his art, for this arch persuader managed to convince the city of Oslo to build him a home/studio in return for all his sculptural works (at an unspecified date), while also managing to upgrade a commission for a fountain into a whole sculpture park filled exclusively with his figurative explorations of the human form expressing different emotions. Both now comprise the Vigeland Sculpture Park and Museum, with the former housing more than 200 sculptures in bronze, granite and cast iron, and the latter transformed into the Vigeland Museum, which exhibits and preserves his work. These fanciful, often overwrought works, replete with dragons and bulging forms, may not be to everyone's taste, but they are definitely memorable.

Muse over Munch treasures in Oslo

Since his death in 1944, some 28,000 paintings, sketches, photographs and sculptures by the world-famous painter Edvard Munch have been housed in Oslo's Munch Museum, but in 2021 they are all due to take up residence in a brand new waterside space in Bjørvika, called MUNCH. Alongside the 28,000 works willed to the country by the artist, another 12,000 pieces associated with him are slated to be added to the new collection, including of course *The Scream* (1893), *Madonna* (1894) and *Girls on the Bridge* (1899). Intriguingly, it is planned that a few historical treasures will also be buried in one of the building's foundation stones, consisting of a small casket with objects from the different municipalities in which Munch lived during his lifetime – including apple seeds from his garden at Ekely, soil from the farm on which he was born and a copy of his will. Look for it in the foyer of the startlingly modern – and very controversial – new building, whose glassy exterior is intended to reflect and merge with the surrounding landscape.

Steilneset Memorial

Andreas Lies Gate, 9950
Vardø, Norway
nasjonaleturistveger.no/en

Fall under the spell of Peter Zumthor and Louise Bourgeois in Norway's Vardø

If one of the roles of art is to make us feel the forces of our world, both dark and light, the 2011 Steilneset Memorial, set hard by the black crashing waves of the Barents Sea on the jagged, barren coastline of Vardø, succeeds brilliantly. Marking the 1621 execution of ninety-one women and men accused of witchcraft, the memorial is an elegiac installation composed of architect Peter Zumthor's shadowy, disconcerting corridor dotted with ninety-one randomly placed small windows illuminated by a hanging light bulb. It is connected by a wooden walkway to a black glass cube containing the last commission of sculptor Louise Bourgeois, *The Damned, The Possessed and The Beloved* (2011) – an endless flame surrounded by seven oval mirrors reflecting the flames like judges surrounding the condemned. Taken together, the two elements manage to convey both the humanity and pathos of the victims and the violent destruction of the flames that killed them, delivering an art experience that is as uncomfortable and disconcerting as a memorial should be.

RIGHT The Ordrupgaard extension, cast in black lava concrete.

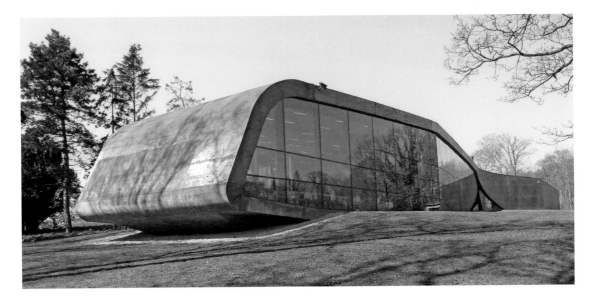

Take a stroll through the romantic landscapes of Lars Hertervig

Stavanger Museum of Fine Arts

Henrik Ibsens gate 55, 4021 Stavanger, Norway
stavangerkunstmuseum.no

There is something wonderfully appropriate about the fact that the paintings of Lars Hertervig are housed in the Stavanger Museum of Fine Arts, a building located in such a bucolic lakeside setting that you can't help but feel that had the Norwegian romantic landscape painter been alive today rather than in the nineteenth century, he would have permanently set up his easel in its grounds – and perhaps have had a much easier life. The seventy works in the collection, ranging from contemplative depictions of primeval forests and forbidding fjords to brighter light-filled skyscapes, clearly illustrate the highs and lows of mental anguish the artist experienced during much of his life, and mark him as one of Norway's most important painters. Equally unmissable are the pieces comprising the Hafsten Collection, a former private collection of works by mid-twentieth-century Norwegian painters.

▲ Admire work by France's most famous female artist ... in Denmark

Ordrupgaard

Vilvordevej 110, DK-2920 Charlottenlund, Denmark
ordrupgaard.dk/en

A short and enjoyable waterside train ride away from Copenhagen lies this wonderful museum, an airy space (with an extension by Zaha Hadid) in extensive parkland housing one of northern Europe's best collections of Danish and French art from the nineteenth and early twentieth centuries – including, from the former, paintings by Wilhelm Hammershøi, L.A. Ring, Jørgen Roed and Christen Købke, and from the latter, works by Édouard Manet, Claude Monet and Berthe Morisot. Morisot is well known as the sister-in-law and muse of Manet, but she was also a prolific and gifted painter, and you'll find her work in national museums across the world, from London and France to tens of North American museums. But it's only here in Denmark that her work can be enjoyed alongside a unique feature – the house of furniture designer Finn Juhl, who sited and furnished one of Denmark's first functionalistic one-family houses next door to the Ordrupgaard.

Mix Mozart with Miró at the Louisiana Museum of Modern Art

Louisiana Museum of Modern Art

Gl. Strandvej 13, 3050 Humlebæk, Copenhagen, Denmark
louisiana.dk

Famous for its design heritage, Denmark doesn't skimp when it comes to art appreciation either, and one of the loveliest art sites in the country is the Louisiana, a delightful 30 km / 19 mi train ride away from Copenhagen in the coastal town of Humlebæk. First views of the gallery's 4,000-strong post-Second World War collection are in the garden, with a Calder mobile dancing in the breeze, a bird-like Miró nestled among the trees, and a monochrome Dubuffet asserting itself among the greenery. Indeed, some sixty pieces can be enjoyed against the backdrop of the Øresund Sound. The modern airy gallery is a great place to visit any time, but on occasional Fridays the café hosts Friday Lounge, with live music spanning everything from jazz and pop to soul and folk. But it's the chamber concerts that really seem to be in tune with the surroundings; contemplating the sculptures in the park to the strains of Mozart or Schubert is a memorably different art experience.

▼ Ride a mule bunker on Blåvand Beach

Blåvand Beach

West Jutland, Denmark
visitdenmark.com/denmark/explore/bunker-mules-blavand-gdk769752

Introducing playful art to little ones is child's play at the gorgeous beach of Blåvand in Denmark, where the unusual mules gazing out from land to sea seem to invite eager riders on to their backs. Just a handful of the more than 7,000 concrete bunkers built here during Germany's occupation of Denmark during the Second World War were turned into the appealing sculptures by British artist Bill Woodrow, who, as part of a collaborative project involving more than twenty-four artists, was commissioned to mark the fiftieth anniversary of the war's end. His mules may look frivolous, but being infertile, Woodrow's choice of them was anything but. His intended statement – that the terrors of war should not be able to reproduce – was, and remains, a powerful piece of symbolism.

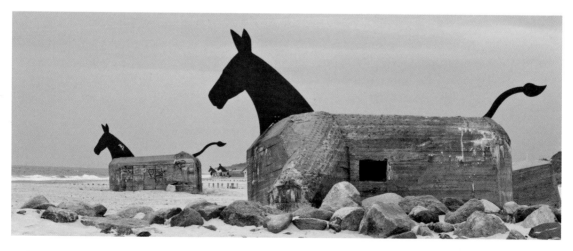

Carl Larsson-gården
in Sundborn

Carl Larssons väg 12, 790 15
Sundborn, Sweden
carllarsson.se

▲ Home in on Sweden's most famous artistic duo

With their delicate lines, winsome subjects and pretty colours, the Art Nouveau works of Sweden's most famous artist are not to everyone's taste, but seeing them in Lilla Hyttnäs, the home Carl Larsson made with his wife Karin Bergöö and their children, is a magical experience that contextualizes it while also offering some insight into the harsh background Larsson endured to get here. But just as enjoyable is seeing Karin's creations as a designer and maker in situ; her boldly coloured and patterned abstract textiles and embroidery in particular stand out amid her graceful interior design. A lovely walk between Falun and Sundborn village, along a trail dotted with signs giving historical information about the old road as well as stories and information relating to the family, adds to the appeal. End your visit with a stop at Stockholm's National Museum to see Larsson's monumental *Midvinterblot* (1915).

LEFT Abandoned Second World War bunkers converted into mules on Blåvand Beach.

ABOVE The home of Carl Larsson and Karin Bergöö.

TRAIL: Walk among the gods and monsters of Niki de Saint Phalle

Had she been a man, the life and times of conceptual artist Niki de Saint Phalle would be far more familiar to many of us than they are. For both were extraordinary – raped by her father at the age of eleven, a *Vogue* cover model by the age of seventeen, incarcerated in an insane asylum where she was given electro-shock therapy, married to Jean Tinguely, and finally an artist whose oeuvre included *Les Tirs* (*The Shots*), a conceptual art act of 1961 in which she fired shots of paint at her canvas. But it's her *nanas* and mosaic sculptures that have been her legacy; decades on, they're loved and loathed across the world.

Tuscany

Italy

The 5.7-hectare/14-acre Tarot Garden sculpture park built over Etruscan ruins in the little Tuscan town of Capalbio was initially loathed by locals, who raged against the mad woman and her monsters but were won round with a range of creative roles in the making of a garden in which the twenty-two figures of the Tarot's major arcana would feature as giant, colourful sculptures covered with glass mosaics.

Paris

France

Saint Phalle and Jean Tinguely's marriage is literally represented in the *Stravinsky Fountain* (1983) outside the Centre Pompidou, where a surreal group of her sculptures – among them red lips, rainbow-coloured fish and birds, mad mermaids and beating hearts – are arranged in a fountain with her husband's kinetic iron machines, all shooting water at one other.

Stockholm

Sweden

It took a frantic six weeks in 1967 for Saint Phalle and Tinguely to create *Le Paradis Fantastique*, during which Saint Phalle lost 6.8 kg/15 lbs and was hospitalized with pneumonia. The flowers, monsters and other imaginary creatures she made using 300 m^3/10,594 ft^3 of expanded polystyrene, 2 tons of polyester and 8 km/5 mi of fibre glass, frolic to this day on the island of Skeppsholmen in central Stockholm.

Jigyo Central Park

Fukuoka City, Japan

Looking for all the world like some crazy cosplay character landed from the future atop a rocky outcrop in the city centre, Saint Phalle's *Oiseau amoureux* from 1990 looks perfectly at home – as do her *Arbre Serpents* (1999) in Tokyo's Tama City.

Kit Carson Park

Escondido, California, USA

Queen Califia's Magical Circle is Saint Phalle's only sculpture garden in America, and it's as magical and surreal as you'd expect. Snakes sit atop the boundary walls, totemic sculptures depict deities, monsters, animals, humans and abstract shapes, and at its centre lies the mythical black Amazon queen Califia, ruler of a terrestrial island paradise.

ABOVE One of Niki de Saint Phalle's Hanover *nanas*.

Hanover

Germany

Three of Saint Phalle's biggest nanas can be seen on the banks of the Leine River, in Hanover, where they fuelled a lively debate about the propriety of public art when they were unveiled in 1974. A year after her death in 2002, another work for the city, a painted grotto for the Herrenhausen Grosser Garten, was her last major artistic project to be completed.

Gwacheon

South Korea

Saint Phalle's take on *The Three Graces*, *Les Trois Graces Fontaine* (1995), is a long way from Antonio Canova's original of 1815–17, but the three colourful bathers dancing in the fountain of a South Korean city somehow seem perfectly in tune with their twenty-first century surroundings.

OVERLEAF ▶
Niki de Saint Phalle's Tarot Garden sculpture park in Capalbio, Tuscany.

No Limit

Borås, Sweden
nolimitboras.com

◀ Spend a colourful weekend living it large in Sweden

About to enter its fifth year, Borås's No Limit street art festival gets bigger and better with each iteration – indeed, last year it joined with fellow arts organization Artscape to create an international festival that not only presented large- and small-scale street art across the town from urban artists as far afield as Canada and Chile, but also brought new elements to it, building on the guided walks and tours already offered by No Limit. Attractively set on the River Viskan, the university town comes alive with the artwork, and to experience it during a balmy autumn makes a vibrant weekend break.

Moderna Museet

Exercisplan 4,
Skeppsholmen, 111 49
Stockholm, Sweden
modernamuseet.se

Hop aboard for a boat trip with a difference

There aren't many modern art museums accessible by boat, but Stockholm's Moderna Museet is just that. Located on the pretty island of Skeppsholmen, the bright red museum holds both temporary exhibitions by artists such as Louise Bourgeois, who exhibited several pieces never previously seen in public, and a fine permanent collection with a strong Russian avant-garde presence. Women are particularly well represented, with, among others, pieces by Dorothea Tanning, Judy Chicago, Susan Hiller, Rosemarie Trockel, Mona Hatoum and Doris Salcedo. A sculpture garden outside contains a delightfully playful piece, *Le Paradis Fantastique* (1967) by Niki de Saint Phalle and Jean Tinguely.

Finnish National Gallery

Kaivokatu 2, 00100 Helsinki, Finland
kansallisgalleria.fi

See Finnish art at its best in spaces old and new

Its white curving spaces will remind art lovers of the New York Guggenheim, but Kiasma's original contemporary art offering is very much its own, with four floors dedicated to permanent collections, quarterly shows and studio spaces with individually curated programmes. It's just one of three buildings that make up the Finnish National Gallery, with the other two, the Ateneum Art Museum and Sinebrychoff Art Museum, respectively showing off very respectable collections of Finnish and international art up until the year 1969, and old international art from the fourteenth century to the early nineteenth century. The Ateneum has some real standouts, including the gorgeous *Luxembourg Gardens, Paris* of 1887 by Albert Edelfelt, and works by Le Corbusier, Edvard Munch and Vincent van Gogh in a historical building that's one of the city's most elegant.

LEFT The colourful No Limits street art of Boras.

Galerie Klatovy Klenová

Klenová 1, 340 21 Janovice
nad úhlavou, Czech Republic
gkk.cz

Wander medieval ruins to find modern delights

The mix of crumbling ruins and modern sculpture in this little corner of the Czech Republic delivers an appealing experience that you're unlikely to forget, not least for its beautiful Šumava Valley national park setting. There's a small painting gallery in a pleasing château that's appealing too, but it's the exterior, a combination of medieval castle ruins, majestic setting and well-considered works by predominantly national sculptors such as Vincenc Vingler, Václav Fiala and Jiří Seifert that will stay with you. Coming unexpectedly across a piece or spotting one framed through a window against a mountain backdrop is lovely.

▶ Follow that baby – and lots more – on a peculiar Prague sculpture trail

David Černý Trail

Prague, Czech Republic
praguego.com/honest-tips/david-cerny-tour

Prague's enfant terrible of the art world David Černý never discusses his artwork, but much of it speaks for itself. Since painting a war memorial pink in 1991 (he was arrested for that one) he has not stopped provoking debate, and on a tour of his work in Prague you will discover why. Don't-misses include *Piss* (2004), in which two mechanical men urinate on a map of the Czech Republic; *Horse* (1999), a parody of the famous King Wenceslas statue read by many as a critique of one-time Czech president Václav Klaus; and the famous faceless *Babies* (2000), found everywhere but particularly powerful crawling up the Žižkov television tower. In *Brown Nosers* (2003), you can even put your head up a politician's backside – climb a ladder, poke your head through and you'll find a video of Czech politicians (including Klaus) feeding each other human waste. Černý is seen as a mad cross between Banksy and Damien Hirst, but he is a true original.

▲ Go underground for a heavenly sight

The Wieliczka Salt Mine

Daniłowicza 10, 32-020 Wieliczka, Poland
kopalnia.pl

Imagine an underground site that contains a lake, 300 km/186 mi of tunnels over nine levels and, among it all, statues, friezes, carvings, chandeliers and even chapels – all made from rock salt. Welcome to the Wieliczka salt mine, 14 km/8½ mi southeast of Kraków in southern Poland. Excavated from the thirteenth century and continuing to produce table salt until 2007, this UNESCO site is a marvel of engineering, but add in the creative endeavours of thousands of miners, and more latterly artists – resulting in works like Leonardo da Vinci's *Last Supper*, statues of St Barbara and Pope John Paul II, and the astonishing Chapel of St Kinga, where everything from altarpieces to chandeliers is hewn from salt – and you have a truly phenomenal cultural experience.

Find a happy marriage of modern and traditional in Kraków

The Church of St Francis of Assisi

plac Wszystkich Świętych 5, 31-004 Kraków, Poland
franciszkanska.pl

You may never have heard of him, but if you visit the Franciscan Church in Kraków (and you should) the name of Cracovian painter, poet, stage designer and typographer Stanisław Wyspiański will stay with you for one reason – or eight. Inspired by the Art Nouveau style taken up with enthusiasm by western Europe, Wyspiański found an early affinity for stained glass and adopted the style to stunning effect in his work on the eight stained-glass windows of the church in his Austrian-occupied hometown. From abstract natural motifs that echo his earlier wall paintings in the space – gorgeous, colourful violets, roses, geraniums and snowflakes in geometric patterns, all inspired by St Francis's love of nature – to flowing, Modernist figurative windows, his style is unique in marrying the bold Expressionistic Modernism of the new century with traditional Polish folk and romantic themes.

ABOVE Chapel in the main hall of the Wieliczka Salt Mine.
LEFT David Černý's *Babies* (2000) on the Žižkov Television Tower.

▲ While away an hour or two getting to know the statues in Bratislava

Bratislava, Slovakia

Although none of the statues in Bratislava can be considered 'high art', they are a lot of fun. Hans Christian Andersen spent time here and loved the city, so he gets a statue, surrounded by many of the characters from his books (apart from the Ugly Duckling, which was stolen). Near him is *Stone Korzo*, placed here in 2003 and related to the Soviet occupation, while *Schöne Náci*, on the main square, is the only statue made of silver (the rest are bronze) and the only one based on a real person. And don't miss *Čumil*, an icon of Bratislava, who can be seen poking up out of an open manhole. Actually, do miss him – when he was first installed in 1997 he was run over by delivery trucks twice and several drunks fell over him, so eventually in the interests of health and safety a post was put up to warn anyone who didn't notice him.

Ponder spiritual matters a heavenly Hungarian roo

Tákos Calvinist Church

Bajcsy-Zsilinszky u. 29, Tákos 4845, Hungary
templomut.hu/uk/takos/34

In many ways, small churches can often feel more spiritual than grand cathedrals, particularly if their contents are unexpected treasure troves in comparison with their humble exteriors. Take the Calvinist church set across the Bereg region of north-east Hungary. These understated wooden churc in villages such as Csaroda and Tákos, usually painted white and bearing small windows, hide riots of colour in their tiny interiors, where their makers decorate walls ceilings and other surfaces with gaily painted motifs from nature and more traditional Romanesque frescoes, and usually throw in a bit of folk sculpture for good measure. A particularly memorable on is the eighteenth-century Tákos Calvinist Church, where the fifty-eight bright panels painted on the ceiling by Ferenc Lándor Asztalos will keep you gazing heavenward for a while, and perhaps even wondering whether something other than the sky and space does lie beyond it.

Déri Museum

4026 Debrecen, Déri tér 1, Hungary
derimuzeum.hu

Find folklore and more in a masterful Hungarian collection

The Déri Museum is one of those places where you think you'll spend an hour and could easily spend a day. Here are themes and works from around the Far East, there archaeological and ethnographic collections, and threaded through it all folk works from near and far. But the main reason to come here is to see the work of painter Mihály Munkácsy, who was clearly influenced by his travels in the late nineteenth century – in particular the loose brushwork of J.M.W. Turner and the naturalism of Édouard Manet. Eschewing the somewhat saccharine romantic painting of his Hungarian forebears for a new style of Expressionist Realism, Munkácsy became one of the country's most revered painters, and his *Passion of Christ Trilogy* (1882–96) takes pride of place in the purpose-built Munkácsy Hall, the monumental *Christ before Pilate*, *Golgotha* and *Ecce Homo* only united here in 1995.

National Gallery of Art

Konstitucijos pr. 22, LT-08105, Vilnius, Lithuania
ndg.lt

Take an award-winning art tour of Vilnius

If you had to guess which country won the 2019 Golden Lion, the Venice Biennale's most prestigious prize, you'd almost certainly not land on Lithuania. And yet *Sun & Sea (Marina)*, in which holidaymakers lounged on an indoor beach being watched from above by visitors, wowed audiences and art pundits alike, and has since been continuing to do so around the globe. The piece, a collaboration between director Rugilė Barzdžiukaitė, writer Vaiva Grainytė and artist and composer Lina Lapelytė, made its debut at Vilnius's wonderfully austere Soviet-era National Gallery of Art, just one of a surprising number of art centres in a tiny city with a population of just over half a million. They range from Daniel Libeskind's angular MO Museum to the dark, semi-crumbling Atletika Galeria via the lively outlier Rupert, literally on the outskirts of town. Collectively, it all makes for a fun mixed bag of art institutions you would be hard-pressed to find anywhere else, which may account for the appeal of the award-winning *Sun & Sea*.

LEFT *Čumil*, the famous statue of a man emerging from a manhole, in Bratislava.

▶ Stir things up with the witches on the hill

Hill of Witches Sculpture Park

Juodkrantė 93101, Lithuania
lithuania.travel/en/place/hill-of-witches

As a memorable example of folk art, places don't come much more memorable than the Hill of Witches on the outskirts of Lithuania's Juodkrantė. For on this sandy, forested hill, wooden sculptures of witches crowd the scene like so many *Macbeth* vignettes. The figures supposedly reside on a spot where real ones congregated to dance and make magic, a fact that inspired local forester Jonas Stanius, who in 1979 invited a group of artists to make the first sculptures. There are now close to one hundred dotted across two sections, light and dark, and needless to say, it's the dark side that will draw you to its dragons and devils. On both sides, the views – of the Baltic Sea on one side and the Curonian Lagoon on the other – will linger as much as the sculpture.

RIGHT Wooden sculptures depciting a dragon as well as human figures in the Hill of Witches Sculpture Park.

Mamayev Kurgan

Volgograd, Volgograd Oblast, Russia
stalingrad-battle.ru

BELOW *Rodina Mat* (1967) monument to the fallen of the Battle of Stalingrad on Mamayev Kurgan.

RIGHT Viewing works by Kazimir Malevich on display at Moscow's State Tretyakov Gallery.

▼ Gaze in awe at the mother of all statues

Many of the former Soviet Union's public commissions are monumental, and *Rodina Mat* – or *The Motherland Calls* – is no exception. Standing 85 m/279 ft high atop the Mamayev Kurgan shrine to the fallen in Volgograd (formerly Stalingrad), she marks the deaths of the millions of souls lost during the Battle of Stalingrad of 1942–43. Designed by sculptor Yevgeny Vuchetich and until 1967 the largest statue in the world, she still wields the largest sword in the world (22 m/72 ft), but it is not the scale that dominates. Another *Rodina Mat*, in Kiev, Ukraine, is actually bigger, but the version in Volgograd, with its bold, fearless stance and strength of the female form, proves that it's not always the size that counts.

▲ Get into Goncharova and other modern Russian works

The State and New Tretyakov Galleries

Lavrushinsky Lane, 119017 Moscow, Russia
tretyakovgallery.ru

Like two sides of the same coin, Moscow's State Tretyakov Gallery and New Tretyakov Gallery could not be more different. The former, a whimsical fin de siècle building designed by the painter Viktor Vasnetsov in a Russian fairytale style, houses some of the country's most famous fine art, but it is the collection contained in the New Tretyakov that best represents the recent history of the country. Behind its late-Modernist façade, key works by the likes of Wassily Kandinsky, Lyubov Popova and the founders of Russia's avant-garde movement, Natalia Goncharova and Kazimir Malevich, tell the story of fine art's unique avant-garde journey in post-revolutionary Russia. And, perhaps best of all, it is all contextualized in a modern framework that brings visitors into the twenty-first century with engagingly innovative temporary exhibitions such as 2018's full virtual reality immersion into the carefully recreated studios of Goncharova and Malevich.

Find the beating heart of Moscow's modern art scene in Gorky Park

The Garage Museum

Krymsky Val, 9, стр.4, Moscow, Russia 119049
garagemca.org

Think of Russian art and chances are you'll think of glorious brightly coloured classical buildings housing some of the world's greatest visual art (yes, we're looking at you, State Tretyakov Gallery, see left), but in 2015 a new gallery opened offering something completely different. The polycarbonate-clad Garage Museum of Contemporary Art, designed by Rem Koolhaas' firm OMA, is a spectacular modern art gallery opened in a refurbished Soviet-era restaurant in Moscow's Gorky Park. It houses the gallery owned by Russian gallerist Dasha Zhukova and her ex-husband Roman Abramovich, who as well as hosting impressive international exhibitions, commission site-specific artworks in the 9.5- x 11-m/31- x 36-ft wide foyer and exhibit local work. Best of all, the space retains original Soviet mosaics, as well as decorative tiles and brickwork elements, to give an elegant juxtaposition of old and new.

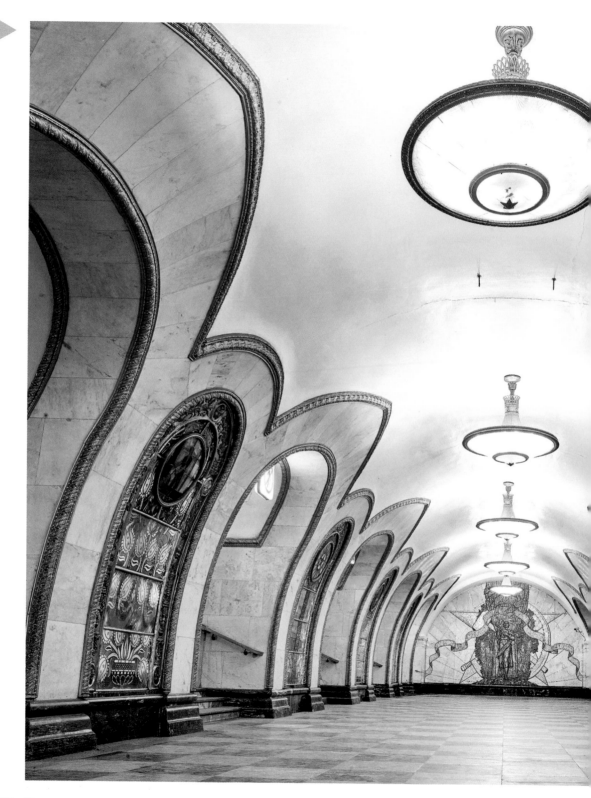

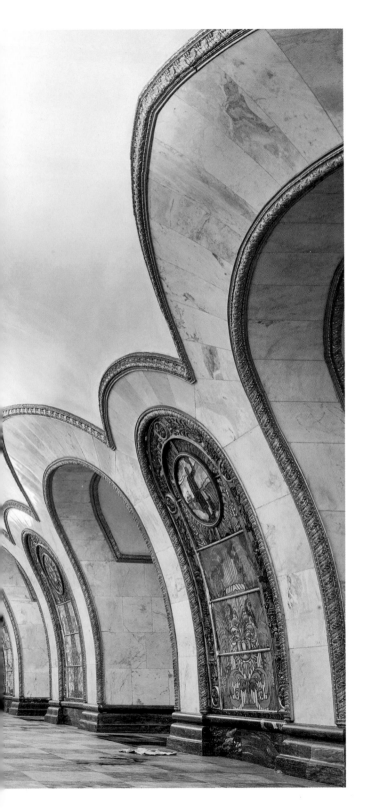

◀ Go low for some high art in Moscow

Moscow metro

mosmetro.ru

Above ground, Moscow boasts some of the best art in the world, but beneath its streets lie an equally arresting array of creative endeavours. The twelve stations that make up the metro system's ring line (Koltsevaya) were beautifully designed and decorated by leading Soviet artists and sculptors in the early twentieth century to illustrate the power and wealth of the Soviet Union, and for the price of a daily ticket you can see them all. Standouts include Isaac Rabinovich's bas reliefs in the marble-clad Park Kultury, the gorgeous gold and silver aircraft-themed decoration of Aviamotornaya, and perhaps best of all, the thirty-two stained-glass panels of Novoslobodskaya, designed by the famous Soviet artist Pavel Korin. And on the Zamoskvoretskaya Line, the Art Deco mosaics of Mayakovskaya are unmissable.

LEFT Novoslobodskaya metro station.

The State Hermitage
Museum

Palace Square, 2, St
Petersburg, Russia 190000
hermitagemuseum.org

▲ Dig up the roots of Abstract Expressionism at the Hermitage

What a strange dichotomy the grandiose gilded-green Winter Palace of Catherine the Great presents in the modern world. Outside, the six-building complex looks for all the world like a private house on a gigantic scale. Inside resides one of the world's most magnificent art museums, with work spanning millennia of creativity and artistic expression. Among them, the one painting that perhaps best illustrates that struggle with pure expression is Wassily Kandinsky's *Composition VI* of 1913. It was a piece the Russian artist struggled with for six months in an attempt to evoke a flood, baptism, destruction and rebirth simultaneously in a canvas that did away entirely with the real world, using line and colour instead to convey emotions and sensations. Fellow painter and partner Gabriele Münter suggested he focus on the word *uberflut* (deluge, or flood), and Kandinsky was able to finish the work in three days.

ABOVE *Composition VI* (1913) by Wassily Kandinsky.

RIGHT Hilye of the Prophet Muhammad in the shape of a pink rose (18th century).

The State Russian Museum

4 Inzhenernaya Street, St
Petersburg, Russia 191186
en.rusmuseum.ru

Explore the history of Russian art with the Wanderers

The sheer scale of this museum complex dedicated to Russian art – more than 400,000 pieces of it – can be daunting, but there is one body of work that has a very special place in Russian art history. Peredvizhniki, known as the Wanderers or Itinerants in English, were a group of late nineteenth-century Russian Realist artists who formed a cooperative in protest against academic restrictions, focusing on journeyman subjects such as peasants and social issues which chimed with and reflected a country about to explode. Among paintings by Ilya Repin, Ivan Kramskoy, Isaak Levitan and Mikhail Nesterov, perhaps the one piece that best sums up Russia's revolutionary road is Repin's work from 1907–11, *The Manifesto of October 17th 1905*. Revolutionary artworks continue with a fabulous modern collection that takes in the second iteration of Kazimir Malevich's game-changing *Black Square* from 1923 (the first, from 1915, is at the Tretyakov Gallery in Moscow; see page 187).

▶ Get wrapped up in some gorgeous textiles at the Sadberk Hanım Museum

Sadberk Hanım Museum

Piyasa Caddesi No: 25/29 Büyükdere, 34453 Sariyer,
Istanbul, Turkey
sadberkhanimmuzesi.org.tr

Istanbul is filled with enough attractions to keep you busy for a very, very long weekend, but it's also a very, very busy city. Pretty much everything you want to see will entail queues and crowds, except, mysteriously, the lovely Sadberk Hanım Museum. Housed in a wonderful example of a nineteenth-century summerhouse on the shores of the Bosphorus, the original private collection of the house's owners, Sadberk Koç and Vehbi Koçc, has expanded to some 20,000 pieces spanning prehistoric Anatolian pieces from the sixth millennium BC to Byzantine art and design, including jewellery, porcelain, glass, sculpture and, our personal favourites, eye-poppingly bright and delicate woven Ottoman textiles and a world-class selection of İznik tile art. It's a great way to escape the hordes, and see a side of Istanbul very few people know about.

▶ Be dazzled by the gem that is the Chora Church Museum

Chora Museum

Dervişali, Kariye Cami Sk No. 18, 34087 Fatih, Istanbul, Turkey
muze.gov.tr/muze-detay?DistId=KRY&SectionId= KRY01

There are more famous and bigger religious sites in Istanbul, but the exquisite Chora Church and Museum, converted in the sixteenth century from a Byzantine church into a mosque, proves that it's not always about fame and size. Its unique position is down to an interior covered with some of the oldest and finest surviving Byzantine mosaics and frescoes in the region, all uncovered and restored after the building was secularized and turned into a museum in 1948. The fourteenth-century works exist thanks to Theodore Metochites, a wealthy Orthodox Byzantine aristocrat who commissioned the frescoes, mosaics and murals before being forced into exile, eventually returning to his beloved church to became a monk and, on his death, be interred on the site.

Istanbul Museum of Modern Art

Meşrutiyet Caddesi, No. 99, 34430 Beyoğlu, Istanbul, Turkey
istanbulmodern.org

Catch a thoroughly modern collection in a thoroughly modern new home

At the time of writing it's unknown quite how Istanbul Modern's 'currently under construction' home will turn out, but if it's anything like the original, Italian starchitect Renzo Piano's reboot will be a sure-fire winner. The building the art gallery was housed in for fourteen years was one of several warehouses built during the 1950s and designed by the eminent architect Sedad Hakkı Eldem, and it's hoped that when it reopens the totally remodelled site will have retained its elegance and swagger while being thoroughly updated with twenty-first-century versatility and flair. Until then, the fine contemporary art collection – among it a number of paintings by renowned twentieth-century abstract painter Fahrelnissa Zeid, subject of a Tate Modern retrospective in 2017 – is well worth catching at its current space, the Union Française, a sprawling low-slung building filled with space and light in the heart of the art and culture district of Beyoğlu.

Odunpazarı Modern Museum

Şarkiye Mah. Atatürk Bul., No. 37, Odunpazarı, Eskişehir, Turkey
omm.art/en/collection

LEFT Mosaic of Christ Pantocrator, south dome of the inner narthex in the Chora Church.

ABOVE Odunpazarı Modern Museum building at sunset.

▲ See modern art displayed at its best in a modern wooden museum

Amid a cluster of historic Ottoman houses in the Turkish town of Eskişehir, a clutch of wooden boxes rises incongruously from a startling white plaza. They are not huge crates, as they appear to be, but a museum housing the 1,000-strong modern art collection of Turkish industrialist Erol Tabanca. The building, designed as stacked, interlocking timber beams to reference the area's past as a centre for timber trading, is an architectural triumph in its relationship with its surroundings, but it's the relationship of the material with the art within that is the real triumph. Sculptural timber elements reach up and down into the galleries to interact beautifully with the modern art displayed so minimalistically in the light-filled spaces. And at its heart, where four of the stacked blocks meet, a sky-lit atrium rising the full height of the three-storey building is the icing on the cake.

CHAPTER 4

Africa

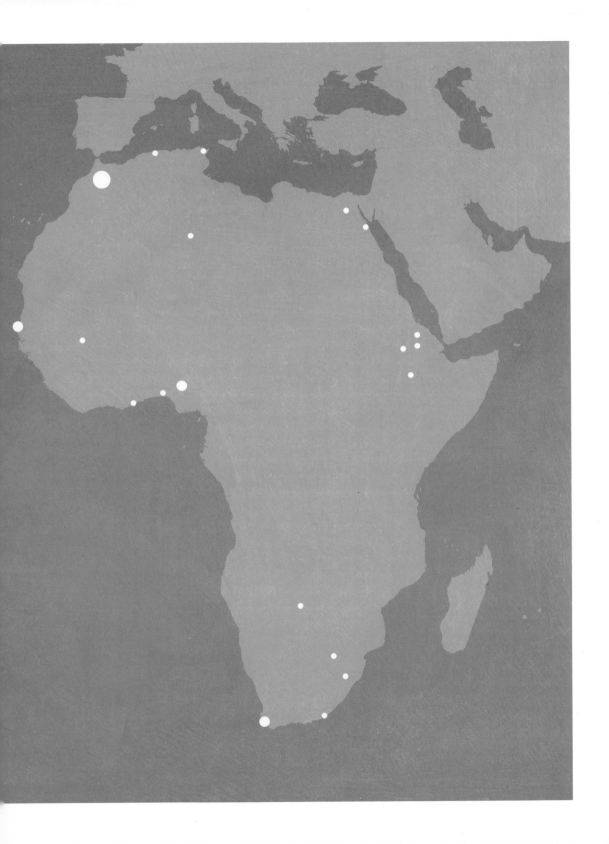

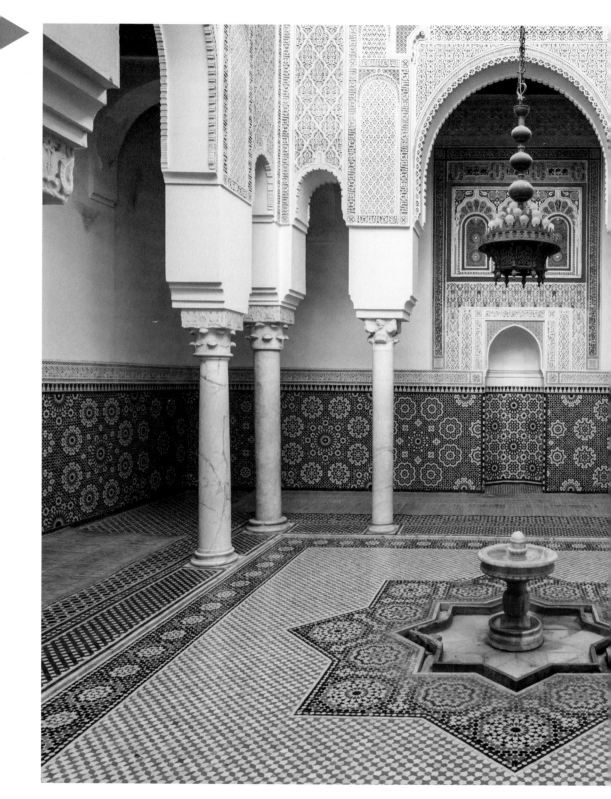

◄ Visit a little-known imperial city for a piece of Islamic art at its best

Mausoleum of Moulay Ismail

Meknès, Morocco

At the time of writing, the early eighteenth-century tomb of Moulay Ismail Ibn Sharif had been closed for extensive renovations since 2016, but it will one day reopen, and when it does, we will hopefully once again be able to admire the glory and opulence the ruler intended when he ordered it – and indeed all of Meknès – to be built as an imperial city during his reign as Sultanate of Morocco from 1672–1727. A blend of bright *zellij* (mosaic tilework), enamel-painted wood, carved plaster, arches, marble columns, fountains and other exquisite elements of Islamic architecture combine here in such harmony and beauty that even if non-Muslims are not allowed beyond the entry hall and the front courtyards when it reopens, as was the case before it closed, just being able to explore some of it, and peek into other bits of it, is worth the trip here.

LEFT The indoor patio chamber to the north of the mausoleum.

▲ Get to meet the cream of Africa's contemporary art crop

1–54 Contemporary African Art Fair

La Mamounia Palace, Avenue Bab Jdid, Marrakech 40040, Morocco
1-54.com/marrakech

We're not sure what it says that an art fair dedicated to showcasing the best of African art was first established in Europe and America before reaching Africa (in 2018), but of the three festival cities – London, New York and Marrakech – we know which we'd rather attend. It's partly because much of the art here – in 2019, pieces by more than sixty-five artists were drawn from eighteen African galleries across eleven African countries – feels better-contextualized in the heat, light and culture of north Africa, but there's also a freshness to the space and venue, the idyllic surroundings of the lovely La Mamounia hotel, that set it apart. Still, across all three locations, it's the art that sings out. Unsurprisingly, given access to the medium, photography is particularly strong, with the work of London-born Moroccan photographer Hassan Hajjaj standing out, and much of it is affordable too. Winter sunshine, great art, the chance to meet inspiring artists and buy their work – it's a no-brainer.

Enter the space of a visionary art collector

Museum of African Contemporary Art Al Maaden (MACAAL)

Al Maaden, Sidi Youssef Ben Ali, 40000 Marrakech, Morocco
macaal.org

This independent, not-for-profit contemporary art museum has a laudable aim of 'promoting African art through diverse exhibition and education programmes' and it does so by mounting consistently thoughtful and intelligent exhibitions showcasing art from Morocco and its neighbouring countries. It's not all emerging work; in a strong twentieth-century collection of more than 2,000 works, Albert Lubaki's ink on paper drawings from 1929 stand strong alongside more modern pieces such as Billie Zangewa's embroidered silk tapestry *Sun Worshipper in Central Park, 2009* and Abdoulaye Konaté's woven West African textiles for *Composition en bleu ABBA 1* (2016). Funded by avid art collectors Othman Lazraq and his father Alami Lazraq, the works of Moroccan artists play a central role in a collection started more than forty years ago by Alami, who began collecting African Modernist works long before they were hot. 'He's probably a visionary,' says Othman. We could not agree more.

Tassili n'Ajjer Cultural Park

Algeria

whc.unesco.org/en/list/179

▼ Take an unforgettable trip at Algeria's Tassili n'Ajjer rock art site

There are many famous rock art sites around the world, but across a vast plateau in the south-east of the Algerian Sahara at the borders of Libya, Niger and Mali, the 15,000 petroglyphs at remote Tassili n'Ajjer are somewhat under the radar. It's not easy to get to (Djanet is the nearest town, and you'll need a guide) but determined art lovers who do make it will find an unforgettable landscape filled with work dating to the ninth or tenth millennia. Here are large wild animals, including antelopes and crocodiles, mixed up with abstract geometrics, mythical creatures and humans in various acts, but it's the fungoid rock art (best represented by the Tassili mushroom man Matalem-Amazar, a shaman covered with mushrooms), that is the standout piece. Many have posited the theory that it offers proof of man's ancient relationship with psychedelic drugs; it certainly shows an extraordinary level of imagination.

LEFT Admiring works at the 1–54 Contemporary African Art Fair.

BELOW Prehistoric rock paintings of Tassili n'Ajjer.

Enter the mind of a Picasso muse in Algiers

Le Musée Public National des Beaux-Arts

178 Place Dar Essalaam, El Hamma, Belouizdad, Algiers, Algeria
musee-beauxarts.dz

When the French occupation of Algeria ended in 1962, the locals had a fight on their hands to stop the departing troops and occupiers taking the contents of the Musée Public National des Beaux-Arts with them. And they succeeded, meaning that the museum founded in 1930 now houses one of the best collections of Western art in Africa and the Middle East. The collection of 8,000 paintings, sculptures, sketches and prints includes works by Auguste Rodin, Édouard Manet, Claude Monet and Paul Gauguin, as well as a strong Orientalist collection featuring enticing pieces by the likes of Eugène Delacroix and Alexandre-Gabriel Decamps. Make sure to explore the works by Algerian and Arab artists and, in particular, in the impressive wooden library, the work of Algerian female artist Baya Mahieddine, a naif outsider artist who provided inspiration for Pablo Picasso.

▼ Find the best of ancient Rome in modern Tunisia

Bardo Museum

P7, near Tunis, Tunisia
bardomuseum.tn

You could be forgiven for thinking that to see the best Roman mosaics you need to head to Italy. In fact, many scholars and historians believe that the world's best and largest collection of Roman mosaics is actually in Tunisia's Bardo Museum. Collected from Roman and Byzantine sites in what was Carthage, these are both more vibrant in colour and more ambitious in composition and narrative than Italian counterparts, and taken together they present a vivid picture of life and beliefs in Roman Africa through works both big and small. Here is a bottle of wine and a rural farm, there magnificent portraits of Diana the Huntress and the poet Virgil flanked by the muses of tragedy and history, Clio and Melpomene. Two scenes from Homer's *Odyssey* and the *Triumph of Neptune* will leave you amazed.

▲ Unearth a crop circle in the desert of Egypt

Desert Breath

El Gouna, near Hurghada, Egypt
danaestratou.com/web/portfolio-item/desert-breath

As well as the physical experience of walking it, you'll want to get up high to really take in the otherness of *Desert Breath*, a land art installation created by Greece's D.A.ST. Arteam – aka sculptor Danae Stratou, industrial designer Alexandra Stratou and architect Stella Constantinidis. The trio completed the work in 1997, and like some vast alien clock, the giant double spiral radiating out from a central point originally filled with water has been marking time ever since, slowly disappearing but still baffling and beguiling visitors with its 178-strong series of cones and round depressions rising up and sinking down from a flat expanse in the Egyptian desert. More than twenty years since its arrival it is still a strong visual presence on the barren landscape, one which, the artists state, 'suggests an experience of infinity with the desert as a landscape of the mind'.

Find a GEM beyond your imagination

Grand Egyptian Museum

Alexandria Desert Road, Kafr Nassar, Al Haram, Giza Governorate, Egypt
gem.gov.eg

At the time of writing, Giza's Grand Egyptian Museum (GEM) is yet to open (an event scheduled for 'some time' in 2021), but it's taking shape nicely not too far from the pyramids of Giza, which is apt as it will not only celebrate the archaeology of the Egyptian civilization, including of course the treasures unearthed in Tutankhamun's tomb, but it will be the largest museum ever devoted to one civilization *and* the largest archaeological museum in the world. The gallery of King Tutankhamun collection alone will display around 4,000 artefacts associated with the young king, while 100,000 artefacts relating to the wider Egyptian Pharaonic culture will be spread across a children's museum, special needs museum and of course GEM itself. Expect queues.

LEFT Mosaic detail of Odysseus and the Sirens.

ABOVE *Desert Breath* (1997) by D.A.ST. Arteam.

▼ Revel in the creative capabilities of Malian mud

National Museum of Mali

Bamako, Mali
musicinafrica.net/directory/national-museum-mali-0

To see the best of Djenné terracotta sculpture – the art form practised near Djenné in the Inland Delta region of the Niger River between the thirteenth and sixteenth centuries – you'd need to head to New York's Metropolitan Museum of Art, but to see its origins, and some of the figures in their natural setting, a trip to Bamako's National Museum of Mali is hugely rewarding. Along with the warriors and military figures you'll find a beautiful collection of Malian masks and textiles and, outside in the garden, a brilliant concrete model of the Great Mosque of Djenné. The museum is also a host venue for the Bamako Encounters Photography Biennial Festival, held every two years in November and December; try to time your visit to coincide with it and you'll be able to take in more than a thousand years of Malian art.

Focus on the conceptual photography of Omar Victor Diop in Senegal

Musée de la Photographie de Saint-Louis

Ibrahima Sarr Road, Saint-Louis, Senegal
fr-fr.facebook.com/MuseedelaPhotographiedeStLouis

Housed in a black and white painted colonial house that sits elegantly amid the pleasing colonial architecture of UNESCO-listed Saint-Louis, MuPho – or the Musée de la Photographie de Saint-Louis – is equally pleasing inside. As a cultural marker for both Senegal's past and the wider African diaspora, it is filled with absorbing historical imagery dating back to the nineteenth century, when the first camera arrived in Saint-Louis. But it's the vibrancy of the contemporary work that will more likely stay with you. In particular, the bright conceptual work of internationally acclaimed commercial-turned-fine art photographer Omar Victor Diop is a standout. Referencing sources as disparate as African studio photography and the work of Cindy Sherman in acting as both the subject of the photo – often drawing on historical African figures – as well as its photographer, Diop's work is unforgettable.

◀ Find meaning in the empty spaces of the Museum of Black Civilizations

Museum of Black Civilizations

Dakar, Senegal

Fifty years ago, Senegal's late poet-president, Léopold Sédar Senghor, envisaged a museum of black civilizations which, in 2018, was realized in his country with the opening of this curvilinear space inspired by traditional southern Senegalese homes. Inside, the pan-African focus on pieces from across Africa and the Caribbean is a joy, not least because it looks forward as much as back. Blank spaces exist in the hope that former colonial rulers will soon start to return the staggering amount of Africa's cultural heritage they plundered over the centuries (Paris's Musée de quai Branly alone has 70,000 sub-Saharan African artefacts), but in the meantime, this breathtaking collection shows African art both old and new in the best possible light, from the arresting entrance exhibit of an 18-m/59-ft high baobab tree, *The Saga of the Baobab* (2018), by Haitian artist Edouard Duval-Carrié, to Senegalese fashion designer Oumou Sy's *The Forest of Africa Across the Universe*.

FAR LEFT The National Museum of Mali building, which recalls traditional Mali architecture.

LEFT Edouard Duval-Carrié's *The Saga of the Baobab* (2018) in the entrance hall.

Feel the art at the heart of Ghana

From its kaleidoscope-bright exterior to an interior space filled with rooms for the many exhibitions, seminars, screenings and other culture-related events held here, the Nubuke Foundation is a joy. Established more than a decade ago as a visual art institution in Accra's East Legon, it shows an intriguing and always enjoyable mix of retrospectives, monographs and group shows, with big names such as James Barnor, a pioneer of Ghanaian photography, rubbing shoulders democratically with group shows from emerging artists. A starring role in the art fair Art X Lagos saw Patrick Tagoe-Turkson's mesmerizing tapestry of works revealed to audiences for the first time in Lagos, and has helped raise the foundation's profile, but it is still very much a community-minded cultural centre with a real heart at its heart.

◄ Explore the rightful home of the Benin Bronzes

Benin City National Museum

King's Square, Benin City, Edo, Nigeria

One day, it's hoped that the British government will return some of the famous Benin Bronzes to this lovely museum – portrait figures, busts and groups created in cast iron, carved ivory, and of course bronze – stolen from the capital city over a century ago. When it does, as it will surely have to, the purloined pieces will doubtless be the stars of the collection, but that doesn't mean it's not a strong one on its existing merits. The best of the three galleries housed in an unusual circular red building is the Oba Akenzua Gallery, which contains notable bronze figures, terracotta and cast iron pieces originating from the Benin Empire, while the two other spaces focus on arts and crafts from beyond the city. Don't miss the bronze head of the renowned and redoubtable Queen Idia, without whom the kingdom would probably not have existed.

Osun-Osogbo Sacred Grove

Osogbo, Osun State, Nigeria

▼ Stumble across a unique sacred site in Nigeria's high forest

Not far from the south-west Nigerian city of Osogbo lies a magical spot in the middle of a forest. A river winds through it, and encountering it is like stepping into a movie – *Jurassic Park*, perhaps, or more likely *Indiana Jones*. For this is a site of great cultural and religious significance, one created more than 400 years ago as a shrine to Osun, the Yoruba goddess of fertility. As you'd expect, it's filled with beautiful ancient wood carvings, but there are also many modern abstract pieces and decorative elements – the result of the New Sacred Art movement led by Susanne Wenger, an artist and Yoruban priestess – that make the site unique. Now featuring some forty shrines, sculptures and artworks made in honour of Osun and other Yoruba deities, it's no wonder the grove was designated a World Heritage Site in 2005.

LEFT Bronze head of Queen Idia (16th century).

BELOW One of the statues at the Osun-Osogbo Sacred Grove.

Home in on the work of Nigeria's leading Modernist artist

Omenka Gallery

24 Modupe Alakija Crescent, Lagos, Nigeria
omenkagallery.com

The personal home of curator and artist Oliver Enwonwu, who founded the Omenka Gallery within it in 2003, houses some real treasures, notably the work of Nigeria's leading twentieth-century painter and arguably most influential African artist of that century, Ben Enwonwu. Single-handedly positioning African art beyond colonialism and firmly in the modern art arena, Enwonwu's flowing, elegant portraiture is filled with dynamism and grace, and a treat to see amid works by contemporary Nigerian artists such as Kano-born Otobong Nkanga, who received a special mention at the Venice Biennale for her winding Murano glass sculpture and works on paper. Pan-African artists such as Owusu-Ankomah and artists with African heritage from other continents complete a wonderfully extensive picture.

▼ Take your life in your hands to see Tigray's rock churches

Hawzen, Ethiopia

You'll need to be fit and fearless to see this arresting collection of ancient Orthodox art in the Gheralta range of Ethiopia, for most of it is housed in yawning gaps in sheer cliff faces that you need to climb with the help of toe-holds and guides, cross narrow ledges or rickety bridges over dangerous drops, or climb a rudimentary ladder to access what is inside – detailed, delicate frescoes dating back centuries. Set 2,500 m/8,202 ft above sea level, the 125 caves include images of nine of the twelve apostles (in the Abuna Yemata Guh church), gorgeous blue and yellow Gondarine frescoes from the late eighteenth and early nineteenth centuries (in the Abuna Gebre Mikael) and a mesmerizing collection of muted saint frescoes from the seventeenth century (at the Petros and Paulos, Teka Tesfai). It all takes the idea of celestial splendour to new heights … literally.

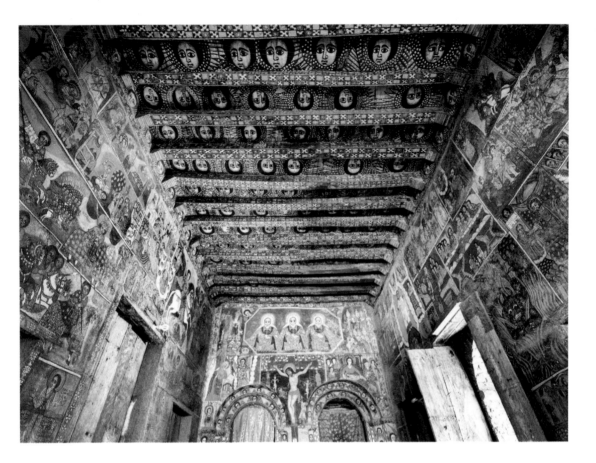

Debre Berhan Selassie

Gondar, Ethiopia
whc.unesco.org/en/list/19/

▲ Get an eyeful of heavenly heads at Debre Berhan Selassie

Prepare to get a crick in your neck in this lovely building, part of the wider UNESCO-listed Fasil Ghebbi site. Arguably Ethiopia's most beautiful church, the seventeenth-century interior of Debre Berhan Selassie can't help but make you smile as you look up to its wooden ceiling to find rows and rows of winged cherubs – more than one hundred of them – gazing back at you. Representing the omnipresence of God, they are just one part of this colourful interior's appeal; other elements well worth examining in detail include a Bosch-like depiction of hell, a luminous Holy Trinity seated above Christ on the Cross and a lovely St George slaying the dragon.

LEFT Cupola with a painting of nine Apostles in the Abuna Yemata Guh church.

ABOVE Ancient wall paintings adorning the interior of Debre Berhan Selassie.

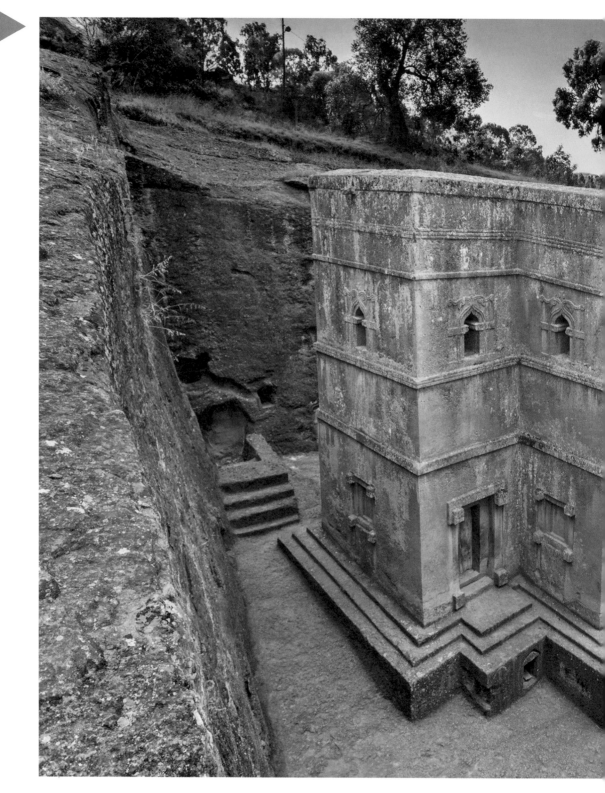

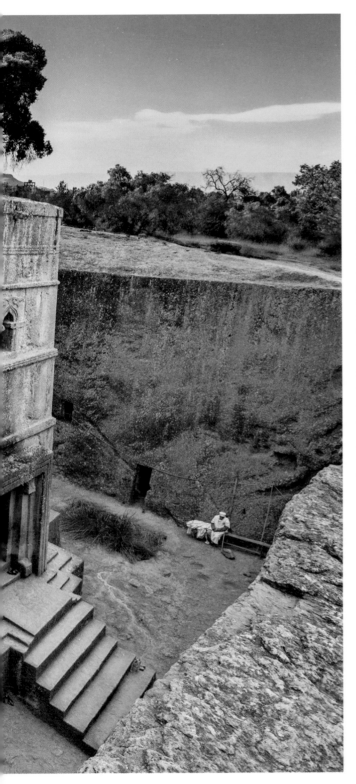

◀ Discover an architectural wonder in the Church of Saint George

Church of Saint George

Lalibela, Ethiopia
www.wmf.org/project/rock-hewn-churches

Looking like so many ancient Rachel Whiteread sculptures, the eleven medieval monolithic cave churches of Ethiopia's Lalibela have to be seen to be believed. Literally carved downward out of gigantic cubes of rock into delicately decorated buildings with chiselled-out openings forming doors, windows, columns, floors and roofs, they rise from their subterranean bases to surprise and delight both visitors and the hundreds of pilgrims who have been coming since their construction in the late twelfth and early thirteenth centuries. The Bete Giyorgis (Church of Saint George), with its remarkable cruciform shape and a roof engraved with a triple Greek cross, is a knockout, and several of the interiors are decorated with murals.

LEFT The Bete Giyorgis building in the shape of a cross.

Get stuck in the mud at the Zoma Contemporary Art Centre

Zoma Contemporary Art Centre (ZCAC)

PO Box 6050, Addis Ababa, Ethiopia
zomamuseum.org

Projects helmed by globally known starchitects are very much the order of the day in contemporary gallery and museum builds, but in Addis Ababa, an arts centre that was very much the opposite of this trend opened a few years ago. Founded by contemporary artist Elias Sime, the Zoma Contemporary Art Centre is an eco-sensitive site with farming plots, herb gardens, a dairy herd and traditional wattle and daub buildings housing artist residencies, workshops and exhibitions. Exterior walls are hand-decorated with carved patterns, and beyond them artists work in studios and mount exhibitions in the galleries, engaging visitors in art practice and appreciation that positions art firmly in the context of its surroundings and local lifestyle. Which probably explains why, in 2014, the *New York Times* cited ZCAC as one of the top places to visit in Addis Ababa. Nearby, Sime's lovely public garden for the Grand National Palace, the former home of Emperor Haile Selassie, is a must as well.

▲ Ride a city bus for a unique art experience

Nairobi, Kenya

Imagine owning a bus, one that has to compete with other privately owned buses as well as more staid government-operated ones to attract passengers. The obvious thing would be to make your bus stand out from the crowd, right? And that's what the matatu buses of Nairobi do, often through art. Amid the hurly-burly of the city's streets, these moving galleries are a familiar sight and attract fans to particular ones, not only through their vibrant urban art but also through their fashionably dressed drivers and conductors, as well as their ability to nimbly and knowledgeably shimmy down back routes to avoid traffic. They are chaotic, colourful, utterly random and huge fun to experience.

Tsodilo Hills

Ngamiland District, Botswana
whc.unesco.org/en/list/1021

Take to the hills to find the Louvre of the Desert

With 400 rock art sites containing more than 4,500 rock paintings, it's not surprising that the Tsodilo Hills region of the Kalahari Desert in north-west Botswana has been given UNESCO protection. Across four main hills – Child Hill, Female Hill, Male Hill and one unnamed hill – the 'Louvre of the Desert' contains animals and human-like figures in a range of colours, among them white rhino, red giraffe, bird-like outlines and humans on horseback. Time your visit so that you can stay into the evening to see the setting sun light up the western cliffs with what locals call the 'Copper Bracelet of the Evening'.

uKhahlamba
Drakensberg Park

KwaZulu Natal, South Africa
*nature-reserve.co.za/
ukhahlamba-drakensberg-
wildlife-preserve.html*

LEFT Decorated matatu buses in Nairobi.

BELOW Bushman rock art near Injisuthi in uKhahlamba Drakensberg Park.

▼ Find your favourite piece of San rock art in South Africa's Dragon Mountains

South Africa is home to literally tens of thousands of rock artworks created by the continent's indigenous San, or Bushmen, who decorated caves with figurative rock paintings and carvings showing hunters, dancers, fights, trance scenes, animals, half-human/half-animal hybrids and more – indeed, there are so many sites to be explored that if you're adventurous enough you might even discover ones not seen by other human eyes for centuries. All take some hiking to reach, but given the spectacular terrain, that's part of the fun. If you want to make sure of seeing some of the best, the uKhahlamba Drakensberg Park, with some 600 sites and more than 35,000 individual images, won't disappoint. Not sure where to head? Ndedema Gorge has an estimated 3,900 paintings, more than 1,000 of them in Sebaayeni Cave.

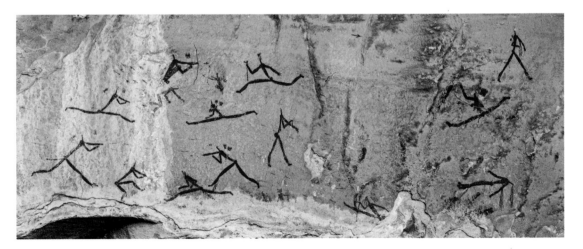

TRAIL: Lay your head in a very arty bed, part 1

The world over, smart hoteliers are waking up to the knowledge that people want to stay in special spaces when they're travelling. And what could be more special than a space boasting original, unique art? Here are some favourites across Europe and Africa; for even more arty places to stay in Asia and America see page 240.

aha Shakaland Hotel & Zulu Cultural Village, Nkwalini

South Africa

This lively and lovely living monument to traditional Zulu culture is an unforgettable experience in which guests stay in traditional round huts featuring authentic African decor, complete with wooden interiors, thatched roofs and lots of Zulu art, from sculpture and carvings to

painting and crafts.

Atelier sul Mare

Sicily, Italy

You would expect Italy to have an art hotel or two, but not necessarily in Sicily. And yet the Atelier sul Mare on the island's northern coast features some of the most arresting hotel rooms in the world, thanks to the artists commissioned to turn them into distinct immersive experiences.

Hotel Altstadt

Vienna, Austria

Much of this appealing hotel's art is on loan or drawn from owner Otto E. Wiesenthal's personal collection, which means you might stay among Warhols and Leibovitzs on one occasion and return to find a totally different selection of work surrounding you.

Hotel Refsnes Gods

Moss, Norway

Believing that 'contemporary art brings joy, inspiration and diversion', Hotel Refsnes Gods offers its guests a fine collection of contemporary art made up of more than 450 original works by emerging and established artists. A standout is the Refsnes frieze by Steinar Christensen, and guided tours of the collection are offered when possible.

The 12 Decades
Johannesburg Art Hotel

South Africa

This beautifully designed boutique hotel
not only chronicles the twentieth-century
history of Johannesburg, but it does so
with rooms designed and conceptualized
by some of South Africa's top artists
and designers, including Lauren Wallet's
literally theatrical design of a room
inspired by the Bantu theatre movement.

Fife Arms

Scotland, UK

Fife in Scotland is not known for its art,
but the five-star Fife Arms, in the foothills
of the Scottish Highlands, most certainly
is, with more than 16,000 antiques
and 12,000 works of art in a collection
ranging from Pablo Picasso to Gerhard
Richter, and even watercolour paintings
by Queen Victoria and Prince Charles.

La Colombe d'Or

St Paul de Vence, France

Arguably the world's most famous
art hotel got in on the act of art as
accommodation wayyyyy before
everyone else, with a collection begun a
century ago in what was then a humble
bar and café. Its incredible cast list –
including Henri Matisse, Pablo Picasso,
Fernand Léger, Georges Braque and
Marc Chagall – keeps up to date with
new works.

The Dolder Hotel

Zurich, Switzerland

This gorgeous old-world space
is understandably revered for its
impressive line-up of more than one
hundred artworks from big-name
artists – and we really do mean
big-name; Salvador Dalí, Henry Moore,
Joan Miró and Camille Pissarro are just
some of the artists who feature here.

The Beaumont

London, UK

A five-star hotel in the heart of Mayfair,
the Art Deco-styled Beaumont offers
one thing no other hotel in the world
can (though if you have $200,000 to
spare, a night with dead sharks floating
in a tank of formaldehyde in Damien
Hirst's Empathy Suite at Las Vegas's
Palms Casino Resort comes close):
the opportunity to actually stay inside
a work of art. Antony Gormley's *ROOM*
(2014), an 'inhabitable sculpture' that
takes the form of a one-bedroom dark-
oak-clad suite, apparently offers a
great night's sleep.

OVERLEAF ▶
Traditional Zulu setting used for performances in
the Shakaland Cultural Village, South Africa

SculptX Fair

Melrose Arch, Johannesburg, South Africa
themelrosegallery.co.za

Take in glass, grass and more at South Africa's largest annual sculpture fair

Each September, Johannesburg's Melrose Arch precinct becomes the home of an arresting display of sculpture drawn from across the continental African diaspora, and as you'd expect from such a geographically, geologically and culturally diverse spread, it's a treat. Materials and forms span the gamut from the obvious – rock, metals, glass and woods – to the more unusual – grass, perhaps, or found objects, or even virtual reality. Exhibited in a range of indoor and outdoor sites across the city, it's a colourful and exuberant mix of work by more than ninety artists, with context added to the works via daily guided tours led by one of those artists.

Ann Bryant Art Gallery

9 St Mark Road, Southernwood, East London 5201, South Africa
annbryant.co.za/permanent-collection

Admire a fine house and even finer collection of Eastern Cape artistry

Approaching this 1900s Edwardian home, the elegance of its architecture gives a hint of what you'll find behind its heavy timber doors. A peacock-bright arch of stained leaded glass leads you through to a fine collection of eighteenth- and nineteenth-century art collected by the home's owners, the Bryants. The focus is on paintings by British and European artists amassed by the art-loving family but, crucially, there's a very strong collection of Eastern Cape art here too – one of the biggest in South Africa. It's mostly twentieth-century work, primarily from the 1960s, and includes landscapes, abstract pieces, collage and more by some of South Africa's most important names in modern art, including George Pemba, Walter Battiss, Judith Mason and Maud Sumner.

Norval Foundation

4 Steenberg Road, Tokai, Cape Town 7945, South Africa
norvalfoundation.org

Explore a space at one with its surroundings

Set like a low-slung building next to a natural wetland in Cape Town's Steenberg area, the Norval Foundation is a beauty, a space that is definitely not part of the landscape but nevertheless works very well with it, both in terms of its architecture and an active and laudable environmental programme. But it's the art that really stands out. Housed across a large exhibition space and six smaller galleries is the Homestead Art Collection, one of the country's leading twentieth-century art collections, while outside Yinka Shonibare's *Wind Sculpture (SG) III* (2018) – the first siting in the African continent for a piece by the British-Nigerian artist – dominates a lovely sculpture garden with his trademark bright colours.

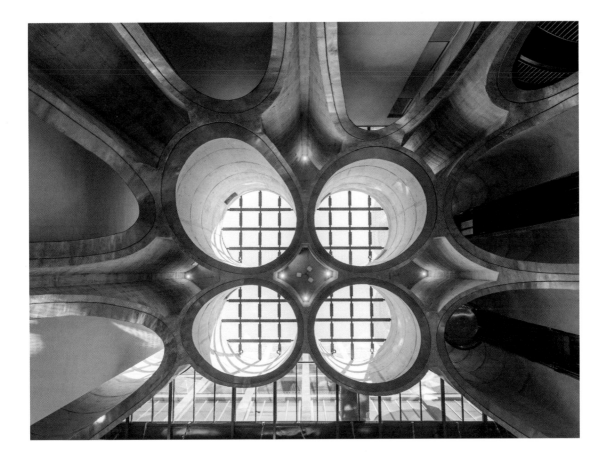

Zeitz Museum of
Contemporary African Art

V&A Waterfront, Cape Town
8001, South Africa
zeitzmocaa.museum

▲ See the seeds of Africa's future art scene in a former grain silo

Located in a converted grain silo, the Zeitz MOCAA is a real beauty, both outside and in. Opened in 2017 as what executive director and chief curator Mark Coetzee has described as a 'platform for Africans to tell their own story and participate in the telling of that story', its one hundred galleries soar over nine floors filled with flowing organic forms, all designed by architect wunderkind Thomas Heatherwick around the theme of the seeds and husks that once filled the space. The art has to work hard to stand out in such a striking space, but manages it via arresting pieces by the likes of visual activist Zanele Muholi, whose large-scale black and white photos give voice to the black, queer and trans people of South Africa. Juxtaposed with pieces by artists as diverse as Chris Ofili, Isaac Julien, Kehinde Wiley, Michele Mathison and William Kentridge, this is an unforgettable collection in an unforgettable space.

CHAPTER 5

Asia

Göreme Open Air Museum

Nevsehir, Turkey
goreme.com/goreme-open-air-museum.php

▲ Shine a light on the frescoes of the Dark Church amid the fairy stacks of Cappadocia

Set in one of the most surreal landscapes in the world, where 'fairy stacks' and other arresting geological forms draw thousands of tourists each year, the fourth- to eleventh-century frescoes that decorate the churches and chapels of the Göreme Open Air Museum in central Turkey's Cappadocia are just as unforgettable as a balloon flight over the white rocks they're cut from. In a cluster of different spaces are biblical scenes, saints and Christian symbols that sing out like beacons of colour and light in the dimly lit interiors. St Basil, St Barbara and the scenes in the nine-domed Apple Church and Snake Church are standouts, but the acme of the site is the Dark Church, so named because it has very few windows. The lack of light has resulted in the excellent preservation of its vividly coloured frescoes and an enchanting encounter with religious art in a totally unique setting.

▼ Enter a rusty cube for a trip back in time to Troy

Troy Museum

17100 Tevfikiye/Çanakkale Merkez/Çanakkale, Turkey
troya2018.com

Set on a dusty plain close to the archaeological site of the ancient city of Troy, the place made famous by Homer's *Iliad*, is a striking rust-coloured box that looks for all the world like an oversized packing crate filled with dusty souvenirs left behind in a garage after a house move. And in a way that's what the Troy Museum is, but the dusty souvenirs here are not anything you'd want to leave behind. Nestled inside the four-storey box, where light floods in through window slits or louvred walls, are jewellery, large-sized statues and friezes, delicate figurines and ceramics excavated from the nearby site of Troy, visible from the terrace at the top of the building. The juxtaposition of ancient and modern in such an arresting way leaves a mark as indelible as the story of Troy itself.

Wander a Baku cemetery to find some surprising art

Fexri Xiyaban Cemetery

Baku, Azerbaijan

Azerbaijanis like to decorate the gravestones of loved ones with photos of them, but at the Fexri Xiyabani Cemetery, created in 1948 by the Azerbaijan Soviet Central Committee as the final resting place for the country's foremost public figures, they've gone one better, with sculpted representations of the dearly departed. In the attractive tree-shaded graveyard also known as the Alley of Honour, much of the work is anonymous but exhibits great skill, with special mention going to the statues of the president Heydar Aliyev and his wife Zarifa. Most of the statues reflect the profession of the departed – from publishers, scientists and artists to musicians, soldiers and poets – with a tool or element of their trade, making a visit here a rewarding experience even if you can't read a word of Azerbaijani.

Witness a testament to the resilience of culture across centuries of conflict

Its strategic position spanning both the Mediterranean world and the ancient realm of Mesopotamia made Syria a collecting point for artefacts from cultures as far afield as Egypt, Greece, Rome and the Byzantine Empire. This is made clear in the National Museum of Damascus in a collection that takes in all manner of unexpected treasures – many looking like something out of the modern art galleries of western Europe, such as a medieval painted ceramic bowl with distinctly Modernist overtones. The Syrian artefacts are arguably the most arresting and compelling, with classical mosaics, jewellery and more drawn from sites across the country, including Palmyra, where cotton textiles were preserved by the desert sands. An even more impressive preservation – that of this entire collection – took place in 2012 when Syria's cultural authorities closed the museum in the wake of the civil war that engulfed Damascus. More than 300,000 artefacts were removed to safe spaces, being returned only in 2018 when their reinstatement was deemed safe.

Be absorbed by world-class video art in Israel ... and around the world

When Christian Marclay's video art piece of 2010, *The Clock*, is exhibited, people queue for hours to see it. Marclay made six editions of the work, a twenty-four-hour-long film cutting together thousands of film clips showing the time for every second of those twenty-four hours, and one of them is jointly owned by the Tate in London, the Centre Pompidou in Paris and the Israel Museum in Jerusalem. If it happens to be on in one of those cities when you're visiting, do everything in your power to see this riveting, compulsive piece. Similarly brilliant video pieces to look out for when you're in those cities – or any other – include Steve McQueen's *Drumroll* (1998), Ragnar Kjartansson's *A Lot of Sorrow* (2013–14), Matthew Barney's *Cremaster Cycle* (1994–2002), Wong Ping's *Jungle of Desire* (2015), Tacita Dean's *Boots* (2003), Kara Walker's *Testimony: Narrative of a Negress Burdened by Good Intentions* (2004), Sam Taylor-Johnson's *Pietà* (2001), Douglas Gordon's *24 Hour Psycho* (1993), William Kentridge's *Anti-Mercator* (2010–11) and Yang Fudong's *East of Que Village* (2007). All are mind-blowing, in very different ways.

▲ Light up your life in Jerusalem

Jerusalem Festival of Light

Across Jerusalem, Israel
lightinjerusalem.com

Some may be troubled by the idea of festooning the historic Old City of Jerusalem with thousands of coloured lights, but most people who see it are delighted by the experience of the annual festival of light. Across a number of different trails, which change every year, are a wide range of light art installations created by local and international artists, among them three-dimensional pieces, videos on landmark Old City walls and sound-and-light shows. In 2019, a group of Viennese artists painting the Dormiton Abbey Stones with light and an immersive work translating body movements into light on the Inner Jaffa Gate Plaza were just two of the highlights.

Scale the heights of Amman for far-reaching views

Dar Al-Anda Art Gallery

Amman, Jordan
daralanda.com

There are ups and downs to Dar Al-Anda's location, literally. Set atop a hill in Jabal Al-Weibdeh overlooking the rooftops of old Amman, it's a stiff climb, but worth every step. For once you arrive at the gallery, set across two historic 1930s villas, you'll find not only a great selection of modern art from the Arab world, but also top-notch works by emerging artists from further afield. The juxtaposition of modern art with the beautiful early twentieth-century decorative arts that feature across the spaces housing them is a joy, creating a thoughtful, reflective experience that makes a great break from the dusty streets below.

ABOVE A light projection show on the Damascus gate by light art collective Lichttapete for the 2019 Jerusalem Festival of Light.

Explore the life and work of Reuven Rubin

The Rubin Museum (Bet Reuven)

Bialik Street 14, Tel Aviv-Yafo, Israel
rubinmuseum.org.il

Tel Aviv is filled with beautiful architecture, and much of it can be found on Bialik Street – including the home of the country's National Poet, Haim Nahman Bialik, and the home-turned-museum of its most famous artist, the painter Reuven Rubin. The latter offers a perfect example of the Bauhaus style for which the city is renowned, and both outside and in, from the modern wrought-iron garden gate to the three floors of the Romanian-born artist's work, it is delightful. Having emigrated to Israel in 1893, Rubin lived in this house with his family from 1945 until his death in 1974, and the paintings on display, from early post-First World War work through to his Naïf-style landscapes of the 1960s and 1970s, are well represented. Additional guest exhibitions focusing on the early period of Israeli art, plus Rubin's studio preserved as it was during his lifetime, make the whole space one of the most charming art encounters in Tel Aviv.

▼ Travel through time in Doha

Museum of Islamic Art (MIA)

Doha, Qatar
mia.org.qa

I.M. Pei's startling Museum of Islamic Art (MIA) is a beauty. Rising out of the waters of Doha Bay like a mirage, a series of near-white limestone blocks build to create a five-storey edifice topped by a high domed atrium featuring an oculus which captures and reflects patterned light within the faceted dome, motifs of Arabic architecture visible in its elegant windows and the linking walkways and colonnades. Inside, a permanent collection showcasing thirteen centuries of Islamic art from Spain to India includes outstanding secular and religious works across all the decorative arts. It might be a fifteenth-century Spanish tile, one of only five known Mamluk enamelled glass buckets in existence, a seventeenth-century silk Iranian figurative textile or a fourteenth-century Syrian apothecary jar, but really, everything you see here will impress and leave a lasting impression.

▶ See site-specificity reversed by Richard Serra in Doha

Museum of Islamic Art Park

Doha, Qatar
mia.org.qa

Against the gleaming backdrop of Doha's soaring skyline on the cobalt blue Doha Bay, a structure rises that has something otherly about it, something that both fits, and doesn't, its surroundings, something that begs to be experienced close up. It is Richard Serra's *7* (2011), the American sculptor's largest ever artwork, set, as desired by Serra, on a purpose-built isthmus made up of the earthworks and detritus of I.M. Pei's adjacent Museum of Islamic Art. It makes the artist unique in having created a specific site for a sculpture, but it's not only this that makes *7* such an arresting experience. As Serra has said: 'I've been making towers for thirty years … but I've never made a tower like this tower.' Inspired by a tenth-century minaret in Afghanistan, *7* is made up of seven steel plates that can be entered through three portals to be surrounded by an ethereal world in which you could spend hours. Out in the western Qatari desert, another Serra sculpture, *East-West/West-East* (2014), makes a memorable day trip.

LEFT Museum of Islamic Art, seen at dawn.

RIGHT *7* (2011) by Richard Serra.

Louvre Abu Dhabi

Saadiyat, Abu Dhabi,
United Arab Emirates
louvreabudhabi.ae

ABOVE The Louvre Abu Dhabi's
striking geometric dome seen
from inside.

▲ **Walk through the story of humanity in Abu Dhabi**

Once you've spent a while marvelling over the ethereally
beautiful dome seemingly floating over Jean Nouvel's Louvre
Abu Dhabi on Saadiyat Island, move inside to find an equally
marvellous space filled with twelve galleries devoted to the
story of humanity, told chronologically over twelve 'chapters'. In
a seemingly obvious but radical approach to curation, the 600
artefacts in the permanent collection here transcend borders,
instead being grouped together by themes beginning with the
first villages and ending with a global stage. Along the way these
chapters encompass a superb trove that takes in everything from
a Jordanian statue with two heads from around 6,500 BC and a
second-century Islamic bronze Mari-Cha lion from the southern
Mediterranean, to a sixth-century white marble Buddha head
from northern China and a 1600 Edo-culture salt cellar from
Benin. The art offering is impressive too – though will likely be
outshone in 2022 by the arrival on Saadiyat of the magnificent
Frank Gehry-designed Guggenheim.

Barjeel Art Foundation

Al-Shuwaihean, Sharjah
Museum of Art, Sharjah,
United Arab Emirates
sharjahartmuseum.ae

Encounter the best of art in the Arab world

The Sharjah Museum is a must if you're in the UAE, its spacious galleries in a three-storey space housing some 500 pieces by Arab artists in varied mediums and techniques. Key among these galleries is the one housing the Barjeel Art Foundation exhibition, an extensive – and always expanding – collection of Modernist paintings, sculptures and mixed media artworks by most of the Arab world's leading twentieth-century artists. Despite often being on loan, there is always enough left here to give a great picture of modern and emerging art in the UEA and the wider Arab world. Look out in particular for works by Mahmoud Sabri, Saloua Ra-ouda Choucair, Samia Halaby, Kadhim Hayder, Huguette Caland and Dia Azzawi.

Jameel Arts Centre

Jaddaf Waterfront, Dubai,
United Arab Emirates
jameelartscentre.org

Find a piece of peace and quiet in Dubai

It takes a brave institution – and architect – to bring that quintessential art trope – the white cube – into the braggadocio skyline of Dubai, but that's exactly what Saudi Arabia's non-profit organization Art Jameel did in 2018 with the Jameel Arts Centre. Two clusters of white aluminium boxes designed by British practice Serie Architects house numerous different spaces, including ten galleries, for rolling exhibitions and a permanent collection whose focus is firmly on modern and contemporary Arabic artists. The lovely space, built around a series of courtyard gardens planted with local desert vegetation and a sculpture park set between the centre and its surrounding Jaddaf Waterfront, is a little piece of quiet paradise in the hurly-burly of Dubai.

Majlis Art Gallery

Al Fahidi Neighborhood,
Bur Dubai, Dubai,
United Arab Emirates
themajlisgallery.com

Meet old and new friends in Dubai's oldest fine art gallery

In the brouhaha surrounding Dubai's annual art fair and mega-billion dollar art sites, it's easy to forget the residents who have been quietly promoting twentieth-century work here for decades, in understated but charming spaces that give a true sense of the old city. One such is the Majlis Gallery, located in one of the wind tower houses in Bastakiya, where acrylics, lithographs, ceramics, glass, drawings, prints, sculpture and more are all set across Dubai's oldest fine art gallery. Majlis means a common meeting place, and when one of the gallery's impressive and eclectic exhibitions opens – among them ones on maritime UEA art, New Orientalists, the late Syrian artist Abdul Latif Al Samoudi and twentieth-century masters – it really does become a meeting place as art lovers fill the rooms and elegant courtyard.

Visit the fair at the heart of Dubai's art

Art Dubai

Across the city of Dubai, United Arab Emirates
artdubai.ae/the-fair

Away from the swanky, glittering starchitect galleries and museums springing up across other parts of the city and wider region is a more down-to-earth art scene that is focused very much around the buzz of contemporary practice. And it's due in no small part to Art Dubai (held each year in March), the art fair which kick-started an art culture across the city. Scores of small galleries all host shows during the fair, which is broken down into four sections covering Contemporary (across fifty-five galleries); Modern (showcasing works by one leading Modernist artist); Bawwaba ('gateway' in Arabic – presentations of solo pieces and site-specific installations); and Residents (with a focus on artists from the African continent). It is a great way to explore and discover the city, as well as its impressively vibrant art scene.

▲ Find a roll-call of history in Persepolis

Persepolis

60 km/37 mi north-east of Shiraz, Iran
britannica.com/place/Persepolis

This Persian wonder is a deservedly UNESCO-listed antiquity whose grandeur is easily evoked thanks to a plethora of immensely impressive elements. It all begins with the Gate of All Nations, still guarded by two winged bulls, beyond which lie bas reliefs featuring stone soldiers climbing the walls of the Apadana Staircase, motifs from the natural world and international visitors bringing gifts to King Cyrus the Great and his descendants in the sixth century BC. Here are noblemen from Ethiopia, India, Egypt, Greece, Armenia and more, the details of their clothing, styling and gifts clearly visible and identifiable. While many of the site's best pieces now reside in Western museums – including the Cyrus Cylinder, the first charter of human rights, in London's British Museum – to see what is still on site and what it once represented is very special.

Vank Cathedral

Vank Church Alley, Isfahan Province, Isfahan, Iran
vank.ir/fa

LEFT Relief from the Palace of Darius at Persepolis.

BELOW The gilded and painted ceiling of the Vank Cathedral.

▼ Be bowled over by an Armenian beauty in the heart of Iran

Its exterior terracotta-coloured structure, a mix of traditional Armenian and local Islamic styling, gives little hint of what is to be found in this seventeenth-century Armenian church. Across the walls and ceilings are amazingly well-preserved frescoes, gilded carvings and tilework created by some of the 150,000 Armenians forcibly resettled here during the Ottoman War in the seventeenth century. Many of the artisans set to work on a church filled with contrasting iconography and motifs, from rich representations of heaven and hell to delicate floral motifs and the torture of Armenian martyrs. A library and museum featuring tapestries, European paintings, embroidery and other treasures from the community's trading heritage add to the appeal.

Experience the bravery of dissent in Uzbekistan

Karakalpakstan Museum of Arts

K. Rzaev Street, Nukus 230100, Uzbekistan
savitskycollection.org

What a truly extraordinary place the Karakalpakstan Museum of Arts (also known as the Nukus Museum or Savitsky Museum) is. Its founder, Igor Savitsky, established it in 1966 as a repository for his huge collection of art and artefacts, including the second largest collection of Russian avant-garde in the world. Much of this work had been banned by Stalin, its creators imprisoned, tortured or even put to death for exploring emerging art forms such as Cubism and Futurism. So far away from Moscow, Savitsky was able to stay under the radar with this 'degenerate' art, collecting pieces by some of the most important exploratory Russian artists of the time, including Vladimir Lysenko, Lyubov Popova and Mikhail Kurzin. Lysenko's *Bull* is a standout in this stirring homage to the enduring power of art as political commentary and artists as a political force.

▼ Enjoy the 1,600-year legacy of a Socialist Soviet art exhibition

A. Kasteyev State Museum of Arts
of the Republic of Kazakhstan

22/1 Koktem-3 microdistrict, Almaty, Kazakhstan
gmirk.kz

Socialist Soviet art can be found across much of the former USSR, where museums devoted to it sprang up to celebrate the work and industry of the post-revolutionary Republic. Some of these museums, such as the A. Kasteyev State Museum of Arts, directly descended from the 1920 Kazakh Socialist Soviet Republic Art Exhibition, have blossomed into culturally and historically rounded spaces that have gone far beyond Socialist art to encompass creativity going both back from that era and forward into contemporary art. Some 23,000 works take in Soviet, Russian, western European and East Asian art, and a notable collection of Kazakh painting and sculpture by, among others, the founder of the Kazakh National School of Painting, Abilkhan (Abylkhana) Kasteyev, after whom the museum was named in 1984.

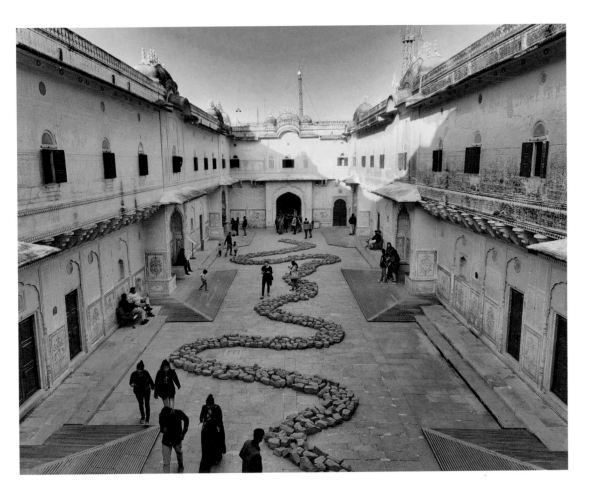

The Sculpture Park at
Madhavendra Palace

Krishna Nagar, Brahampuri,
Jaipur, Rajasthan 302007,
India
thesculpturepark.in

▲ Feel the thrill of exploration in Jaipur

Just as travellers along the Silk Road would have been startled
by the sudden appearance of a palace on the horizon after days in
the desert, modern travellers are equally blown away by the sight
of the early nineteenth-century Madhavendra Palace peeking up
from the stone walls of Nahargarh Fort near Jaipur. And what's
inside the elaborately decorated palace is equally enjoyable, for
the annually changing work in India's first contemporary sculpture
park makes a stark but pleasing contrast to the glitzy fixtures and
fittings. With pieces drawn from around the world, many of them
site-specific, there is lots here to enjoy, with monumental works
such as Richard Long's sinuous *River of Stones* (2018) sitting
intelligently alongside more intimate works in courtyards, hallways
and elegant rooms. The combination makes for a captivating mix.

ABOVE *River of Stones* (2018)
by Richard Long.

LEFT Inside the A. Kasteyev
State Museum of Arts.

Gangori Bazaar

J.D.A. Market, Jaipur,
Rajasthan 302002, India
whc.unesco.org/en/list/1338

▼ Get the measure of art as geometry at Jaipur's Jantar Mantar

In the searing heat of Jaipur's midday sun, a number of instruments align to the 'ooohs' and 'ahhs' of satisfied observers. And they really are observers, making scientific observations of the nineteen astronomical and cosmological instruments that comprise the Jantar Mantar built by Sawai Jai Singh II, the founder of Jaipur, in 1734. The combination of forms and materials – among them metal, stone and marble – creates a visual feast that, with the myriad shapes and sizes, may well remind you of a school maths kit whose set square, compass, protractor and ruler have been constructed on a monumental scale. But taken together, they also deliver a sculpture park like no other, the art forms beguiling through their setting, precision and interaction with light.

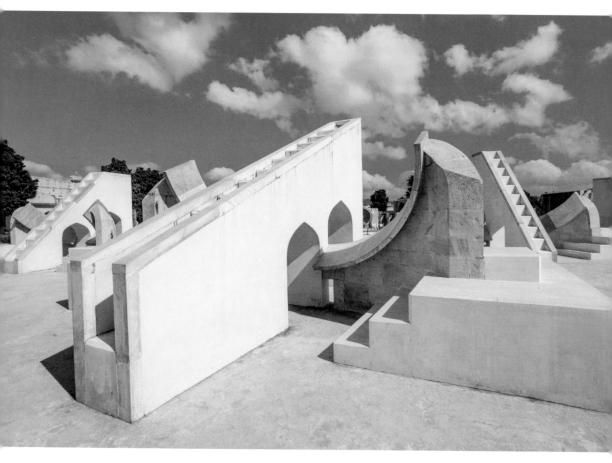

Ajanta Caves

Aurangabad,
Maharashtra state, India
whc.unesco.org/en/list/242

▲ Find ancient beauty in Buddhist cave art

Just over 100 km/62 mi from the Mughal city of Aurangabad, the wonders inside the Buddhist cave at Ajanta lay undiscovered until 1819, when Captain John Smith, a young cavalry officer from Madras, stumbled across them. What he saw was spectacular cave art dating back 2,000 years, a mesmerizing mix of colourful monks, lively crowd scenes, handsome princes and lovelorn princesses, dancing girls and meditating monks, hermits, devotees and bodhisattvas of supremely beatific stillness. Two of the caves have recently been restored, but all should be seen as an essential and sublime example of ancient Indian art.

National Gallery of
Modern Art (NGMA)

Jaipur House, India Gate,
New Delhi 110003, India
ngmaindia.gov.in

See old meet new and east meet west in New Delhi

While Westerners wax lyrical about traditional Eastern arts, there is all too often little appreciation of modern and contemporary art practice in areas such as the Indian subcontinent. So if you're touring Rajasthan, or beating a path to the Taj Mahal, make a stop at Delhi's National Gallery of Modern Art (NGMA), where your eyes will be opened to such delights as *Woman's Face* (1931) by the polymath Rabindranath Tagore and *Cat and the Lobster* (*c.* 1930) or *Bengali Woman* by his pupil Jamini Roy, whose adoption of local folk painting in a palette of just seven colours will have you mesmerized. Both reference ancient traditional Indian techniques and colouration, but do so with a modern eye that looks as much to the West, creating a unique and captivating mix.

▶ Be dazzled by recycled ceramics in northern India

Rock Garden of Chandigarh

Sector No.1, Chandigarh, India
nekchand.com/visit-rock-gardens

Private passions and creative visions often take rather esoteric forms, and folk artist Nek Chand Saini's rock garden in the north Indian city of Chandigarh is no exception. The roads inspector began the project in 1957, using found materials such as broken crockery, bottle fragments and colourful tile pieces to transform an old waste ground into what is now a dazzling 16-hectare/40-acre sprawl of rock gardens and waterfalls. In the sunlight it is literally dazzling, its paths and nooks filled with thousands of figurative concrete sculptures covered, in part, in broken ceramic shards from the officially sanctioned collection centres Chand established around the city in the 1970s – by which time he had been employed by the city and given fifty labourers to realize his vision. It's perhaps unsurprisingly the most visited attraction in the city, and possibly one of the most surreal in the country.

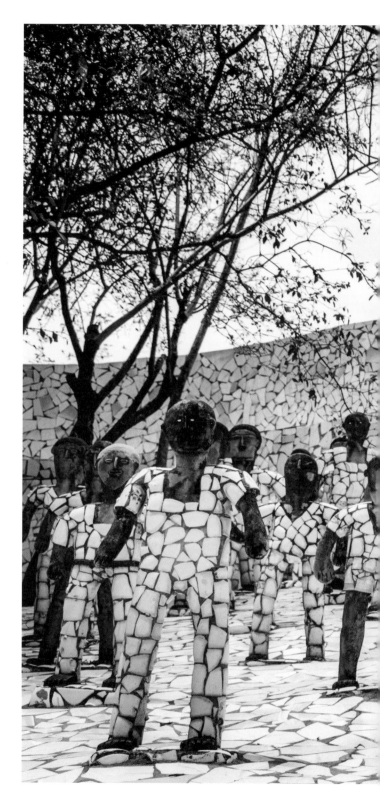

RIGHT Sculptures by Nek Chand Saini at his rock garden in Chandigarh.

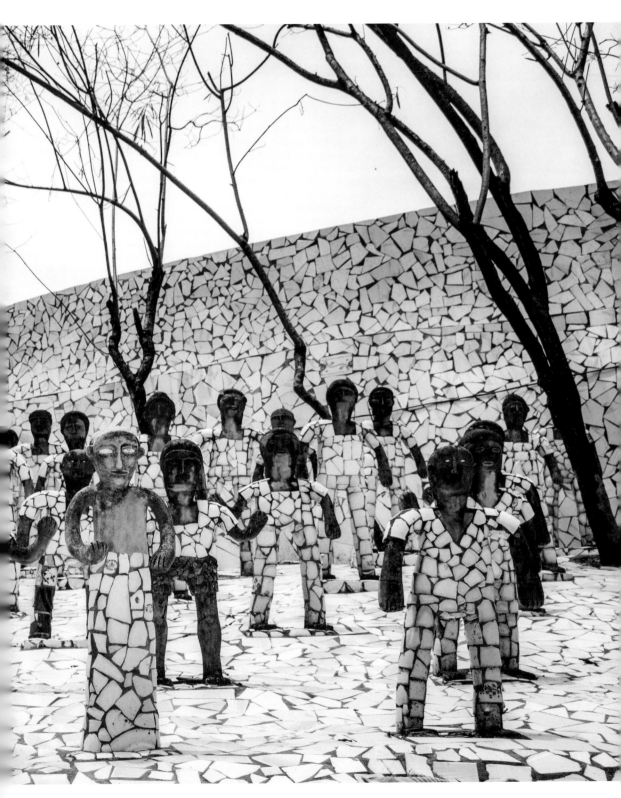

Geoffrey Bawa House

Number 11, 33rd Lane,
Bagatelle Road, Colombo 03,
Sri Lanka
geoffreybawa.com

Make yourself at home in the house of Sri Lanka's most famous creative

The home of Geoffrey Bawa, Sri Lanka's most famous creative and the principal force behind the architectural style known as Tropical Modernism, is a must for fans of mid-century art and design. What began as a small terraced house sympathetically extended in both space and contents from 1958 onwards is now a warren of indoor and outdoor spaces filled with art from across the centuries and globe. A medieval religious statue might be a highlight in one room, a stunning trompe l'œil wooden door leading into a room with an ancient wall covering another, while a vintage Rolls-Royce makes you feel Bawa himself might appear at any moment. It all feels very homely, and if you really want to make yourself at home, you can; two rooms are available to rent on the first floor.

Red Brick Art Museum

Hegezhuang Village,
Cuigezhuang Township,
Chaoyang, Beijing, China
redbrickartmuseum.org

Warm to the art and forms of the Red Brick Art Museum

Sarah Lucas, Olafur Eliasson and Dan Graham have all had solo shows in this contemporary art museum, but equally starry is the building itself – nine exhibition spaces housed within a sculptural building by architect Dong Yugan that's as much a work of art as the work it houses. Circular spaces are flooded with warm colour, dramatic shadows and arresting light patterns, thanks to the punctured red brick walls that give the museum its name. A permanent collection mixes an intriguing line-up of Eastern and Western artists, including Huang Yong Ping, Izumi Kato, Anselm Kiefer and Tony Oursler. To cap it all, a gorgeous garden referencing traditional Chinese landscaping continues the use of red brick to create a cohesive and memorable whole.

798 Art District

2 Jiuxianqiao Road,
Chaoyang, Beijing, China
798district.com

Find contemporary Chinese creativity in Beijing

Located in the Chaoyang District in Beijing, the 798 Art District, also known as the Dashanzi Art District, is the place to head if you're keen to discover what young proletarian creatives are up to in China. Set inside and around the cavernous industrial spaces of a decommissioned factory filled with old Maoist slogans are numerous galleries, studios and workshops that are a treat to explore – and easy to explore too, thanks to English-language maps and signs. The UCCA Center for Contemporary Art, the largest and most visited venue in the area, is close by, and is also definitely worth a visit.

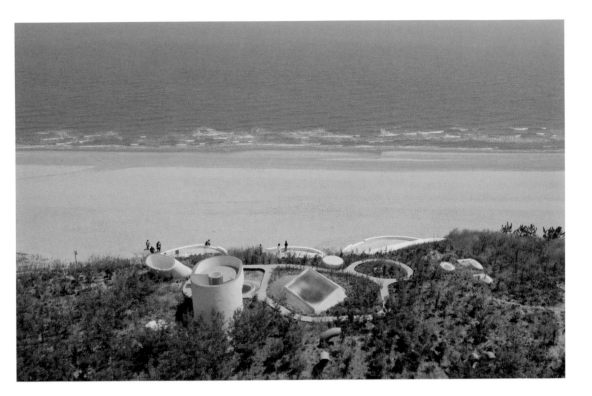

UCCA Dune Museum

Beidaihe, Aranya Gold Coast,
Qinhuangdao, China
ucca.org.cn

▲ Enjoy a day of organic art at the seaside

Seen from above, the UCCA Dune Museum looks like an abstract series of white concrete ribbons and blobs, elegantly mirroring the white beach it sits behind. But get underground and a series of lofty caverns open out to create one of the most arresting modern art museums in China. Comprised of ten interlinked subterranean galleries, the design ethos is centred around the very first art galleries – caves – and the environmentally friendly site sits under a large dune to help protect its delicate eco-system. As an outpost of Beijing's UCCA Center for Contemporary Art and with a curatorial focus on art examining the relationship between the human and natural worlds, the temporary, site-specific installations and exhibitions held here are always absorbing, but it's really the space, in perfect harmony with its landscape and with unexpected views through huge organic openings on to that landscape, that is the real art.

ABOVE UCCA Dune Museum complex seen from above.

Lintong District,
Shanxxi, China

*bmy.com.cn/2015new/
bmyweb*

▲ Be blown away by the most impressive funerary art in the world

The spectacle of some 8,000 life-sized terracotta soldiers, accompanied by hundreds of chariots and horses, that greets visitors to the necropolis of the first Chinese emperor Qin Shi Huang is as breathtaking as you imagine it will be, and then some. Constructed to accompany the emperor to the afterlife in 210–209 BC, mindboggling facts like no two soldiers' faces being alike simply cannot prepare you for the actual sight of these dignified sculptures. Even more mindboggling, though, is trying to imagine them in their original forms, painted in realistic colours of purple, green, red and blue with pink skin, using ground precious stones and pigments such as iron oxide, malachite, azurite and charcoal. Utterly spectacular.

ABOVE A few of the terracotta soldiers and horses on view in the Lintong District.

RIGHT Entrance to the Mogao Caves.

De-stress to some Dalí at Beijing's Hotel Éclat

Hotel Éclat

9 Dongdaqiao Road, Chaoyang, China, 100020
eclathotels.com/beijing

When you've had your fill of the challenging contemporary works that make up the 798 Art District (see page 236) and the more accessible pieces at the National Art Museum of China and Beijing World Art Museum, take a rest at the Hotel Éclat Beijing, which has more than one hundred artworks spread across its hotel museum – many in the hotel's bar and eateries. They include Andy Warhol and Salvador Dalí, but also pieces by many of China's top artists, including Zhang Guoliang, Chen Wenling, Gao Xiao Wu and Zou Liang. It's a rare chance to see an intriguing juxtaposition of Eastern and Western art.

▼ Gain Buddhist enlightenment in the Mogao Caves

Mogao Caves

Dunhuang, Jiuquan, Gansu, China
www.mogaoku.net

Rightly granted UNESCO status in 1987, the 492 temples inside the Mogao Caves offer a magnificent collection of Buddhist art spanning a thousand years, beginning in the fourth century with the emergence of nearby Dunhuang as a garrison and crossroads on the Silk Road. With traders from different cultures came the need for religious veneration and expression, found in the caves' elaborate Buddhas, bodhisattvas, mendicants and *apsaras* – or celestial beings – but also in hundreds of beautiful texts contained in the caves. These were removed to their home countries by explorers who discovered the caves a century ago, but the wall art remains as a testament to the extraordinary skill and creativity of Buddhist monks during the Tang Dynasty.

TRAIL: Lay your head in a very arty bed, part 2

Travelling the world to take in our amazing art experiences? You will need to stay in appropriately arty lodgings then. And with more and more hotels using art as a way of distinguishing themselves from the competition, there are plenty of great ones to choose from. Here are some favourites, old and new. For hotels in Africa and Europe, see page 212.

The Rosewood Hong Kong

Hong Kong (China)

The Rosewood Hong Kong's curated art collection sets out its stall with a Henry Moore sculpture before you even enter the building, where you immediately encounter a life-size elephant by Indian artist Bharti Kerr. Damien Hirst's butterflies are in the Butterfly Room. Rooms all feature commissioned works by William Low.

The Beekman

New York, USA

The majestic Beekman not only offers art in its rooms, but across its public areas as well, where a collection curated by Katherine Gass takes in more than sixty paintings, photographs, prints, works on paper and sculptures by international and American artists, including site-specific pieces.

Fontainebleau Miami Beach

Miami, USA

In many ways, Morris Lapidus's stunning Fontainebleau is a work of art in its own right, but add in enormous chandeliers lighting up works by the likes of artists such as Damien Hirst, John Baldessari, Tracey Emin and James Turrell, and you have one of the best art experiences possible in a space that also has beds.

Soho House Mumbai

India

Asia's first Soho House has all the things its members have come to know and love; a cinema, a gym, work spaces and, of course, a rooftop bar and pool, but it's in the thirty-eight hotel rooms that the local artwork sings out, in the shape of block-printed fabrics from Rajasthan and more than 200 art pieces by South Asian artists.

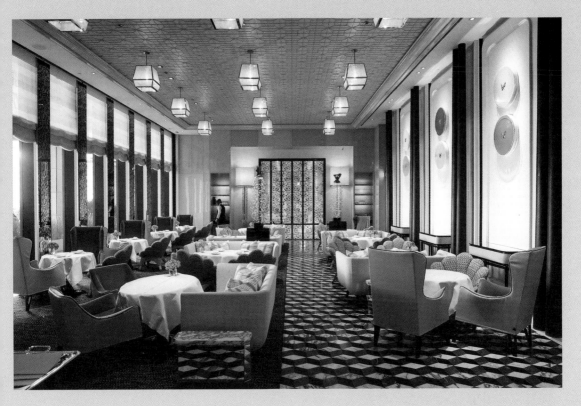

ABOVE The Butterfly Room at The Rosewood Hong Kong.

The Other Place

Guilin Litopia, China

You know those nightmares that feature endless staircases and doors that open to nowhere? You can now realize them with a stay at this boutique hotel, where two suites – the pastel-pink *Dream* and forest-green *Maze* – pay homage to the work of the trippy twentieth-century Dutch artist M.C. Escher, famous for his explorations of infinity and impossible spaces.

The Cosmopolitan

Las Vegas, USA

If you can't afford to stay in one of the Cosmopolitan's luxury suites, featuring original work by artists such as Julie Graham and Jessica Craig-Martin, you could always try your luck at one of the hotel's six Art-o-mat machines, which dispense original artworks.

OVERLEAF ▶
Bharti Kerr's lifesize elephant in the lobby of The Rosewood Hong Kong.

▶ Explore the gigantic artistic achievements of an ancient culture

Sanxingdui Museum

Guanghan, Sichuan, China
sxd.cn

A large bronze head clad in gold foil mask glares imperiously down on you from its pedestal, overshadowed only by a huge bronze tree decorated with birds. Both were unearthed in 1986 at the nearby archaeological site of Sanxingdui, where carbon dating has placed finds as far back as the twelfth and eleventh centuries BC. The pieces, and many others in gold, jade, bronze, porcelain, clay and other materials, are beautifully crafted cultural relics to be found at the Sanxingdui Museum, an entertainingly arranged space themed around the ancient kingdom of Shu which prizes these alarmingly stern bronze heads and statues, some more than 2.6 m/8.5 ft high and 1.38 m/4.2 ft wide, in its central exhibition hall, *Ancient City, Ancient State and Ancient Shu Culture*. The collection nicely balances artistic and archaeological presentation in a prize-winning museum which rises like a circular fortress from landscaped gardens set around a large lake, making a visit here unforgettable.

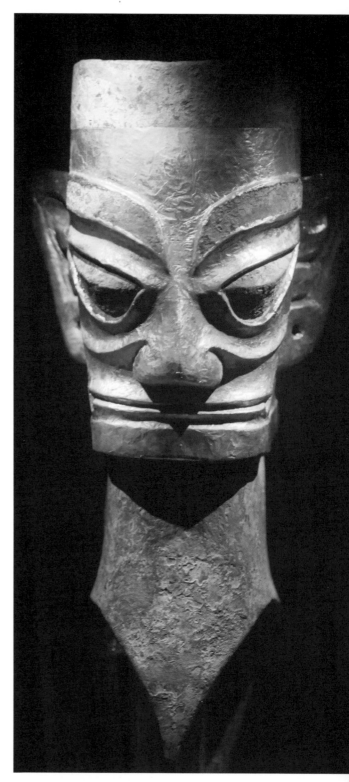

RIGHT A bronze portrait frame with gold, displayed at the Sanxingdui Museum.

Luyeyuan Stone
Sculpture Art Museum

Yunqiao Village, Xinmin Town,
Pi County, Chengdu, Sichuan
Province, China

Get spiritual amid 1,000-stone sculptures in Chengdu

Sometimes museums are perfectly in tune with their contents, as is the case at the Luyeyuan Stone Sculpture Art Museum in Chengdu. Set in a bamboo forest by a river, the building is constructed in reinforced concrete, shale brick, pebble, blue stone, glass and steel, all combining to create a grey monolithic hulk that shouldn't work in such a pretty setting, but does because of the striking contrast between the man-made and natural. Inside, stone-grey concrete spaces cut through with suspended steel walkways lit by thin vertical windows and skylights ensure the focus lies firmly on the art – 1,000 stone sculptures ranging from the Han to the Ming and Qing dynasties. Unimpeded by extraneous gallery design or fittings – not even vitrines – these exquisite forms are allowed to shine in all their glory, making for an art encounter that borders on the spiritual.

He Art Museum (HEM)

Shunde, Guangdong, China
hem.org

Trip the light fantastic in Guangdong

This luminous (it literally glows) museum of stacked discs connected by a double helix staircase (designed by Japanese architect Tadao Ando) houses the growing collection of Lingnan art (South of the Ranges art referring to three of China's southernmost coastal provinces of Guangdong, Guangxi and Hainan) owned by industrialist millionaire He Jianfeng and his family. But being a savvy and globally minded industrialist millionaire, He Jianfeng has also added into the mix some 400 world-class works by the likes of Picasso, Anish Kapoor and Yayoi Kusama, and Chinese modern artists including Liu Ye, Qi Baishi, Ding Yi, Chang Dai-chien and Zao Wou-Ki. In an industrial region this is a shining light that, it's hoped, will have the Bilbao effect.

Sheshan National
Tourist Resort

Shanghai 201602, China
*shanghai-sculpture-park.
com.cn*

Relax in a Shanghai scene at its most serene

When the teeming day-to-day life of China's largest city becomes too much, Shanghai residents in search of space, light, quiet and art head to the city's western borders, where the Yuehu Museum of Art and, in particular, its surrounding Sculpture Park, offer a restful slice of nature. Themed around the four seasons and divided by promenades, boardwalks and four architecturally distinct piers leading into the waters of Lake Yuehu, the park is home to more than seventy widely diverse sculptures, largely by Chinese artists, which range from the small and delicate to the large and eye-catching. The mix of man-made and seemingly natural is a total winner.

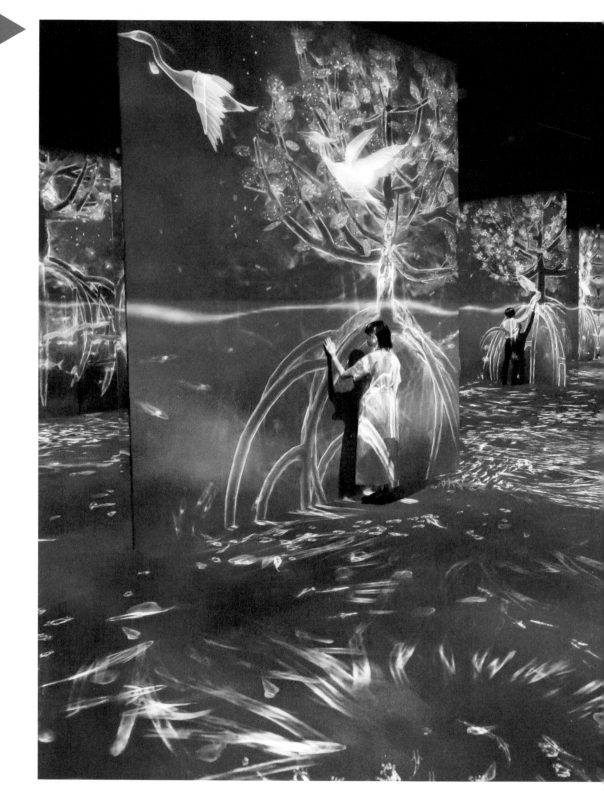

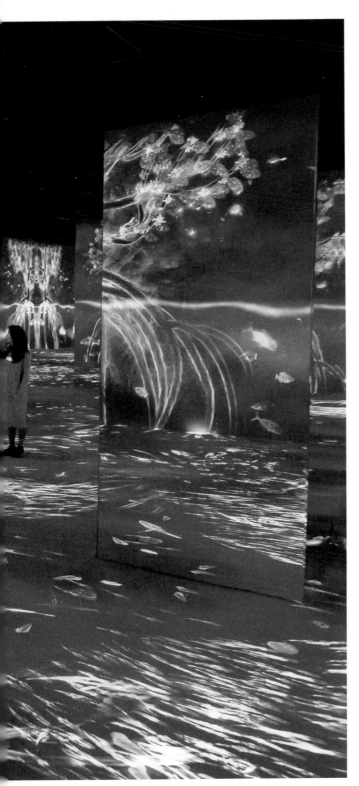

◀ See flowers bloom in a teacup courtesy of teamLab Borderless

teamLab Borderless Shanghai

Unit C-2 No 100, Hua Yuan Gang Road, Huangpu, Shanghai, China

MORI Building DIGITAL ART MUSEUM: teamLab Borderless

1-3-8 Aomi, Koto-ku, Tokyo (Palette Town, Odaiba)
teamlab.art

As the medium of immersive art grows in popularity, it can be hard to sort the wheat from the chaff. teamLab Borderless is definitely wheat rather than chaff. The art collective has been creating beguiling immersive art experiences for years now, and with permanent museums in Shanghai, Tokyo and Macau, goes from strength to strength with each new city and museum in which its work appears. As the name suggests, the group's work is about removing boundaries, so expect digital landscapes where artworks react to your presence in different ways, all of them colourful collaborations between artists, animators, programmers and architects. Whether it's a flutter of butterflies, columns of light that appear to be as solid as icebergs, a forest of Murano glass lamps or flowers blooming inside a teacup, each piece is distinct, distinctive and utterly magical.

LEFT *Continuous Life in a Beautiful World* – an example of teamLab Borderless's interactive digital art installations.

Luolong District

Luoyang, Henan, China
lmsk.gov.cn

ABOVE Vairocana Buddha in the Fengxian Temple.

RIGHT Spiral staircase inside JC Contemporary art gallery, Tai Kwun.

▲ Scale the heights of Buddhist art at the Longmen Grottoes

Yes, it's usually rammed, but the Chinese Buddhist art on show along the 1-km/0.6-mi length of the Longmen Grottoes is worth the wait and the hordes. As UNESCO stated when it included the site on its World Heritage List in 2000, this is 'an outstanding manifestation of human artistic creativity' created by the Northern Wei and Tang Dynasties between the fifth and eighth centuries. Exquisitely carved out from huge rock faces or the walls of limestone caves are as many as 100,000 statues, ranging from a tiny 25 mm/1 in to 17 m/56 ft. All are carved in superb detail, perhaps seen at its most spectacular in the serene features of the 17-m/56-ft Vairocana Buddha in the Fengxian Temple, but equally impressively – and more emotionally impactful for their intimacy – in the 15,000 little Buddhas carved out of the rock in the Wanfo Cave, and the 1,000+ Buddhist niches of the Guyang Cave. Genuinely jaw-dropping.

◀ Cross the centuries in a much-loved complex

Tai Kwun Centre for Heritage and Arts

10 Hollywood Road, Central, Hong Kong (China)
taikwun.hk

A happy marriage of old and new took place in central Hong Kong (China) in 2018. For it was then that the once-grand-turned-derelict colonial compound housing the city's first and longest-running prison, its Central Police Station and a magistrates court was revitalized courtesy of the Hong Kong Jockey Club and the architectural practice Herzog & de Meuron, and was reborn as the Tai Kwun Centre for Heritage and Arts. Across a range of old buildings, as well as in the additional two new ones, are performance spaces, galleries and events areas that give a great overview of the city's culture and heritage. Contemporary art is largely housed in a series of museum-standard galleries designed by Herzog & de Meuron, but also across many public areas of the complex, including the old prison yard, where commissioned site-specific pieces always draw enthusiastic crowds.

M+

West Kowloon Cultural District, Hong Kong (China)
mplus.org.hk

Focus on the screen-like space that is M+

Looking like a giant glass screen on the harbour of West Kowloon, Herzog & de Meuron's elegant new addition to the West Kowloon skyline is made up of two perpendicular buildings that reflect the waters in front of them with a steely grey gaze. They could be an upmarket hotel or office blocks, but are actually a new museum for visual culture, M+, with a focus on twentieth- and twenty-first-century art, design, architecture and moving image. At time of writing the building was yet to open, but early images, and the museum's website, suggest that when it does, it will have a strong and welcome selection of modern and contemporary art from Asia.

Catch the Asian art wave in one of its most liberal cities

Taipei Dangdai

Taipei Nangang Exhibition Center, Nangang District, Taipei City, Taiwan Province of China
taipeidangdai.com

Taiwan Province of China is known throughout Asia and beyond for its liberal and diverse culture, and has long been host to Art Taipei, Asia's longest-running art fair and arguably its best biennial too, held at the luminous Taipei Fine Arts Museum (TFAM). In 2019 it was joined by a new fair which has made the city even more enjoyable for visiting art fans. Taipei Dangdai's strength lies in the calibre of its carefully selected galleries, which mount exhibitions and first-class installations by the likes of Jihyun Boo and Chen Wan-Je, not just within the confines of the Taipei Nangang Exhibition Center but beyond it throughout the city, turning the public spaces of Taipei into an engaging sculpture and art experience. Associated gallery shows and satellite fairs such as Ink Now, dedicated to promoting ink art and ink-related culture, add to the fun.

▼ Find crafty folk at work on a walk around Bukchon Hanok Village

Bukchon Hanok Village

37 Gyedong-gil, Jongno-gu, Seoul, South Korea
hanok.seoul.go.kr

Traditional arts abound in Seoul's Bukchon Hanok Village, a cultural area filled with art to enjoy and practising craftspeople with whom to learn from or even practise with. It's all best seen on a walking tour of an area famous for its traditional houses, or *hanok*, many of which now operate as cultural centres, museums, workshops and galleries. In Hanok Hall, for example, you can admire the work and artefacts of master embroiderer Han Sang Soo, while the Traditional Culture Centre offers classes on natural dyeing, black bamboo craft and *jogakbo* (patchwork). Add in the 2,000+ pieces of folk art at the Gahoe Museum (gahoemuseum.org) and you collectively have an enlightening and architecturally pleasing insight into the cultural history of the country and its people.

Gamcheon Culture Village

Busan, South Korea
gamcheon.or.kr

▲ See art in the making at Gamcheon Culture Village

Sometimes art experiences aren't about seeing great art, but rather about discovering the environments that nurture and support it. Such an environment is the alluring maze of colourful houses, alleyways, studios, galleries and craft shops that make up Busan's Gamcheon Culture Village. Built in the 1950s to house refugees of the civil war, this shanty town grew into the cultural hub it now is when the government decided to renovate it in collaboration with local artists. It was a bold move, and one that has resulted in the area becoming a real tourist draw – a good one. Buy an interactive map at the Gamcheon Culture Village Tourist Information Centre and immerse yourself in the pleasure of coming unexpectedly across street art, meeting an artist, chatting to craftspeople in their studios … it's living, thriving art at its most accessible and enjoyable.

LEFT Traditional Korean-style architecture at Bukchon Hanok Village.

ABOVE The brightly painted houses of Gamcheon Culture Village.

Gallery Yeh

Gangnamgu, Seoul,
South Korea
galleryyeh.com

See art, Gangnam style

It's no wonder the soaring white slabs of Gallery Yeh have been
the recipients of numerous architectural awards, for whether
you see them from outside or within, the space they create is a
futuristic beauty. Three floors of exhibition space are filled with
light, illuminating big-name works by the likes of Jean-Michel
Basquiat, Damien Hirst, Alberto Giacometti, Tracey Emin,
Anish Kapoor, Julian Opie and Andy Warhol, but also acting as
a perfect foil to the exuberant dynamism of anime- and cartoon-
inspired artists like Japan's Mr Takashi Murakami and Yoshitaka
Amano. It's a bold and colourful mix that can't help but make
you smile … a smile broadened by the life on the streets outside
the gallery, where downtown Gangnam and Garosu-Gil buzz with
art, culture, fashion, food and design.

◀ See sculpture come and go in Sapporo

Sapporo Art Park and Sculpture Garden

Minami Ward, Sapporo, Hokkaido, Japan
artpark.or.jp

The largest city on Hokkaido has lots to offer
art lovers, not least the Sapporo Art Park, a
near-40-hectare/100-acre space comprising
the Museum of Contemporary Art and a
sculpture garden studded with seventy-four
wildly diverging artworks by artists with strong
ties to the island. The best time to explore it
is in winter (bring your snowshoes!), which
is also the time to catch the fantastically
fun Sapporo Snow Festival. Since its small
beginnings in the 1950s, this snow sculpture
extravaganza has expanded to cover three
sites around the city – at Odori Park, Susukino
and Tsudome. If you only have time to visit
one, make it the original at Odori Park, where
temporary fantastical pieces are lovingly
constructed by teams or individual artists. And
to warm up, don't miss the arresting Hokkaido
Museum of Modern Art, where a jewel-like
collection of glassworks takes pride of place.

Fushimi Inari-Taisha shrine

68 Fukakusa Yabunouchicho,
Fushimi Ward, Kyoto 612-
0882, Japan
inari.jp

▼ Explore the mother of all installations in Kyoto

There is something magical about exploring a man-made environment constructed to engage our emotional or spiritual senses. The best do both, of course, and Kyoto's Fushimi Inari-Taisha shrine complex truly is one of the best. Meandering 4 km/2½ mi up a thickly wooded mountain, the thousands of seemingly infinite vermillion shrine gates evoke all kinds of feelings, from awe and wonder at its grandeur and scale to sympathy, pathos and delight at the little graveyards, miniature shrines and stone foxes dotted liberally along the pathway. This is site-specific art at its most primal and engaging.

LEFT Sculpture of Buddha at the Sapporo Snow Festival.

BELOW A path through a tunnel of gates at the Fushimi Inari-Taisha shrine.

Float on a sea of wonder in Obuse

Hokusai-San Museum

Obuse, Nagano, Japan
hokusai-kan.com

He is the most well-known Japanese artist in the world, but the small museum in Obuse gives little inkling of the global fame and importance of Katsushika Hokusai. A world away from Tokyo's gleaming behemoth devoted to the master painter and printmaker (the Sumida Hokusai Museum, see opposite), this little place, in a gorgeous setting with far-reaching views, is the home that he retired to in his mid-eighties to paint festival floats and temple ceilings, and to continue to work on the elegant paintings and expressive woodblock prints he's famous for. Many of them – including the swirling seas of his dragon and phoenix festival float ceiling for the Higashimachi Float of 1844 – are here to enjoy in a traditional space that you can't help but feel truly evokes and expresses the spirit of the man who gave us *The Great Wave Off Kanagawa* (c. 1830).

▼ Have an anime adventure at the Ghibli Museum

Ghibli Museum

1 Chome-1-83 Shimorenjaku, Mitaka, Tokyo 181-0013, Japan
ghibli-museum.jp

Hayao Miyazaki and Studio Ghibli are world-famous, but a trip to their museum is a whimsical treat even if you've never heard of the anime masters. It begins outside, where the ivy-clad building sporting round windows shielded by bright blue window eyebrows across primary coloured walls clearly signpost what you can expect inside – an imaginative, surreal and totally unique space filled with everything related to the animation style, including sketches, drawing boards, mock-ups of artists' spaces, books and, of course, movies. On the lovely roof garden, a 5-m/16.4-ft high robot soldier from *Laputa: Castle in the Sky* (1986) stands guard over Inokashira Park, offering a fine photo op of you with your unique ticket – each containing a strip of cells from a Ghibli film.

The Sumida Hokusai
Museum

Sumida City, Tokyo 130-0014,
Japan
hokusai-museum.jp

▲ Get inside the mind of a world-famous printmaker

The dazzlingly modern design of the Sumida Hokusai Museum in east Tokyo is determinedly at odds with its contents, the ethereal works and world of arguably Japan's most famous artist. Best-known for his mesmerizing woodblock works *The Great Wave Off Kanagawa* and *Red Fuji* (both *c.* 1830) from the series *Thirty-Six Views of Mount Fuji*, Katsushika Hokusai is honoured in Kazuyo Sejima's gleaming building with a permanent gallery of his prints and lots of fun, interpretive material and interactive elements. There are also temporary exhibitions around his work, but it's perhaps the full-scale model of the house and studio he inhabited and worked in during his eighties, based on a sketch by a disciple, that is the most fascinating element of the museum.

ABOVE *Red Fuji* (*c.* 1830)
by Katsushika Hokusai.

LEFT The colourful facade of the
Ghibli Museum.

Naoshima

Kagawa District, Japan
benesse-artsite.jp

▲ Cross the Seto Inland Sea to land at an island of art

Contemporary art is everywhere on the islands of the Seto Inland Sea, particularly on its main island, Naoshima, where works by Andy Warhol, Donald Judd, Yayoi Kusama, Claude Monet and Korean artist Lee Ufan are just part of the art appeal. Plus, the island serves as a main venue of the Setouchi Triennale art festival. But it's the island's Art House Project that is perhaps its most site-specific and enjoyable. In it, artists – among them Hiroshi Sugimoto and James Turrell – take empty houses and turn them into works of art that reference their history and the history of the island. Because the uninhabited properties are set amid inhabited ones, visitors interact with the locals and so not only engage with the works of art but with the community and its daily life as well.

Follow a beacon of white light to a kaleidoscopic pumpkin patch

Yayoi Kusama Museum

107 Bentencho, Shinjuku City, Tokyo 162-0851, Japan
yayoikusamamuseum.jp

You expect the inside of a museum housing the eye-popping pumpkins and other works of Yayoi Kusama to be remarkable, and it is, with even toilets and non-exhibition spaces dotted with her much-loved polka dots and mirror reflections. But it's the exterior that immediately grabs you, with the striking design of the minimalist white and glass five-storey space shining like a beacon in the Shinjuku residential district, and giving little hint of the cornucopia of colour that lies within. Indeed, it's almost the diametric opposite of the queen of maximalist's oeuvre, which is spread across four floors and flooded with natural light. Don't miss the roof too; expansive Tokyo views are the perfect backdrop for an outdoor installation and a bench, on which you can sit in near-solitary contemplation for a good while because, in a genius move, only limited numbers of pre-booked visitors can enjoy their visits of up to 90 minutes. Works on view change along with an exhibition theme.

▼ Go potty over ceramics at the Japan Folk Crafts Museum

Japan Folk Crafts Museum

4 Chome-3-33 Komaba, Meguro City, Tokyo 153-0041, Japan
mingeikan.or.jp

It was the love of objects exquisitely crafted by mostly anonymous rural artisans that led to the creation of this magical space by art historian Sōetsu Yanagi and ceramicists Kanjirō Kawai and Shōji Hamada. Keen to preserve rustic craftsmanship in the early twentieth-century rush to industrialization, Yanagi, a fervent admirer of *mingei*, meaning 'folk crafts' or 'common crafts', campaigned for the 1936 founding of the museum, a wooden building using Oya-stone, which he partly designed and built using traditional Japanese materials and techniques. In this quiet, beguiling suburban space, some 17,000 craft works from Japan and beyond take in wood works, paintings, kimonos, costumes, jewellery, woven/dyed textiles, slipware and ceramics. Fans of the latter might also want to pay a visit to the Tomimoto Kenkichi Memorial Museum in Nara, near Osaka, where the exquisite porcelain works of the master ceramicist can be seen in the house where he was born.

LEFT *Yellow Pumpkin* (1994) by Yayoi Kusama on Naoshima.

RIGHT Entrance to the Japan Folk Crafts Museum.

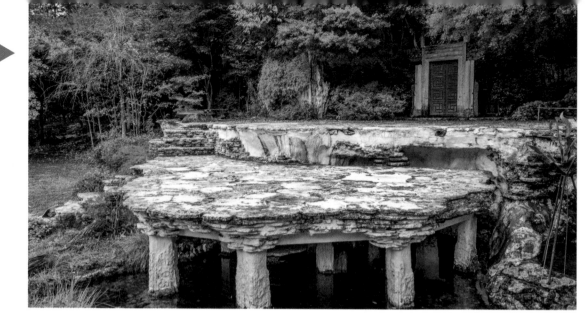

Get an insight into the world and work of Isamu Noguchi

Isamu Noguchi Garden Museum

3519 Mure, Mure-cho, Takamatsu City, Kagawa
Prefecture 761-0121, Japan
isamunoguchi.or.jp

When the American/Japanese artist, designer and landscape architect Isamu Noguchi went in search of stones for his Japanese garden in Paris's UNESCO headquarters in 1956, he visited the island of Shikoku. So taken with it was he that he vowed to one day create a studio there; thirteen years later, he did – with the help of local craftsman Masatoshi Izumi, who had worked with him on the monumental sculpture *Black Sun* (1969) for the Seattle Art Museum. It was a relationship that would last twenty years, and result in a garden filled with artworks in Mure-cho, where the studio was established in an Edo-period merchant house, with granite and basalt sculptures that both reflect and play off the landscape in elegant and harmonious ways. Turned into a museum after Noguchi's death, it is a vastly different experience to his museum in New York; an intimate space that houses 150 works as well as offering an insight into how he worked.

▲ See art and nature in accord at the Itchiku Kubota Art Museum

Itchiku Kubota Art Museum

2255 Kawaguchi, Fujikawaguchiko-machi,
Minamitsuru-gun, Yamanashi 401-0304, Japan
itchiku-museum.com

The stunning setting and coral and limestone Gaudí-esque design of this museum dedicated to textile artist Itchiku Kubota, with a waterfall, tearoom, extensive sculpture garden and Mount Fuji views, would be enough reason to visit, but inside, the one hundred or so sumptuously coloured, nature-themed works of the artist who single-handedly revived the art of Tsujigahana silk dyeing (used to decorate kimono during the fourteenth- to fifteenth-century Muromachi Period) are even lovelier. In particular, his unfinished *Symphony of Light*, comprised of thirty-six kimono that together form a picture of Mount Fuji, is magical, set as it is in an airy timber-framed space of ancient cypress trees which, like the museum and garden in their Fuji Five Lakes surroundings, achieves perfect harmony between nature and art.

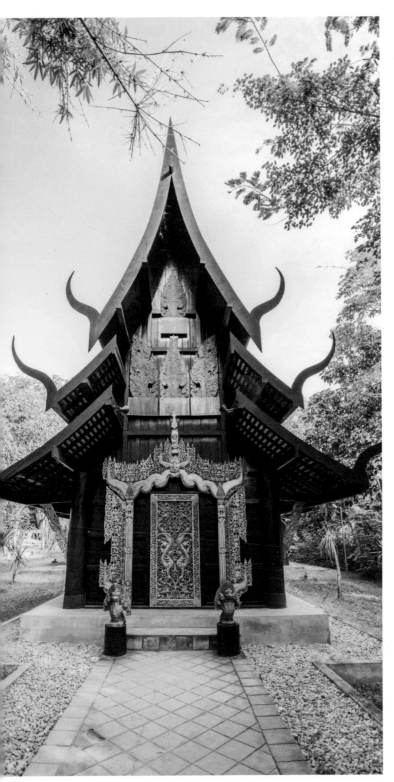

◀ **Go back to black in Chiang Rai**

Black House (Baan Dam Museum)

Chiang Rai, Thailand
thawan-duchanee.com/ index-eng

Chiang Rai is rightly famed for its impossibly ornate White Temple (Wat Rong Khun) decorated with Hieronymus Bosch-like imagery by local artist Chalermchai Kositpipat, but nearby its polar opposite deserves just as much attention. The work of artist Thawan Duchanee, Black House (Baan Dam) is a complex which contained his home and studio among a large cluster of black tiered temple-like wooden buildings. Every one of them is filled with animal remains, taxidermy and sculptures. Crocodile and snake skins decorate floors and tables, walls are covered in horns and skulls, and everywhere reminders of our mortality abound, some tiny, some huge – an entire elephant skeleton being perhaps the most impressive. Laid out with reverence and an artistic approach, it's an intense, and unforgettable, experience. Appropriately, a lake on the complex is home to several black and white swans.

FAR LEFT Kubota Itchiku Art Museum, set in wooded hills.

LEFT Traditional Thai architecture with a modern twist at the Baan Dam.

▶ Climb an elephant's trunk for some astonishing sights

Erawan Museum
99/9 Moo 1, Sukhumvit Road,
Bang Mueang Mai, Samut Prakan
10270, Thailand
*muangboranmuseum.com/en/
landmark/the-erawan-museum*

Set just outside Bangkok amid tropical gardens is the wonderfully surreal sight of a huge three-headed bronze elephant sculpture of Airavata, or Erawan, Indra's mount from Hindu mythology. Even more surreal is the fact that this elephant is actually a three-storey museum whose interior and contents are just as special as their housing. From the first floor's representation of the underworld, filled with antique porcelain, ceramic and jade decorative arts from the Ming and Qing dynasties, up to the brilliant Buddha relics and sixth-century statues of the top floor, via Thai ceramics, stained glass, European potteries and a stunning stained-glass window illustrated with the world and signs of the zodiac, the collection of business tycoon Lek Viriyapant makes for one of the best museums in Thailand – and one of the best museum experiences in the world.

RIGHT View of the stained glass ceiling at the Erawan Museum.

Da Nang Museum of
Cham Sculpture

Hai Chau district, Da Nang
550000, Vietnam
chammuseum.vn

ABOVE Statues of the demigod
Dvarapala at the Da Nang
Museum of Cham Sculpture.

RIGHT Inside the Ho Chi Minh
City Museum of Fine Arts.

▲ Discover the ancient cultures of Vietnam at the Museum of Cham Sculpture

Displayed in and around a lovely old colonial townhouse that intriguingly marries French colonial architecture with elements of Cham design, the Cham Museum in Da Nang, founded in 1915 by the École Française d'Extrême Orient, houses the largest collection of Cham sculpture in the world. Never heard of it? We neither, until we were encouraged to see it by fellow culture vultures who had. It turns out the works of this ancient Hindu-inspired culture, dating back to AD 192 and spanning eight centuries, are as beguiling as any ancient cultural artefacts you *have* heard of – at least if the 300 or so terracotta and stone works displayed here are anything to go by. Influences are clearly Hindu or Buddhist, but the religious-based works – including teeth-baring mythological animals, deities, dancers and arresting narrative panels and pedestals – not only prove the Cham were highly skilled artists, but that they also held their own identity and style.

Ho Chi Minh City
Museum of Fine Arts

97 Pho Duc Chinh Street,
Ho Chi Minh City, District 1,
Vietnam
*baotangmythuatphcm.com.
vn/lien-he*

▲ Find more than echoes of war in Ho Chi Minh City

It's not Vietnam's biggest fine art museum, but with its resident ghost (they say) and 1930s interiors of colourful rooms lit by stained-glass windows and beautiful tilework interspersed with bright courtyards, the Ho Chi Minh City Museum of Fine Arts is arguably the city's most enjoyable. Across it an eclectic collection spans historical arts going back to the fourth century, among it seven centuries of Cham art and Vietnamese woodcut paintings in different styles through to ceramics and contemporary Asian art – plus a surprisingly large number of war-themed paintings – all of it spanning an equally surprising range of media.

War Remnants Museum

28 Vo Van Tan, District 3,
Ho Chi Minh City 700000,
Vietnam
warremnantsmuseum.com

See world-class photography confront the brutality of war

Does art have a place in a war museum? Absolutely, particularly when it's used to help convey the brutal effects of war as powerfully as it does here. If you're a Westerner, it's eye-opening to see the Vietnamese perspective through items such as its propaganda posters, but wherever you're from, the wide range and undeniable impact of the photography – much of it by world-greats such as Larry Burrows and Robert Capa – will stay with you. It is sobering and heart-rending, but not relentlessly so; a section showing support for the anti-war movement from around the world helps restore the balance of humanity in what was a horrifically inhumane conflict.

Discover the world and work of Vietnamese women in Hanoi

Vietnamese Women's Museum

36 P Ly Thuong Kiet, Hanoi, Vietnam
baotangphunu.org.vn

Galleries with dusty names like 'women in family' and 'worshipping mother goddess' might not inspire confidence, and their design is in no danger of winning any whizz-bang architectural or museum design awards, but this quietly absorbing museum, dotted with colourful, beautifully crafted costumes, tribal basket ware and fabric motifs from Vietnam's ethnic minority groups, is a must if you're in Hanoi. The graphic design and decorative arts by and about women in the galleries devoted to propaganda posters and women in fashion are the highlights, but occasional temporary art exhibitions, such as the MAM-Art Projects – a collaboration between the museum and the Menifique Art Museum – are worth exploring too.

▼ Be fooled by the streetwise tromp l'œils of inner city Penang

George Town, Penang, Malaysia

penang-insider.com/old-penang-street-art/

Is it a painting? A sculpture? A caricature? A real-life alleyway scene of kids on a bicycle? The street art of inner city Penang, created and coordinated by Lithuanian artist Ernest Zacharevic, is a winning combination of painting and objects that in many cases – such as *Boy on Chair* and *Kids on Bicycle* by Zacharevic, and *Brother and Sister on a Swing* by Louis Gan, a local deaf-mute self-taught artist – are gorgeous little tromp l'œils that are delightful to discover. Addressing the council's desire to heighten local and visitors' awareness and understanding of the area's ancient Chinese shop-houses, other pieces have a political or historical context, such as the iron wall piece *Jimmy Choo*, marking the site where the famous shoe designer started his apprenticeship, and *Labourer to Trader*, honouring the work of the early convict labourers who helped build civic Penang. While many have more sociological value than artistic merit, some are beautifully executed.

ArtScience Museum

Marina Bay Sands,
Singapore
*marinabaysands.com/
museum*

▲ Pick this flower from Singapore's tantalizing bouquet

Singapore has a plethora of great art sites, from its mammoth National Gallery to its charming Art Museum, housed in a former Catholic boys' school, via the fascinating Philatelic Museum, but our top pick would be the ArtScience Museum, famous on the city's skyline for its lotus-flower 'hand' designed by renowned Green architect Moshe Safdie and matched by a real lotus flower pond in front of it, fed by a waterfall of rainwater collected from the roof of the building. Ostensibly a space dedicated to the arts and sciences, its twenty-one gallery spaces are always used to great effect, marrying art and science in permanent shows such as *Future World*, designed by the always unforgettable TeamLab, but also dedicating them to temporary shows focusing on one artist, a broad range that has taken in Leonardo da Vinci, M.C. Escher and Annie Leibovitz, or themed shows such as *Minimalism: Space. Light. Object* and *Art from the Streets*.

LEFT Street art to fool the eye in George Town.

ABOVE The flower-like exterior of the Artscience Museum by Marina Bay.

CHAPTER 6

Oceania

▶ Enter a field of light in Uluru ... and beyond

Uluru

Northern Territory, Australia
ayersrockresort.com.au

British artist Bruce Munro conceived his magical *Field of Light* all the way back in 1992, while camping at Australia's beguiling Uluru. He said the red desert had an incredible feeling of energy, with a 'charge in the air that gave me a very immediate feeling I didn't fully understand'. Trying to physically capture that feeling, he envisaged a landscape of stems which 'like dormant seeds in a dry desert, quietly wait until darkness falls ... to bloom with gentle rhythms of light'. The ensuing installation, first realized at Cornwall's Eden Project in 2008, has since appeared across the world, but it is in Uluru, where it landed in 2015, that it can be experienced at its most elemental and powerful. As Munro's largest iteration of the artwork and the first to be solar-powered, its supposedly temporary placement keeps being extended, and it's to be hoped it will continue to bloom nightly for the foreseeable future.

RIGHT *Field of Light* by Bruce Munro, installed at Uluru in 2015.

Nanguluwurr Art Site Walk

Kakadu National Park, Jabiru, Northern Territory 0886, Australia
parksaustralia.gov.au/kakadu

Make contact with some contact art in a quiet woodland

Think of Australia and you'll likely think of dramatic landscapes like Uluru. But the 3.4 km/2.1 mi Nanguluwurr art site walk is a peaceful ramble through woodlands, leading to a quiet – and quietly mind-blowing – Aboriginal rock art site, just one of three in the Northern Territory's Kakadu National Park (see page 276). The fact that it was a major camping site for Aboriginal people probably explains the array of different styles and images here, including hand stencils, animals, spirits and mythical figures. There's even a fine example of contact art in the shape of a sailing ship with a mast, anchor and dinghy – pretty impressive given the site's location is 90 km/56 mi inland and nowhere near a waterway.

Museum of Underwater Art (MOUA)

John Brewer Reef, and Magnetic Island, Palm Island, Townsville and other locations along the Queensland coast, Australia
moua.com.au

Dive into the splendours of **MOUA** and more

British artist and keen diver Jason deCaires Taylor is a man dedicated to using his art to good purpose – namely diverting human traffic away from endangered coral reefs. And so, at Cancun's Museo Subacuático de Arte, Lanzarote's Museo Atlantico, Grenada's Molinere Underwater sculpture park and museum and the Museum of Underwater Art (MOUA, currently developing along the shores of North Queensland), the sculptor, marine conservationist, underwater photographer and scuba-diving instructor has constructed underwater sculpture parks that are both otherworldly and seemingly of the natural aquatic world they inhabit. The Great Barrier Reef's MOUA promises to be directly concerned with environmental issues through works such as *Coral Greenhouse* (at John Brewer Reef), planted with more than 2,000 coral fragments from marine nurseries, to help it generate a marine ecosystem. With its stated aim of highlighting reef conservation, restoration and education on a global scale, this is surely an art project that will hopefully amaze for centuries to come.

RIGHT *Shifting Horizon VII* by April Pine for Sculpture by the Sea 2018.

Araluen Arts Centre

61 Larapinta Drive, Alice Springs, Northern Territory 0870, Australia
araluenartscentre.nt.gov.au

Come for a beanie, stay for the art

From a small community event established in 1997 aiming to sell beanies crocheted by Aboriginal women in remote communities, the joyous Alice Springs Beanie Festival (beaniefest.org) held each June has expanded to celebrate Aboriginal art through all manner of indigenous arts and crafts, including textiles, weaving, basketry and, of course, fine art. The event is held in the grounds of the Araluen Arts Centre, which year-round houses a terrific collection of Aboriginal and Australian art across a multitude of 'storytelling' spaces, including four art galleries, one of which features artworks by renowned watercolourist Albert Namatjira, celebrated for his evocative depictions of the central Australian landscape.

Sculpture by the Sea

302/61 Marlborough Street, Surry Hills, New South Wales 2010, Australia
sculpturebythesea.com

▼ See Sculpture by the Sea in Sydney

As if it weren't spectacular enough, the Bondi Beach to Tamarama Beach walk is made even more arresting each year for a few weeks in October and November, when more than one hundred sculptures by local and international artists are set along the 2 km/1¼ mi clifftop coastal trail. From large-scale figurative elements to abstract pieces spanning sharp geometric and undulating forms, the sculptures are enjoyed by hundreds of thousands of locals and visitors alike – so much so that the event has led to a second event, Cottesloe, in Perth, which takes place each March, and, beyond Australia, in Aarhus, Denmark.

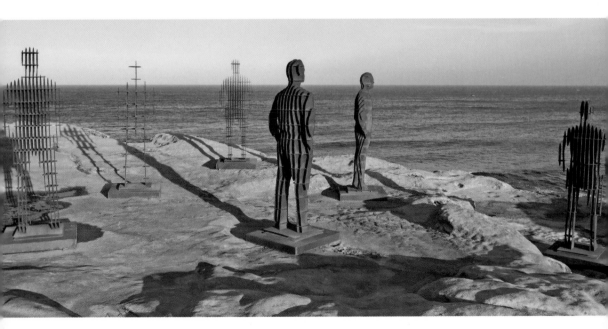

◀ Explore a spectacular sculpture site in the outback

The Broken Hill Sculptures &
Living Desert Sanctuary

Broken Hill, New South Wales 2880,
Australia
discoverbrokenhill.com.au

Sitting on the edge of the Australian
outback, the town of Broken Hill
and, just outside it, the Living Desert
Reserve, offer a very real sense of
what that vast, inhospitable area
is like. Gullies and rocky outcrops
rise majestically from a terrain
patrolled by marsupials and less
charming critters, and to explore
it is a real adventure. Throw in a
dozen naturalistic organic sandstone
sculptures starkly set against the
landscape on top of a hill, created
by twelve international artists for
a Sculpture Symposium organized
by local artist Lawrence Beck, and
you have an edge of the outback art
experience that is unforgettable –
particularly at sunrise or sunset.

LEFT Sandstone sculptures in the
Living Desert Reserve.

Bunjil Geoglyph

You Yangs Regional Park, Branch Road, Little River, Victoria 3211, Australia
parks.vic.gov.au/places-to-see/parks/you-yangs-regional-park

Trace the flight of a mythical protector in Australia

Many land art pieces can be hard to distinguish from the land in – or on – which they're set, but Andrew Rogers's 2006 tribute to the indigenous Aboriginal people of Wathaurong, the *Bunjil Geoglyph*, is clearly man-made. Looking like a vast piece of ancient rock art, the Bunjil, a mythical protector bird and spirit of the Wathaurong, has a wingspan covering 100 m/328 ft of land and was made primarily with rocks and granite found in the area. Try to get above it on to one of the You Yangs granite ridges for a stunning view of the eagle-like form.

Silo Art Trail

Victoria, Australia
siloarttrail.com

▼ Gain some grains of knowledge about a disappearing world

Site-specific art is rarely so closely connected to its environment as it is in Victoria's remote, arid Wimmera-Mallee region, which stretches north of Melbourne to Mildura and the Murray River. Here, across a range of huge abandoned grain silos dating from the 1930s, Australian artist Guido van Helten and a host of other international creatives have created the 200-km/124-mi long Silo Art Trail. From south to north, it begins with Russian mural artist Julia Volchkova's local sportspeople at Rupanyup and ends at Patchewollock, where Fintan Magee's dignified portrait of local grain farmer Nick Hulland beautifully illustrates the environment and its inhabitants. In between, Drapl & The Zookeeper's magical Mallee region landscape set across a group of silos at Sea Lake and Kaff-eine's gutsy female farmer at Rosebery deliver a fascinating reflection of an age and way of life that have all but disappeared.

RIGHT Silo Art Trail mural, painted by Russian artist Julia Volchkova in Rupanyup.
OPPOSITE *20:50* (1987) by Richard Wilson.

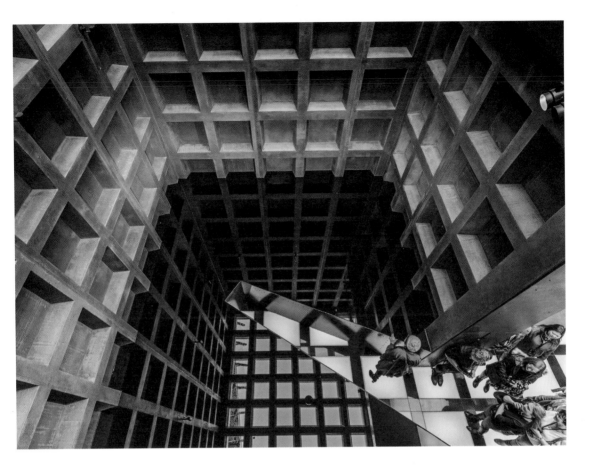

Museum of Old and New Art

655 Main Rd, Berriedale, Tasmania 7011, Australia

mona.net.au/museum/pharos

▲ Fall under the spell of some mind-altering installations in Tasmania

Dreamed up by local millionaire David Walsh in 2011 as a 'subversive adult Disneyland', Tasmania's Museum of Old and New Art (MONA) has always been a popular tourist attraction in an eccentric space, with its eclectic array of exhibits ranged seemingly randomly throughout the cliff-set museum. With the addition of a new wing, Pharos, it has become one of the most memorable places to see contemporary art installations in the southern hemisphere. It is here you'll find Richard Wilson's always arresting oil installation *20:50* of 1987, the famous 1969 self-destructing sculpture *Memorial to the Sacred Wind or The Tomb of a Kamikaze* by kinetic artist Jean Tinguely, and four pieces by James Turrell. The most mind-blowing of them, *Event Horizon* (2017), is likely to literally floor you.

TRAIL: Aboriginal rock art, Australia

Australia is home to some of the oldest rock art in the world, with a vibrant mix of rock and dot painting, engravings, bark painting, carvings and sculptures. Styles, too, are fascinating, from cross-hatch and X-ray art to abstraction, stencil arts and, perhaps best of all, Wandjina painting that wouldn't look out of place in MoMA. Here are the country's best locations in which to see the best of them.

Murujuga National Park

Burrup Peninsula, Western Australia

This stunning red island is home to the world's largest collection of petroglyphs, including what is thought to be the oldest image of the human face in the world, as well as animals such as the Tasmanian tiger, fat-tailed kangaroos and numerous species of birds, reptiles, mammals and marine animals.

The Kimberley

Western Australia

A special site for its wonderful Wandjina – cloud and rain spirits from Australian Aboriginal mythology characterized by halo-like headdresses, mouthless faces, and large round eyes, calling to mind Basquiat and Picasso. The celebrated Gwion Gwion or Bradshaw paintings are here too, with their elongated bodies clad in elaborate dress and bearing boomerangs, spears and ornaments.

Kakadu National Park

Northern Territory

At Kakadu's three sites of Nourlangie, Ubirr and Nanguluwurr (see page 270), the ever-popular X-ray art showing internal skeletons are the standouts, in particular the Namarrkon man at Nourlangie's Anbangbang gallery and shelter, and the Tasmanian tiger at Ubirr. But contact art, showing contact between indigenous peoples and outside cultures, is also strong – look for the early 'whitefellas' at Ubirr, identifiable by their boots, trousers, rifles and pipes.

Mount Borradaile and Arnhem Land

Northern Territory

The honeycombed escarpments at Mount Borradaile are home to an unknown number of rock artworks, thought to date back 50,000 years. Only a small number of visitors are allowed access at any one time, on carefully constructed low-impact tours that make encounters with pieces like huge rainbow serpents, diving fish, sailing boats and more very special.

ABOVE Manja Shelter in the Grampians National Park, Victoria.

Quinkan Country

Queensland

Mythical Aboriginal quinkans are the draw here, alongside paintings of dingoes, eels, other wildlife and of course humans. Colours are largely red ochre, but white, yellow, black and a rare blue pigment also exist. To get the best from this site, take a guided walk with an Aboriginal guide from the Quinkan and Regional Cultural Centre in Laura, 210 km/130 mi north-west of Cairns.

Ku-ring-gai Chase National Park

New South Wales

The closest rock artworks to Sydney are impressively large and their location, along the banks of the Hawkesbury River on the Lambert Peninsula, makes for a great day trip from the city. A lovely 4.4-km/2.5-mi loop walk, the Aboriginal Heritage Walk, gives easy access to them.

Grampians National Park

Victoria

South Australia's key rock art site is this national park, where four sites and the Bunjil Shelter just east of the park in the Gariwerd area feature handprints, emu tracks and abstract horizontal bars thought to be a rudimentary form of calendar.

Preminghana

Tasmania

You'll need to get a permit to explore this Indigenous protection area, but once you do, you'll find 1,500-year-old etchings of abstract designs and patterns covering cave surfaces and rock slabs. The location, close to the beach with waves breaking nearby, makes visiting them an unforgettable experience.

OVERLEAF ▶
Wandjina figures at Raft Point,
The Kimberley, Western Australia.

Martin Hill Studio

1 Harrier Lane, Wanaka
9305, Central Otago,
New Zealand
martin-hill.com

See magical sleights of hand and eye in Wanaka

Martin Hill's sculptures/land art pieces are the stuff of magic, and none is more magical than *Synergy*, his 2009 sculpture made in collaboration with partner Philippa Jones. Looking for all the world like a delicate circle of non-touching bulrush stems emerging from placid Lake Wanaka, the ethereal and ephemeral aspect of the piece is a feature of all Hill's work. That ephemerality, a common component of land art, means you often can't see his actual pieces, but in his Wanaka studio and gallery, seeing prints of the works that have been and gone brings its own pleasures and understanding of land art.

Gibbs Farm

Kaipara Harbour, North
Island, North Auckland,
New Zealand
gibbsfarm.org.nz

Explore an arresting collection of land art in an even more arresting landscape

The landscape of Gibbs Farm in North Auckland, dominated by the vast, windswept Kaipara Harbour, can be a challenge for the artists who have chosen to create an artwork in it, but many have taken it up – among them Richard Serra, Daniel Buren, Andy Goldsworthy and Maya Lin. It's all stunning, and a lovely collection of work that ranges from bombastic and monumental, such as Chris Booth's *Kaipara Strata* (1992), to the more intimate or ethereal, like Marijke de Goey's *Artwork One* (1999). Lin's monumental undulating earthwork *A Fold in the Field* (2013), echoing the relentless weather fronts that shape the nearby coastline and the inevitable gravitational slide of the land towards the sea, is the standout.

Museum of New Zealand Te Papa Tongarewa

55 Cable Street, Wellington
6011, New Zealand
tepapa.govt.nz

Open a container of treasures in Wellington

Set against a beautiful background of mountains, New Zealand's national museum in Wellington is a relative newcomer to the city, having opened in 1998 as Te Papa, or 'Our Place'. Its Te Papa Tongarewa – or Container of Treasures – is literally filled with treasures, albeit not jewels or precious metals, but wonderfully original pieces that span everything from a mesmerizing mask that, with its European-style, broad-brimmed hat and voodoo-like feathers, chillingly calls to mind Freddy Krueger, to twentieth-century paintings by New Zealand artists such as Colin McCahon and Paratene Matchitt, and bold contemporary works like *Atarangi* (1990) by Michael Parekowhai, part of a collection attempting to expand the definition of contemporary Maori art.

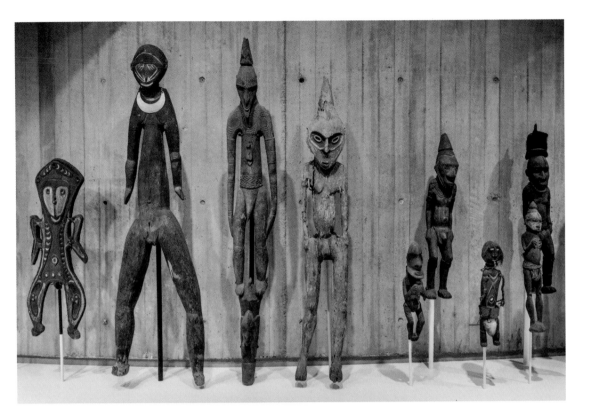

Papua New Guinea National
Museum and Art Gallery

Boroko Pob 5560, Port
Moresby 121,
Papua New Guinea
ncc.gov.pg

▲ Travel through nineteen provinces of Papua New Guinea

Australian architect Martin Fowler clearly enjoyed himself in
1974 with this dynamic gallery, where the Brutalist concrete
blockwork of the decade is nicely mixed with colourful African
art motifs under a dramatic sweeping entrance. Forty years later,
another Australian practice, Architectus, updated Fowler's work
with bright, light-filled gallery spaces featuring versatile hanging
walls filled with more than 400 collection items. They range from
large timber sculpture, statuary, shields and headdresses through
to textiles, modern art and natural history objects drawn from
nineteen provinces of Papua New Guinea. The result is a plethora
of rave reviews from visitors, including 'a fantastic collection of
primitive art, better than the NY Metropolitan Museum!' and
'some fantastic modern art'. I couldn't agree more.

ABOVE Figures on display at
the Papua New Guinea National
Museum and Art Gallery.

Index

Picture Credits

Author Biography

Yolanda Zappaterra is a London-based author, editor and researcher who has credits on more than 30 art, design and travel titles. She has been writing about architecture, art and travel for more than 20 years, and contributes regularly to leisure and lifestyle magazines and specialist art and design magazines and websites, including *Time Out*, *Communication Arts* and *Culture Trip*.

With contributions from James Payne, Ruth Jarvis, Sarah Guy, Cath Phillips and Paul Murphy.

Author Acknowledgements

Amazing Art Adventures is the result of the incredible generosity of friends and colleagues whose passion and enthusiasm have helped shape its contents. For recommendations I'm particularly grateful to Steve Miller, Cathy Lomax, Hilary Cross, Andy Swani, Jan Fuscoe, Mark Croxford and Richard Farias, but the breadth of the book is the result of hundreds of suggestions from many people.

The contributors who helped me come up with the final list and to write the book – James Payne, Ruth Jarvis, Sarah Guy, Cath Phillips and Paul Murphy – deserve a special thanks and credit for making it more than the sum of its parts. As do the fantastic team at Quarto – my Senior Commissioning Editor Nicki Davis, Senior Editor Laura Bulbeck and Copy Editor Ramona Lamport, who all worked so hard to ensure the end publication looked as impressive as it could, and read as well as it does.

And lastly, my parents, in adventurously emigrating from Italy to Wales in the 1950s, set an example that has shaped my life, instilling a lifelong curiosity for the world around me, and an attempt to understand that world's different cultures through their history, art and culture. For that, I'm eternally grateful to them.

Brimming with creative inspiration, how-to projects and useful information to enrich your everyday life, Quarto Knows is a favourite destination for those pursuing their interests and passions. Visit our site and dig deeper with our books into your area of interest: Quarto Creates, Quarto Cooks, Quarto Homes, Quarto Lives, Quarto Drives, Quarto Explores, Quarto Gifts, or Quarto Kids.

First published in 2021 by Frances Lincoln Publishing,
an imprint of The Quarto Group.
The Old Brewery, 6 Blundell Street
London, N7 9BH,
United Kingdom
T (0)20 7700 6700
www.QuartoKnows.com

Text © 2021 Yolanda Zappaterra

A catalogue record for this book is available from the British Library.

ISBN 978 0 7112 5372 8

10 9 8 7 6 5 4 3 2 1

Design by Sally Bond

Printed in China

MIX
Paper from
responsible sources
FSC® C016973